A Collector's Journey

CHARLES LANG FREER AND EGYPT

A Collector's Journey

CHARLES LANG FREER AND EGYPT

Ann C. Gunter

FREER GALLERY OF ART

SMITHSONIAN INSTITUTION

SCALA PUBLISHERS

Smithsonian
Freer Gallery of Art

Funding for this publication was provided by the Freer and Sackler Galleries' Publications Endowment Fund, initially established with a grant from The Andrew W. Mellon Foundation and generous contributions from private donors.

Head of Publications: Lynne Shaner
Editor: Gail Spilsbury
Designer: Michael Hentges

Published by the Freer Gallery of Art, Smithsonian Institution, Arthur M. Sackler Gallery Washington, D.C. 20560-0707
in association with Scala Publishers, Gloucester Mansions, 140a Shaftesbury Avenue, London WC2H 8HD, England

Page 12: Map of Egypt, watercolor and ink on paper. © 2002 Mike Reagan.
Note: Dimensions are given in centimeters; height precedes width precedes depth.
Library of Congress Cataloging-in-Publication Data on page 160.

Contents

Foreword

When the Freer Gallery of Art first opened its doors in May 1923, the most sensational archaeological discovery of the twentieth century was still virtually front-page news worldwide. Six months earlier, Howard Carter and Lord Carnarvon had opened the tomb of Tutankhamun, the young Egyptian pharaoh whose magnificent resting place had miraculously survived among the many royal burials in the Valley of the Kings opposite Luxor. Along with the rest of the world, Americans showed an insatiable appetite for news and photographs of these extraordinary finds. Charles Lang Freer (1854–1919), the Detroit businessman whose collection and vision established the Smithsonian Institution's first art museum, would have appreciated both the beauty and the great antiquity of the treasures that emerged from the tomb.

Charles Lang Freer himself collected Egyptian antiquities, and, like every other group of objects he collected, they had a specific role to play in his vision of beauty and its universal forms of expression. In practice, however, his own collecting of Egyptian antiquities was relatively modest, and traditionally his Egyptian collection has played a marginal role in the museum's activities. This is for several reasons. First, Freer's collection was dominated by Chinese and Japanese art, Syrian and Persian ceramics, and late-nineteenth-century American paintings. His acquisitions of ancient Egyptian art were

comparatively few, and they presented limited opportunities for exhibition and publication because the bulk of the holdings consist of tiny amulets, glass beads, and other small items. Moreover, without a resident specialist on the curatorial staff to build upon Freer's acquisitions, the collection has remained essentially static. Under the stewardship of Richard Ettinghausen, curator of Near Eastern art at the Freer Gallery of Art from 1944 to 1967, portions of the collection were occasionally displayed, specialists consulted, and visitors warmly welcomed. With few other exceptions, only a small number of Freer's Egyptian acquisitions have been exhibited or published, and even the most famous of these are seldom displayed.

In celebration of the museum's seventy-fifth anniversary in 1998, Ann C. Gunter, associate curator of ancient Near Eastern art, assembled an exhibition titled *Charles Lang Freer and Egypt*, which remains on view indefinitely. For the first time, more than a few objects from the Egyptian holdings are on display for an extended period of time. Dr. Gunter's research for the exhibition demonstrated both the potential for a broader exploration of Freer's ideas about the collection and the need to present the results of such study in a book. In reconstructing Freer's travels in Egypt and investigating the records of his acquisitions, Dr. Gunter conducted her own excavations among the rich resources of the Freer Gallery of Art and Arthur M. Sackler Gallery Archives. Her efforts have resurrected in these pages scores of the anonymous Egyptian artifacts that have long inhabited the museum's storerooms. For the first time since Freer acquired these objects, they can be appreciated from the viewpoint of the collector himself. Freer's understanding of ancient Egyptian art and its relation to his other possessions creates an absorbing story, which Dr. Gunter narrates with learning and enthusiasm, presenting fresh insights into the mind of an individual who continues to inspire through his extraordinary vision, taste, and generosity.

Julian Raby
Director

Acknowledgments

In 1995, in connection with plans to celebrate the Freer Gallery of Art's seventy-fifth anniversary in 1998, I proposed an exhibition devoted to the ancient Egyptian objects acquired by gallery founder Charles Lang Freer. I soon realized that the rich documentation for Freer's Egyptian travels and purchases preserved in the gallery's archives was too extensive to include in the exhibition texts, and I conceived a longer study in which to explore the subject in greater depth. Milo C. Beach, former director of the Freer and Sackler galleries, and Thomas W. Lentz, former deputy director, encouraged both projects and supported applications to fund needed research. Grants from the Smithsonian Institution's Research Opportunities Fund in 1998 made it possible to travel in Egypt and to conduct research at the Griffith Institute, Oxford University. A Collections-based Research Grant from the Smithsonian's Office of Fellowships and Grants enabled me to return to Egypt in 2000 to see additional sites and consult libraries and archives in London, Glasgow, Detroit, Ann Arbor, and New York.

I owe a special debt to several colleagues for their key roles in the evolution of this book. Linda Merrill, former colleague and enduring friend, first alerted me to the rich potential of Charles Lang Freer's correspondence as a source for exploring his ideas about Egyptian art, and she shared my delight in

each new archival discovery. John Siewert's research on James McNeill Whistler led him to references in Freer's diaries to the collector's travels in Egypt and the Near East, which he kindly made available to me. Betsy M. Bryan, Alexander Badawy Chair in Egyptian Art and Archaeology at Johns Hopkins University, has made this project possible in countless ways. She reviewed the Freer's collection of Egyptian art, accompanied me on trips in Egypt and to Egyptian collections in England and Scotland, and introduced me to her Egyptological colleagues both in the United States and abroad. She has unstintingly made available her unrivaled knowledge of Egyptian art as well as her wise counsel, and I have benefited equally from her inspiration and example. Tammy Krygier and Thomas Kittredge, both doctoral candidates in Egyptian art and archaeology at Johns Hopkins University, carried out essential research on Freer's Egyptian collection and on collectors of Egyptian art, respectively.

Individuals and institutions both here and abroad generously supplied information and access to resources. I enjoyed a particularly rewarding period of research at the University of Michigan at Ann Arbor, thanks in no small measure to the hospitality provided by Margaret, Larry, Ben, and Katherine Root. Kathy Marquis, reference archivist at the Bentley Historical Library, University of Michigan, assisted with access to the records of Francis W. Kelsey. Lori Mott, registrar of the University of Michigan Art Museum, located records of Margaret Watson Parker's gift of Raqqa ceramics. With astonishing speed, John Gibson, archivist at the Burton Historical Collection, Detroit Public Library, sent references to sources on Freer's fellow Detroit citizens. Marlis J. Saleh and Olaf Nelson of the Middle East Department, University of Chicago Library, went to exceptional lengths to make available for reproduction images from their institution's fabulous photographic archives. Richard A. Fazzini and James F. Romano of the Department of Egyptian, Classical, and Ancient Middle Eastern Art of the Brooklyn Museum of Art were model colleagues who introduced me to the rich holdings of the

Wilbour Library of Egyptology and cheerfully came to my rescue on many occasions with information, references, and photographs. Mary Gow, acting head librarian of the Wilbour Library, unearthed rare publications I would never have located on my own.

Stephen Quirke, curator at the Petrie Museum, University College London, discussed the project with me on several occasions and kindly permitted me to consult Petrie's notebooks. Jaromir Malek welcomed me at the Griffith Institute, Oxford University, and gave me access to the correspondence of Percy Newberry and F. Llewelyn Griffith. W. Vivian Davies, keeper of the Department of Ancient Egypt and the Sudan, British Museum, and Christopher Date of the museum's Central Archives, located photographs of the Egyptian galleries. John E. Curtis, keeper of the Department of the Ancient Near East, allowed me to consult the correspondence of E. A. Wallis Budge. Harry James, former keeper of Egyptian antiquities at the British Museum, helpfully steered me toward important sources at critical moments. One of those sources was John Ray, Herbert Thompson Reader in Egyptology at the University of Cambridge, who tracked down details of Thompson's visit to Egypt. In Glasgow, Nigel Thorp, director of the Centre for Whistler Studies at the University of Glasgow, referred me to Simon R. Eccles, who in turn generously provided access to the Egyptian antiquities at the Burrell Collection. Lawrence Hurtado, director of the Centre for the Study of Christian Origins, University of Edinburgh, furnished information on the Freer biblical manuscripts.

Colleagues here at the Freer and Sackler galleries furnished expertise and patiently assisted in myriad ways. Colleen Hennessey, head archivist, never tired of requests to consult the Charles Lang Freer Papers and maintained an unflagging enthusiasm for the project from start to finish. David Hogge and Linda Machado located records and scanned images; Kathryn Phillips answered numerous requests for books. Simona Cristanetti, Barbara Brooks-Reeder, and Weina Tray took care of travel arrangements and many

other tasks in preparation for the exhibition and the book, and Angela Jerardi proved herself indispensable in final preparations for publication. Beth Duley, Freer Gallery of Art registrar, and Tara Coram, Tim Kirk, and Susan Kitsoulis, assisted Tammy Krygier and me in studying objects in collections storage. Rebecca Barker and Mia Vollkommer processed orders of images from the collections and archives, and John Tsantes, Michael Bryant, Neil Greentree, and Robert Harrell produced their usual superb photographs. Thomas Lawton and Joseph Chang answered questions about Chinese paintings; Barry Flood reviewed sections devoted to the monuments of medieval and modern Egypt. Karen Sagstetter, former head of publications, encouraged me to create this book, and I am grateful to her for seeing the potential and value in such a study. The project was completed under the capable guidance of Lynne Shaner, head of publications, and Kate Lydon, art director. Gail Spilsbury, the editor, was an author's dream; her suggestions invariably improved the clarity of my writing and thinking, and it has been an unqualified pleasure to work with her. Michael Hentges, the designer, brought to the book his fine eye and a wonderful appreciation for the entire enterprise. To all who made this project possible and enjoyable, my heartfelt thanks.

Ann C. Gunter
Associate Curator of Ancient Near Eastern Art

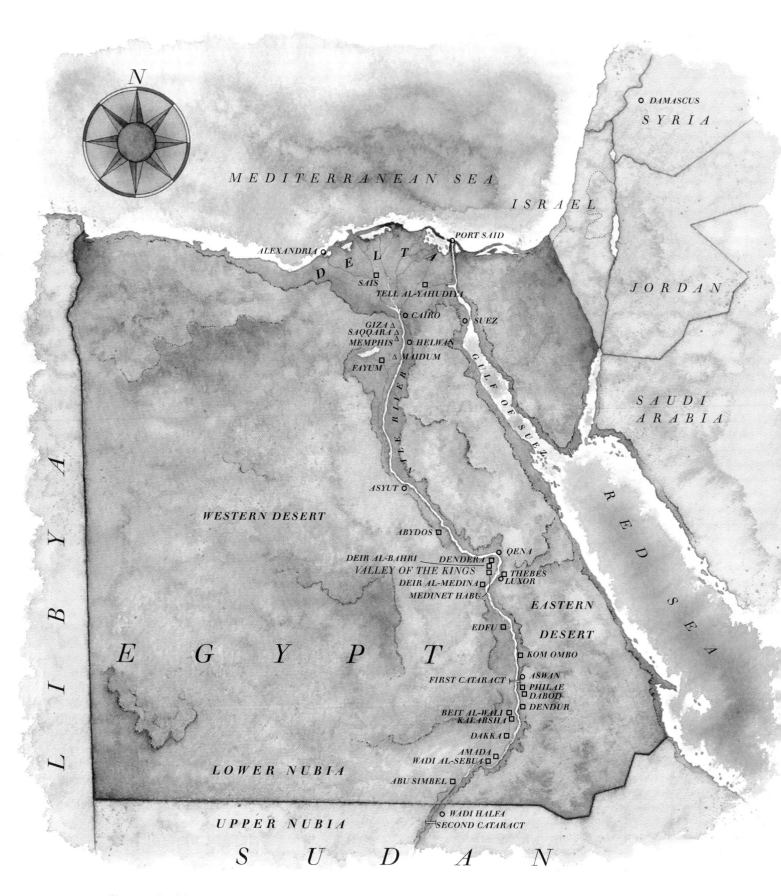

N

MEDITERRANEAN SEA

ISRAEL

S Y R I A

○ *DAMASCUS*

J O R D A N

PORT SAID

ALEXANDRIA ○ D E L T A

□ SAIS

□ TELL AL-YAHUDIYA

○ CAIRO

○ SUEZ

GIZA △
SAQQARA △
MEMPHIS △
○ HELWAN

△ MAIDUM

□ FAYUM

S A U D I
A R A B I A

N I L E R I V E R

G U L F O F S U E Z

ASYUT ○

WESTERN DESERT

R E D

ABYDOS □

S E A

DEIR AL-BAHRI — DENDERA
VALLEY OF THE KINGS □
DEIR AL-MEDINA □
MEDINET HABU

○ QENA
□
□ THEBES
□ LUXOR

E A S T E R N

EDFU □

DESERT

L I B Y A

E G Y P T

□ KOM OMBO

FIRST CATARACT ○ ASWAN
□ PHILAE
□ DABOD
□ DENDUR

BEIT AL-WALI □
KALABSHA □

DAKKA □

AMADA □
WADI AL-SEBUA □

LOWER NUBIA

ABU SIMBEL □

UPPER NUBIA

○ WADI HALFA
SECOND CATARACT

S U D A N

Sites south of Aswan are shown in their original locations, before construction of the Aswan High Dam (1960–71).

A Collector's Journey

CHARLES LANG FREER AND EGYPT

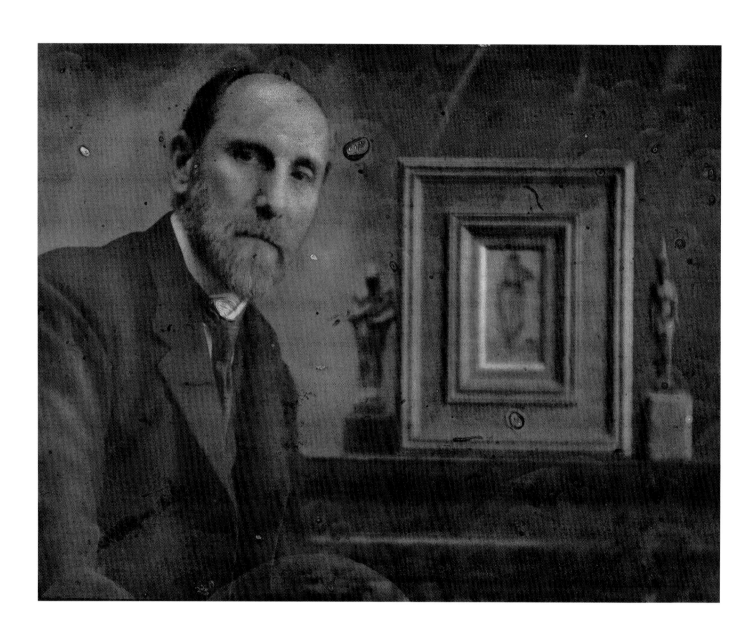

"The Greatest Art in the World"

In a 1909 photograph of Charles Lang Freer, the collector appears with two Egyptian bronze figurines, which flank a pastel drawing by the American-born artist James McNeill Whistler (1834–1903; fig. 1.1). Both figurines depict ancient Egyptian deities. Closest to Freer is Anubis, the jackal-headed god of embalming and guardian of the cemetery. On the other side of the pastel is an image of Neith, patron deity of the northern city of Sais; a warrior goddess, she protected both the living and the dead. Whistler's tiny pastel, titled *Resting* (1870–75), depicts a female figure inspired in part by the ancient Greek terracottas known as Tanagra figurines, which became widely known to Western collectors and artists in the late nineteenth century.

This portrait by Alvin Langdon Coburn is one of only two surviving photographs for which Charles Lang Freer posed with objects in his collection. Considered as autobiography, it suggests that, at this point in his life, Freer considered ancient Egyptian art and the works of Whistler to be related to each other in a significant way. What was that relationship? When, and how, did Freer discover ancient Egyptian art for himself, and what part did it play in his overall collecting interests? How did those interests compare with the interests of Freer's contemporaries?

FIG. 1.1 Alvin Langdon Coburn (1882–1966), portrait of Charles Lang Freer, 1909. Autochrome. Charles Lang Freer Papers, Freer Gallery of Art Archives, Smithsonian Institution, Washington, D.C. Works depicted, left to right: figurine of Anubis, Dynasty 26 (664–525 B.C.E.) or later; bronze; 24.1 x 6.9 x 5.2 (F1908.52); James McNeill Whistler (1834–1903), *Resting*, 1870–75; chalk and pastel on brown paper; 15.1 x 7.6 (F1902.176); figurine of Neith, Dynasty 26 (664–525 B.C.E.) or later; bronze; 21.3 x 3.8 x 6.9 (F1907.1).

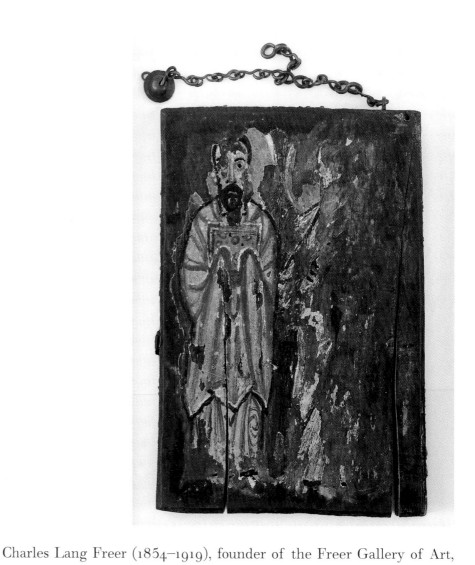

Charles Lang Freer (1854–1919), founder of the Freer Gallery of Art, made his fame as a collector principally through his acquisitions of Chinese and Japanese art and of the works of James McNeill Whistler. Yet he also developed a keen interest in Egypt's ancient art and monuments, in part as a result of his initial visit there in the winter of 1906 to 1907, when he traveled south by train and boat from Alexandria in the Nile Delta to Wadi Halfa, near the modern border with Sudan. Egypt's ancient monuments captivated Freer. His first trip convinced him that his collection would be incomplete without examples of ancient Egyptian sculpture in stone and wood. "I now feel that these things are the greatest art in the world," he wrote to Colonel Frank J. Hecker, his Detroit business partner and close friend, "greater than Greek, Chinese or Japanese."[1]

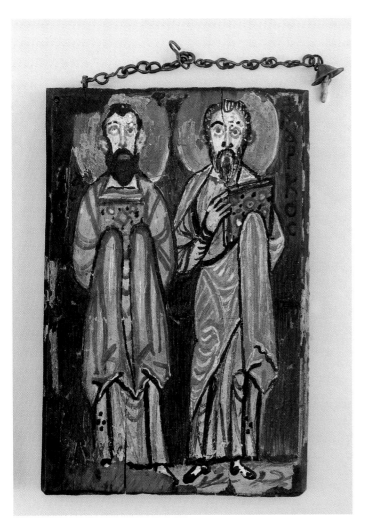

His second and third trips, in 1908 and 1909, were devoted primarily to purchasing works of art in Cairo and Alexandria. On all three trips he frequented the shops of antiquities dealers and visited the homes of private collectors. His purchases in Egypt constitute the bulk of his Egyptian acquisitions, but he also bought from dealers in New York, London, and Paris, both before and after he visited the country. In all, he accumulated more than fifteen hundred objects made of glass, metal, wood, faience, stone, parchment, and papyrus, ranging in date from the end of the Old Kingdom (ca. 2675–2130 B.C.E.) to the fifth and sixth centuries, when Egypt formed part of the Byzantine Empire ruled from Constantinople. These impressive quantities must be put in perspective: over thirteen hundred consist of tiny glass beads and inlays; two hundred are

ceramic amulets and sherds; several score are fragments written on parchment or papyrus.

A few of these objects are familiar to specialists. The five biblical manuscripts commonly known as the Washington Manuscripts comprise the most important collection of their kind outside Europe. The four purchased in Cairo in 1906 are parchment manuscripts written in Greek in codex form, that is, with folded sheets forming leaves like the modern book. The Washington Manuscript of the Gospels, which dates to the late fourth or early fifth century, is the third oldest parchment manuscript of the Gospels in the world. It was enclosed in painted wooden covers of seventh-century date that depict the four Evangelists (fig. 1.2). The other manuscripts purchased in 1906 consist of an early fifth-century codex containing Deuteronomy and Joshua; a fifth-century codex of the Psalms; and a sixth-century codex of the Epistles of Paul. In 1916, Freer acquired a fragmentary third-century papyrus codex of the Minor Prophets. In the field of Egyptology, according to *Who Was Who in Egyptology*, Freer is remembered for his valuable collection of manuscripts written in Coptic, the form of the Egyptian language used from the third century.[2] Among these manuscripts are a large portion of the Coptic Psalter, dating to the mid-third century, and part of a homily written by Theophilus, archbishop of Alexandria. In addition, of more than a dozen fragments, three preserve portions of the Psalter, Matthew, and Job. Immediately celebrated as major acquisitions, the manuscripts received significant press attention and played a key role in establishing the United States as an important repository of biblical manuscripts.[3]

Thanks to Freer's financial backing and the able efforts of Francis W. Kelsey (1858–1927), professor of Latin literature at the University of Michigan, the Greek and Coptic manuscripts were quickly published and widely distributed; most volumes appeared even before Freer's death in 1919.[4] Kelsey also helped to arrange for publication of Byzantine gold artifacts and

FIG. 1.3 Objects from the "Gold Treasure," Byzantine works probably made in Constantinople, 6th to 7th century; a portion of a larger group of objects allegedly found as a hoard and purchased in Cairo in 1909. Gold; diameter of large medallion 10.7. Freer Gallery of Art, Smithsonian Institution, Washington, D.C., gift of Charles Lang Freer (F1909.62–65, F1909.67–70).

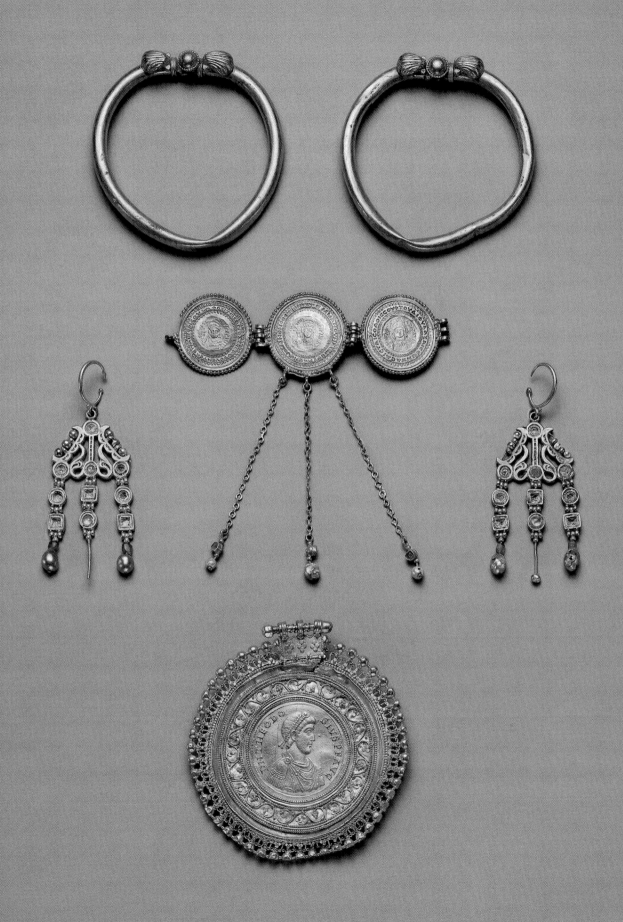

paintings purchased in Cairo on Freer's behalf (fig. 1.3).[5] Some of Freer's other Egyptian acquisitions were not studied or published during his lifetime, but have subsequently come to be regarded as important works. Twenty glass vessels dating from the New Kingdom (ca. 1539–1075 B.C.E.), part of a large collection of ancient glass purchased in 1909 from the collector and numismatist Giovanni Dattari (died 1923), are now widely considered to comprise some of the finest surviving examples produced during the reigns of Amenhotep III (ca. 1390–1353 B.C.E.) and Amenhotep IV, who changed his name to Akhenaten (ca. 1353–1335 B.C.E.; fig.1.4).[6]

Since the opening of the Freer Gallery of Art in 1923, scholars have occasionally examined selected works in the Egyptian collections in connection with research projects or for small, temporary exhibitions.[7] In 1962, Richard Ettinghausen, curator of Near Eastern art at the Freer Gallery of Art, organized an exhibition of glass that included over sixty examples from the collection purchased in 1909.[8] The museum's sixtieth anniversary in 1983 provided

FIG. 1.4 Vessels, Egypt, New Kingdom, Dynasty 18 (ca. 1539–1295 B.C.E.). Glass; 13.3 x 9.3 x 8.7; 12.2 x 5.4 x 5.4; 8.1 x 6.4 x 4.9; 10.2 x 8.0 x 8.0. Freer Gallery of Art, Smithsonian Institution, Washington, D.C., gift of Charles Lang Freer (F1909.430, F1909.413, F1909.428, F1909.423).

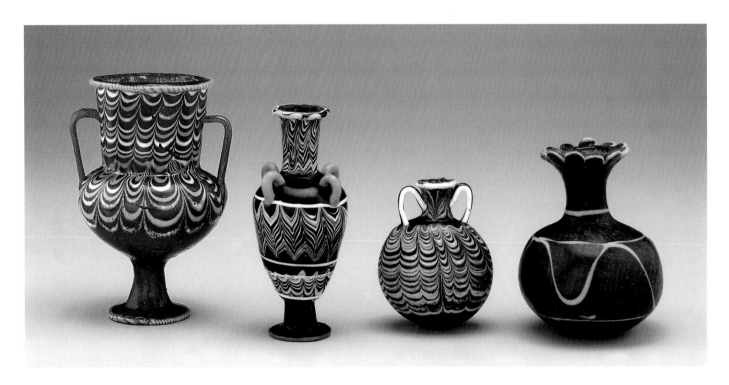

another opportunity to celebrate key acquisitions from this source: ancient glass, Byzantine gold artifacts, and Byzantine paintings (fig. 1.5).[9] More recently, research on New Kingdom glass workshops has revived interest in the beautifully preserved, but archaeologically unprovenanced, vessels in the Freer collection; it has also enabled scholars to assign more precise dates and probable places of origin to several examples. Over the past few years, research on the collection has contributed substantially to the proper identification of many objects, situating them within the modern scholarly understanding of Egyptology and paleography. From this perspective, a few works stand out as world-class specimens: the biblical manuscripts and the New Kingdom glass vessels. Most of Freer's other Egyptian acquisitions were unexceptional, judging both by the standards set by other areas of Freer's collection and by those of his contemporaries. Only a few categories are represented, often by fragments: glazed ceramic amulets and vessels, glass inlays and beads, limestone relief plaques, and bronze figurines; they are exemplary of well-known types. As a unit, Freer's Egyptian acquisitions appear limited and idiosyncratic, assembled by a collector whose real knowledge and passion apparently lay elsewhere. They form a modest group, overshadowed by his examples of medieval Syrian and Persian ceramics, and eclipsed by his incomparable holdings of Whistler's works and of Chinese and Japanese art.

But we misunderstand Freer's aims, and misjudge his accomplishments, if we approach the Egyptian collection only as an isolated or self-contained set of artifacts. Freer viewed his Egyptian acquisitions as an integral part of his collection, and he pursued and selected them for highly specific purposes. The biblical manuscripts were an unanticipated and, for him, uncharacteristically impulsive purchase. Freer's interest in Egypt grew chiefly from his passion for Asian and especially Near Eastern ceramics; it gained impetus with plans for a museum housing his collection in Washington, D.C. Freer wished his collection to represent the Nile Valley's ancient glazed ceramics which,

together with those of Mesopotamia, comprised "the earliest *glazed* potteries thus far exhumed in the world," and he valued them equally for their beauty and historical importance.[10] Moreover, the presence of ancient ceramics and sculptures in his collection served a loftier goal: to enable "those who have the power to see beauty" to recognize aesthetic harmonies with the artistic products of other great civilizations worldwide. Approached from this perspective, the Egyptian acquisitions emerge as primary, untapped sources for investigating Freer's collecting aims and aesthetic ideals. This book seeks to describe Freer's experience and elaborate his understanding of ancient Egypt rather than to investigate his collection from the viewpoint of Egyptology. For this reason, most examples will be chosen to illustrate those objects that engaged Freer. In turn, probing the nature and role of Freer's Egyptian interests ought to contribute new evidence for the tightly knit set of relationships Freer perceived within his seemingly eclectic collection.

Recent studies of Freer's acquisitions and aesthetic interests that focus on the large, internationally distinguished collections of Chinese and Japanese art and the works of James McNeill Whistler have also referred to Freer's travels and purchases in Egypt and unearthed key archival material with which to launch a more detailed investigation.[11] Freer's own documents concerning his journeys and acquisitions in Egypt, preserved in diaries, correspondence, and financial records, can be supplemented by annotated inventories he prepared for the creation of the Freer Gallery of Art in Washington, D.C. Freer's travels and collecting can also be elaborated by turning to the considerable literature documenting foreign tourists in Egypt at the beginning of the twentieth century. Between 1900 and 1907, fifty books were published by Americans who described their travels in Egypt. In addition, accounts by those of other nationalities were often translated into English and published in editions in the United States.[12] These volumes supply additional information with which to compare and, as needed, flesh out the often skeletal entries in Freer's diary.

FIG. 1.5 *The Heavenly Ladder*, Byzantine, 11th century. Final page from a lost copy of St. John Climacus's *Heavenly Ladder*. Color and slight gold on vellum; 15.6 x 13.2. Freer Gallery of Art, Smithsonian Institution, Washington, D.C., gift of Charles Lang Freer (F1909.152).

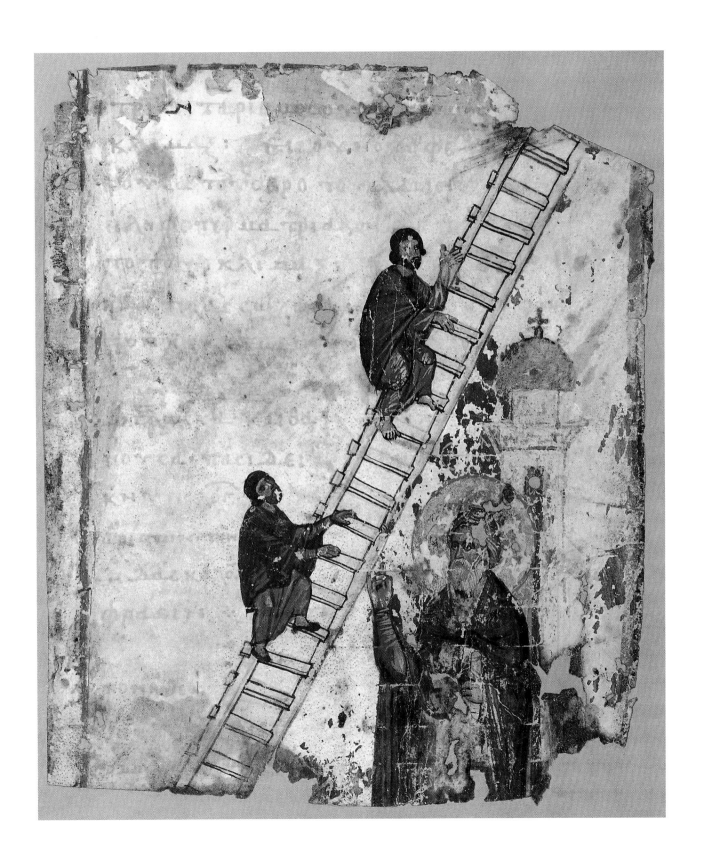

Many furnish myriad details concerning transportation by land and along the Nile, hotel accommodations, visits to sites and museums, shopping in the bazaars, and other aspects of the tourist experience not always available in Freer's diaries and letters. Read in conjunction, these sources yield a remarkably comprehensive picture both of Freer's experience in Egypt and of the place Egyptian art occupied in his collecting aims and notions of beauty.

Born in Kingston, New York, in 1854, Freer was first employed as a clerk in the general store of John C. Brodhead. He was subsequently hired by Colonel Frank J. Hecker, a Civil War veteran, who ran the office of the New York, Kingston, and Syracuse Railroad. In 1880 Hecker established in Detroit the Peninsular Car Works, with Freer as assistant treasurer. By 1900, having made his fortune through a series of highly successful business transactions, Freer retired from active business and began to pursue his passion for collecting works of art. Freer had begun in 1887 to collect the etchings of James McNeill Whistler, an American-born artist who had lived in Paris and London for most of his adult life. Freer first met Whistler in London in 1890 and soon became both a devoted patron and a close friend. Whistler, in turn, introduced Freer to Asian, and particularly, to Japanese art.[13] Freer traveled extensively in India, China, and Japan in 1894 to 1895, avidly visiting monuments, museums, dealers, and private collections. In subsequent years he purchased Asian art in the United States and Europe and continued to collect the works of Whistler, along with those of three other American artists whom he also knew personally: Thomas Wilmer Dewing (1851–1938), Dwight W. Tryon (1849–1925), and Abbott Handerson Thayer (1849–1921).

Freer became interested in Syrian, Mesopotamian, and Persian ceramics around 1902, and over the next fifteen years pursued acquisitions in this area, along with Japanese, Chinese, and Korean painting and ceramics. Toward the end of 1904, he proposed to donate his collection to the Smithsonian Institution in Washington, D.C., an offer that met with no immediate positive

response. For over a year, discussions continued over the terms of the gift and the issue of proper housing for the collection. Finally, President Theodore Roosevelt intervened on Freer's behalf.[14]

The year 1906 marked a dramatic turning point in Freer's life. On 24 January, the Smithsonian Institution's Board of Regents unanimously agreed to accept his proposed gift as outlined in a letter Freer had sent to Secretary Samuel P. Langley nearly two years earlier. As Freer explained to Langley, his aim was to compose a collection centered in the art of Whistler, in whose work Freer detected aesthetic qualities also discernible in the arts of other, historically unrelated civilizations. "My great desire has been to unite modern work with masterpieces of certain periods of high civilization harmonious in spiritual suggestion, having the power to broaden esthetic culture and the grace to elevate the human mind," Freer wrote. He had stipulated in his proposal that he would retain the collections during his lifetime, principally in order to make certain improvements: "Believing that good models only should be used in artistic instruction, I wish to continue my censorship, aided by the best expert advice, and remove every undesirable article, and add in the future whatever I can obtain of like harmonious standard quality."[15] Similarly, in correspondence with colleagues and friends written in subsequent years, Freer expressed his determination to improve the collection both through systematic weeding and new acquisitions.

Freer thus had a new mission in his collecting pursuits. Having stipulated that the gift be transferred to the Smithsonian Institution after his lifetime, his next step was to reappraise his current holdings, weed them, and make additions in certain key areas. He undertook this project comprehensively, as his continued study of Asian art both improved his own connoisseurship and led him into novel collecting territory. Fresh archaeological discoveries also prompted an interest in artistic cultures he had not previously explored, including Egypt.

Freer's interest in Egypt began with his passion for Asian ceramics, but above all in ancient and medieval Syrian and Mesopotamian glazed wares then labeled "Babylonian" and "Raqqa." In his travels and in studying and acquiring these wares, he became acquainted with ancient Egyptian glazed vessels, sculptures, and other objects. Freer sought to keep abreast of new information as ongoing excavations in Egypt and Mesopotamia yielded additional ceramic specimens and refined their history and chronology. He later explicitly placed his trip to Egypt in the context of this pivotal year: "I felt also the absolute necessity of having in my collection some specimens, at least, of the Egyptian wares, if after seeing the very best of them in their original home, they impressed me deeply in all points of beauty," he wrote to Hecker early in 1907. "These ideas I mentioned to no one, but then decided to go to Egypt with open mind and see for myself."[16] Freer had not traveled to Asia since his initial journey over a decade earlier. The needs of the collection—and those of the future museum in Washington—created a new set of circumstances, compelling him to return. In 1906, therefore, he planned another trip to Asia, this time by way of Egypt, whose ancient ceramics he now regarded with keen interest.

The Smithsonian Regents' decision also brought about significant changes in the way Freer envisaged his collection from a physical point of view. Freer enjoyed showing his possessions to visitors in his Detroit home and expressed a desire to create a gallery that would preserve the intimate atmosphere in which he was accustomed to appreciating his collection.[17] In 1904, and again a few years later, when the collection had outgrown available space in his home, he added galleries where works of art could be displayed.[18] Following the Regents' decision, however, these works of art were destined to reside eventually in Washington and to be exhibited in permanent galleries. The museum in Washington would ensure "the protection of [the collection's] unity and the exhibition of every object . . . in a proper and attractive manner."[19] The new goal of sorting and classifying objects and juxtaposing them in fixed spaces

and exhibition cases added a different dimension to his thoughts about his holdings, and required constant revision as he expanded and refined his collection until his death in 1919.

In 1906, Egypt was nominally governed by an official who held the hereditary title of khedive ("sovereign" or "viceroy") and was a tributary vassal of the Ottoman Empire ruled from Istanbul. Effectively, however, Egypt was under British rule from 1882, when British troops put down an attempted revolutionary government and occupied the country as far south as the Sudan. In 1883, Sir Evelyn Baring (later Lord Cromer) was appointed consul general, a post he held until 1907, and under his administration tensions grew as a fledgling nationalist movement increasingly opposed foreign domination and privilege.[20] Less than six months before Freer's arrival, a confrontation between villagers and British officers occurred at Dinshawai in the Nile Delta region, resulting in the death of one of the officers. Four villagers were later executed, and others sentenced to floggings and hard labor. The harsh sentences aroused indignation worldwide, and the Dinshawai incident, as it came to be known, became a rallying cry in Egypt's emerging nationalist struggle. The incident demonstrated dramatically the British administration's insensitivity and failure to undertake needed political and judicial reform.[21]

Initially, foreigners who traveled to Egypt were often invalids, advised to winter there because of serious illness that wet, chilly northern climates made worse. With the opening of the Suez Canal in 1869, foreign attention was increasingly drawn to Egypt, and an enterprising Englishman named Thomas Cook set out to create a tourist industry. Thomas Cook & Son offered guided tours and quickly built up an impressive infrastructure of hotels, boats, and organized land transport consisting of carriages, donkeys, and camels.[22] A factor that did temporarily depress foreign tourism was the periodic outbreak of cholera. One epidemic occurred in 1896; during another, in 1902, there were one thousand deaths a day in Cairo alone.[23] But the numbers of foreign travelers

steadily increased despite such occasional setbacks. Especially for the British, Egypt became, in the late nineteenth century, a popular place for wealthier (and healthier) members of society to spend the winter months. This group formed a community in need of familiar social and cultural institutions in order to enjoy their lengthy overseas residence.[24]

Americans visited Egypt in comparatively small numbers until after the Civil War, which coincided with the surge of foreign interest that followed the opening of the Suez Canal in 1869. Following years of internal strife, the United States possessed few resources in abundance other than military equipment and well-trained soldiers. Egypt bought arms and imported more than forty former Union and Confederate officers, who were employed in the Egyptian Service chiefly to organize exploration and mapping expeditions. American missionaries had early established a presence in Egypt, where the Associated Reformed Presbyterian Church set up a mission in 1854.[25]

If Egypt's Muslim inhabitants drew the missionaries, its pharaonic past and biblical ties attracted American artists, photographers, and authors.[26] The creation of a modern tourist industry made Egypt's ancient splendors increasingly accessible, transforming the Holy Land into an earthly as well as a spiritual destination. Most tourists visited the country briefly on excursions to the Holy Land that included stops in Cairo and the Giza Pyramids, Jerusalem, and Petra. Yet many tourists chose a longer sojourn in Egypt, seeing sites in Alexandria and Cairo and joining the Nile cruises that typically lasted about ten days. Egypt possessed many advantages as an exotic place for Americans to travel, including the well-established presence of English speakers and territory that seemed comfortingly familiar to generations intimately acquainted from childhood with the Bible. "We are now coming to Old Testament Ground, and if you look in your Bagster you can follow along with us," one American tourist wrote to her family upon arriving in Egypt.[27] In addition, visits by well-known figures rendered the country increasingly familiar

to Americans. Many people followed the Nile travels of British explorer Henry Morton Stanley and General Ulysses S. Grant. Samuel Clemens's *The Innocents Abroad* (1869), Charles Dudley Warner's *My Winter on the Nile* (1899), and Charles Dana Gibson's *Sketches in Egypt* (1899), among many other titles, were eagerly consumed.

Freer's travels to Egypt and the vast majority of his Egyptian acquisitions took place during a decade in which a growing number of museums and individuals, including such financial giants as J. Pierpont Morgan, began seriously to collect works of that ancient civilization.[28] This period also witnessed the first American excavations in Egypt, archaeological expeditions organized principally by museums and universities and sometimes financed by Morgan and other Gilded Age barons.[29]

Freer's interest in Egyptian art developed from his fascination with Asian and especially Near Eastern glazed ceramics and his vision of universal aesthetic harmonies. Freer's real quest in the Holy Land was for the home of Raqqa pottery; his journey was as deeply spiritual as that of any devout pilgrim. Seeing Egypt through Freer's eyes thus offers enlightenment on several fronts. It takes us back a century to an exceptional American collector's experience of this famous land and its ancient monuments. It also situates Freer's Egyptian acquisitions in the wider framework of his overall collecting pursuits; in so doing it contributes another perspective on the American appreciation of Egyptian art at the beginning of the twentieth century. Above all, seeing Egypt through Freer's eyes deepens our understanding of this unusual American, whose distinctive aesthetic vision permeated all aspects of his collecting. Freer sought to bequeath to the nation a collection that exhibited the transcendent harmonies he perceived among the works of disparate cultures worldwide. This book explores the place of ancient Egyptian art, "the greatest art in the world," in those aesthetic harmonies. As seems fitting to an investigation of Charles Lang Freer's collection, it begins and ends with Whistler.

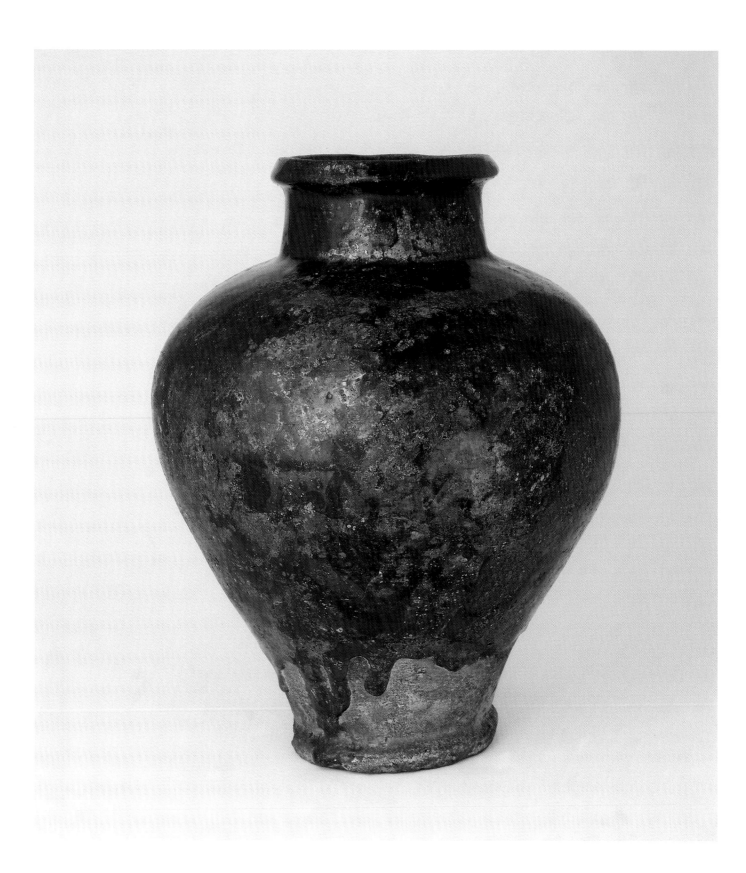

Egypt from Afar

In December 1904, Freer received at his Detroit home three cases containing, among other objects, Egyptian antiquities to consider for his collection. The sender was Siegfried Bing (1838–1905), his generation's most influential Parisian dealer in Asian art and a prominent patron of the Art Nouveau movement. On this occasion Bing sent via his agent, Miss Marie Nordlinger, examples of Near Eastern glazed ceramics, which Freer had begun to acquire a few years earlier. Perhaps confident of the collector's open mind, Bing had also included Egyptian antiquities. "I know practically nothing about Egyptian antiquities," Freer acknowledged, "but will, of course, be pleased to examine those you sent, as a matter of artistic gratification."[1] But he soon returned them, along with Near Eastern ceramics that did not attract him or whose quality he felt did not match those he already owned. "The Egyptian antiquities are very interesting," he wrote to Bing, "and I have enjoyed studying them very much. I must say, however, that it is a kind of art with which I find myself without the appreciation which is probably its just due. The art of China, Japan and Central Asia appeals to me more deeply, and I feel that I can accomplish much more for myself and others by collecting the art of those wonderful places of production."[2] Yet, exactly two years later, Freer was on his way to

FIG. 2.1 Jar, "Raqqa" ware, Syria, 12th to 13th century. Stone-paste painted under green-blue glaze; 28.0 x 22.2. Freer Gallery of Art, Smithsonian Institution, Washington, D.C., gift of Charles Lang Freer (F1904.144).

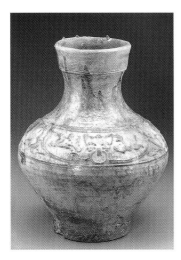

FIG. 2.2 Vessel, China, Han dynasty (206 B.C.E.–220 C.E.). Earthenware with lead silicate glaze; 36.4 x 29.2. Freer Gallery of Art, Smithsonian Institution, Washington, D.C., gift of Charles Lang Freer (F1905.87).

OPPOSITE TOP
FIG. 2.3 Vessel, "Raqqa" ware, Syria, 12th to 13th century. Stone-paste with turquoise glaze; 12.9 x 19.8. Freer Gallery of Art, Smithsonian Institution, Washington, D.C., gift of Charles Lang Freer (F1902.244).

OPPOSITE LEFT
FIG. 2.4 Jar, "Raqqa" ware, Syria, 12th to 13th century. Stone-paste painted under turquoise glaze; 31.1 x 21.6. Freer Gallery of Art, Smithsonian Institution, Washington, D.C., gift of Charles Lang Freer (F1908.156).

OPPOSITE RIGHT
FIG. 2.5 Pitcher, "Raqqa" ware, Syria, 12th to 13th century. Stone-paste painted over glaze with luster; 19.5 x 13.2. Freer Gallery of Art, Smithsonian Institution, Washington, D.C., gift of Charles Lang Freer (F1908.140).

Egypt in search of additions to his collection. What had happened to change his mind?

Freer's interest in Egypt grew from his passion for Asian ceramics, and especially those of the Near East. He began his ceramic collecting with celadon and glazed stonewares from Japan, China, and Korea, purchasing large quantities from dealers in Boston, New York, and Paris between 1897 and 1901. Freer was increasingly drawn to study the earliest examples of glazed wares from China and its neighbors, including examples produced during China's Han dynasty (206 B.C.E.–220 C.E.) (fig. 2.2). What initially attracted him to the Near Eastern sphere were turquoise- and green-glazed ceramic vessels, in which he discerned aesthetic harmonies with the glazed ceramics of China and Japan. His first Near Eastern purchases consisted chiefly of glazed vessels belonging to two loosely defined groups, which were often confused with one another and whose chronology was poorly understood. Raqqa wares, named for the site in north central Syria from which they were thought to derive, had just begun to appear on the art market. The term embraced an assortment of wares, shapes, and decorative schemes, all attributed to the same source, and dated variously from the late eighth to the thirteenth century (figs. 2.3–2.5, and 2.1). Pottery designated "Babylonian" usually consisted of green- and turquoise-glazed earthenwares produced in Mesopotamia, at least some of which was thought to predate the Raqqa pottery anywhere from a few hundred to nearly a thousand years (fig. 2.6). The less common term "Mesopotamian" typically embraced Raqqa wares.[3] Freer eventually assembled a collection of nearly 1,750 ceramic works of Near Eastern origin. Examples identified as Raqqa wares initially dominated his purchases, but he also bought a large number of Persian ceramics and about a dozen labeled as Babylonian.[4]

By 1900, ancient pottery had been unearthed both in northern Mesopotamia near modern Mosul, and in the south, around Baghdad and at sites closer to the Persian Gulf. In the northern region, ancient Assyria, the

enormous mounds covering the remains of Nineveh and Ashur were the principal sources for these wares. In the south, ancient Babylonia, they derived from organized excavations and clandestine digging at Babylon, near Baghdad, and the nearby ancient cities of Seleucia and Ctesiphon. South of Baghdad, sites explored chiefly for their ancient clay tablets inscribed with cuneiform texts, including Nippur and Uruk, also yielded similar glazed ceramics. Not far to the east in southwestern Iran, excavations at Susa (ancient Shushan) launched in 1885 by the French mission to Persia, had yielded related varieties of glazed wares.[5] Beginning in the late nineteenth century, examples of both ancient and medieval glazed ceramics from Syria, Mesopotamia, and Iran made their way to European and American museums, the art markets in Paris and London, and the homes of private collectors.

Today, the earthenwares with alkaline glaze typically colored green and turquoise are assigned to the Seleucid (305–95 B.C.E.) and especially the

BELOW AND BOTTOM
FIG. 2.6 "Babylonian" vessels, Mesopotamia (modern Iraq), Parthian period (ca. 160 B.C.E.–224 C.E.). Earthenware with alkaline glaze; 7.3 x 14.2; 26.4 x 19.4; 27.0 x 21.4; 27.4 x 19.9; 26.3 x 20.5. Freer Gallery of Art, Smithsonian Institution, Washington, D.C., gift of Charles Lang Freer (F1904.150, F1902.7, F1902.192, F1903.190, F1903.191).

Parthian (ca. 160 B.C.E.–224 C.E.) periods in Mesopotamia, although earthenwares covered with monochrome glaze continued to be manufactured in the Sasanian (ca. 224–651) and early Islamic periods (ca. 650–900) in the same region. In 1900, however, knowledge of the regional styles, developmental sequence, and absolute dating of Near Eastern ceramics was still in a primitive stage, just beginning to emerge from organized excavations with new standards of accuracy in digging and recording. Investigations conducted under the auspices of museums and universities were chiefly in search of museum-quality sculptures and inscribed clay tablets. In any case, intact or well-preserved ceramic specimens were most frequently recovered from burials, which seldom furnished information on the sequence of ceramic development that

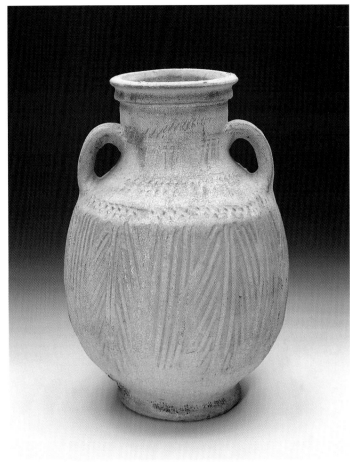

archaeologists would find by carefully digging the stratified remains of ancient settlements. Some experts, for example, interpreted the turquoise-glazed ceramics attributed to Raqqa as a survival of Parthian wares; indeed, a few types, such as two-handled amphora shapes bearing turquoise glaze, are common to both traditions (see fig. 2.6).

FIG. 2.7 Jar, Mesopotamia (modern Iraq), Parthian period (ca. 160 B.C.E.–224 C.E.). Earthenware with alkaline glaze; 27.3 x 19.4. Purchased from Kalebjian Frères, Paris. Freer Gallery of Art, Smithsonian Institution, Washington, D.C., gift of Charles Lang Freer (F1905.255).

Undoubtedly, the qualities Freer most admired in these vessels were their often subdued blue-green colors, their subtly textured surfaces, and the rich iridescent decay of the glaze. "Interesting. Note color of decoration," he later commented on a small bowl with faintly preserved blue-green rim glaze purchased in 1904 (see fig. 2.6).[6] His favorite vessels were often those whose glaze had almost entirely disappeared through chemical decomposition resulting from prolonged burial in the soil (fig. 2.7). Around the time Freer

purchased his first example of Raqqa ware, he became intrigued by the products of the Pewabic Pottery of Detroit. This fledgling workshop, established around 1900 by Horace James Caulkins (1850–1923) and Mary Chase Perry (1867–1961), later joined by her husband, William B. Stratton (1865–1938), benefited significantly from Freer's patronage and generous access to his large ceramic collections. He encouraged their experiments with iridescent glaze effects, which sought to imitate the effect wrought on Asian and Near Eastern ceramics by lengthy burial (fig. 2.8).[7] But Freer was also concerned with the geographical source of the Near Eastern wares, together with related questions of chronology and regional variations. A letter to Bing encapsulates the two aspects of Freer's interest in glazed wares—aesthetic and historical—that would soon spur a trip to Egypt. "The large green jar with golden brown iridescence has been received in good condition. I find the jar very beautiful and have decided to keep it," Freer wrote in February 1905 (fig. 2.9).

I am curious to know something about the origin of this jar. Can you give me any information concerning it? Your letter calls it Racca. Is it a piece from the tomb found at Racca? It differs so much from any other piece I have heretofore seen attributed to Racca. I am particularly anxious to learn all I can about it. Have you learned any fuller particulars about the discovery of Racca since the time you and I talked about it last? Any information you can give me on this subject of an authoritative character I shall be very glad indeed to have.[8]

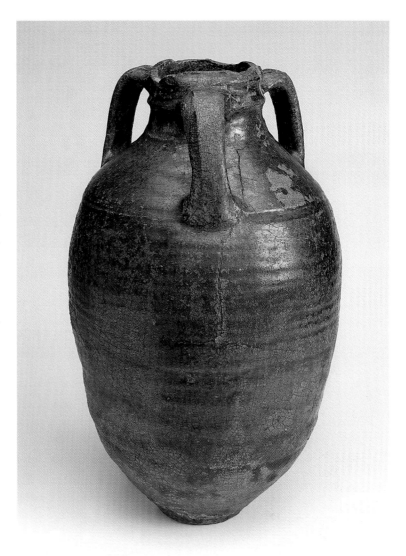

FIG. 2.9 Jar, Syria, 16th to 17th century. Earthenware with alkaline glaze; 49.2 x 30.1. Freer Gallery of Art, Smithsonian Institution, Washington, D.C., gift of Charles Lang Freer (F1905.61).

Freer was understandably puzzled, given the almost bewildering variety of wares that bore this label. And his observation was perceptive, for scholars would subsequently assign this specimen not to the Raqqa group, but to a later Syrian industry of the sixteenth or seventeenth century. For the next fifteen years, Freer would seek both to obtain beautiful examples of Syrian and Persian ceramics, and to understand their chronology and historical relationships. Indeed, this particular jar conjoins his aesthetic and historical interests, for it appears in a 1909 photograph of Freer together with Whistler's painting titled *Venus Rising from the Sea* (ca. 1869–70) (see fig. 2.11).

Bing died in September 1905, less than a year after this exchange with Freer. Earlier the same year, Freer had purchased several ceramic objects

labeled "Egyptian," "Babylonian," and "Racca" from the Paris shop of Kalebjian Frères (fig. 2.10; see fig. 2.7).[9] Over the next two years, he continued to obtain Raqqa and Babylonian ceramics from another leading Paris dealer who had sold the Detroit collector his first examples of these wares. Dikran Garabed Kelekian (1868–1951) was to play an important role in Freer's acquisitions of both Egyptian and Near Eastern art, as he did with many other American collectors and museum curators (fig. 2.12).[10] The son of an Armenian goldsmith, Kelekian formed a major collection of Near Eastern and Egyptian antiquities and Islamic art and became one of the most important dealers in these fields. He organized the Persian Pavilion at the World's Columbian Exposition in Chicago in 1893, selling ancient Near Eastern cylinder seals and Persian ceramics to prominent American collectors who included Henry Walters of Baltimore and Isabella Stewart Gardner of Boston.[11] Following his Chicago success, Kelekian opened shops in New York and Paris, gaining such important clients as Louisine and Henry O. Havemeyer, and Freer himself. At the Louisiana Purchase Exposition in St. Louis in 1904, Kelekian held the even more prominent position of commissioner general for Iran. A close friendship developed between the American painter Mary Cassatt (1844–1926) and

FIG. 2.10 Bowl purchased from Kalebjian Frères in 1905, Egypt, Roman Imperial period (ca. 100–200 C.E.). Faience (glazed composition); 7.2 x 28.2. Freer Gallery of Art, Smithsonian Institution, Washington, D.C., gift of Charles Lang Freer (F1905.252).

Louisine Waldron Elder, later Louisine Havemeyer, forming a circle that later embraced the Armenian dealer. Have-meyer's sugar fortune enabled the couple to lavish large sums in pursuit of a magnificent, wide-ranging art collection.[12] In 1901, Cassatt accompanied the couple on a trip to see Egyptian sculpture housed in the Turin Museum, and early in 1906, Louisine, Henry, and their daughter, Electra, trav-eled in Egypt together with

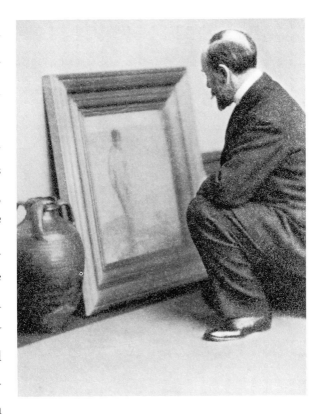

FIG. 2.11 Alvin Langdon Coburn (1882–1966), 1909, photograph of Charles Lang Freer comparing James McNeill Whistler's *Venus Rising from the Sea* (see FIG. 5.9) to a Syrian glazed jar (see FIG. 2.9). Charles Lang Freer Papers, Freer Gallery of Art Archives, Smithsonian Institution, Washington, D.C.

Dikran Kelekian.[13] The Havemeyers never added Egyptian art to their primary collecting interests, but they shared Freer's enthusiasm for Syrian and Persian glazed wares, for which Kelekian remained their principal supplier.[14]

In turning his attention to the various ancient and medieval glazed wares of Near Eastern origin, Freer joined a relatively new collecting trend inaugurated on the other side of the Atlantic. As the market in Japanese art began to decline, Bing and other dealers in Asian art began to explore the com-mercial prospects offered by the arts of the Islamic world, especially textiles and ceramics. From the 1890s on, unofficial excavations at several sites in Egypt and southwest Asia produced ceramics for an expanding circle of European and American collectors interested in moving into other areas of non-Western art. One of these sites was Rayy (then often called Rhages), in northern Iran, where digging operations led by dealers supplied ceramics to private collectors and museums.[15] Another was Raqqa in north central Syria,

FIG. 2.12 Dikran G. Kelekian (1868–1951). From a copy of *The Kelekian Collection of Persian and Analogous Potteries, 1884–1910* (Paris, 1910), presented to Charles Lang Freer by Kelekian. Library, Freer Gallery of Art, Smithsonian Institution, Washington, D.C.

located on the eastern bank of the Euphrates River northeast of Aleppo. Founded when the area came under Arab rule around 638, Raqqa and its environs were substantially expanded during the late eighth and ninth centuries, when the Abbasid caliphate ruled from Baghdad. Later, the city was revived under the Ayyubid dynasty in the twelfth and thirteenth centuries, when Salah al-Din (Saladin) conquered the Fatimid rulers of Egypt and established a united empire over Egypt and Syria.[16]

Fustat, the earliest Arab settlement near which the city of Cairo subsequently grew, was a third site whose remains were mined for ceramic treasures beginning in the late nineteenth century. During the Fatimid period (969–1171), Fustat had itself been a center for ceramic and glass production, and sherds of luster-painted vessels and other objects abounded in its ruins. Destroyed and abandoned in the late twelfth century, Fustat became a site for the rubbish dumps of Cairo, the new urban center that replaced it. These enormous mounds yielded samples of locally made wares from many periods, as well as export ceramics obtained from distant production centers such as China, which had reached many parts of the Islamic world and inspired local imitations.[17]

When Raqqa wares first appeared on the art market, they were dated variously between the late eighth and thirteenth centuries because the city's two most prominent eras occurred at the beginning and end of that span of time. With the benefit of subsequent excavations at Raqqa and other Syrian sites, scholars now date to this later era a group of decorated glazed ceramics known as Raqqa wares, although the location of their center (or centers) of production remains disputed. Raqqa wares share a body composed of quartz, clay, and sometimes also ground glass frit, and an alkaline glaze, either clear or colored turquoise with copper, which is typically thickly applied. Stylistically, they are linked both to ceramics produced in Fatimid Egypt and to the industry centered at Kashan in west central Iran (mid-twelfth to mid-thirteenth century).

The term embraces several subgroups, distinguished by color and style of decoration: white wares; wares with black decoration under a clear or turquoise glaze; luster wares; wares with polychrome decoration under a clear glaze; wares with polychrome decoration and carved or incised designs, known as *laqabi* wares; and luster wares with relief decoration.[18] Freer's collection of approximately one-hundred-fifty examples represents several different groups, but is dominated by three: those covered with a transparent turquoise glaze (the first Raqqa wares he purchased); those with turquoise glaze over black painted decoration; and the polychrome wares (see figs. 2.1 and 2.3–2.5).[19]

Around the time Freer turned his attention to Near Eastern ceramics, he also became acquainted with the ancient Egyptian glazed material generally known as faience (fig. 2.13). In 1902, he purchased his first example, along with several Babylonian pots, from Kelekian's New York shop.[20] The term "faience" derives from an erroneous identification with the white-bodied, tin-glazed earthenwares named for one of their production centers in Italy's Faenza. Freer usually referred to the Egyptian material as "glazed pottery," and it was also commonly labeled "porcelain," although ceramic specialists were already aware that it was composed mainly of silica with small amounts of lime and other elements.[21] In the context of ancient Egypt, faience designates a glazed ceramic material without clay; the body is composed primarily of crushed quartz or sand, then coated with a soda-lime-silica glaze to which artisans added a copper compound to achieve the favored turquoise color.

FIG. 2.13 "New Year's" flask, Egypt, Dynasty 26 (664–525 B.C.E.). Faience (glazed composition); 15.6 x 12.2 x 5.7. Freer Gallery of Art, Smithsonian Institution, Washington, D.C., gift of Charles Lang Freer (F1907.11).

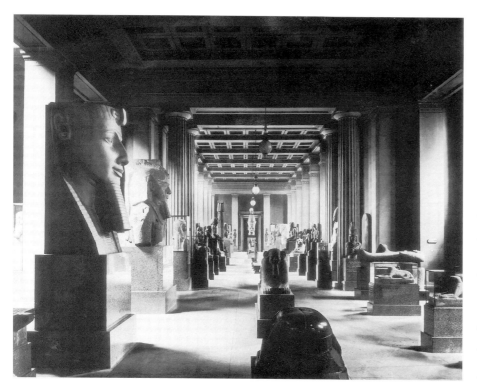

FIG. 2.14 Egyptian Sculpture Gallery, British Museum, London, ca. 1909. Photograph by Donald Macbeth. London, Courtesy of the Trustees of the British Museum, Central Archives.

Faience can be modeled by hand or pressed into a mold, and it was often used in ancient Egypt to form vessels, amulets, beads, scarabs, and other common artifacts. Before an object received its final firing, it was often painted in black, or incised and filled with glaze of a different color.[22]

Freer's growing interest in ancient and medieval glazed wares and their region of origin was freshly stimulated early in 1906, when the Smithsonian Regents' acceptance of his proposed gift set in motion plans for a new museum in Washington. A letter Freer wrote to Frank Hecker immediately after his first trip to Egypt deserves close attention, for here the collector succinctly outlined the evolution of his thinking over the course of that momentous year. When first introduced to "really fine" Egyptian art at the British Museum several years earlier, he wrote, he had "had to consider the chronology of things already possessed."

Formerly, and correctly, my question had been what were the aesthetic qualities of things already bought or under consideration for purchase, of course, always having in mind the very important consideration of harmony. Well, the thought so often given attention was should not articles of beauty and sympathy of earlier or earliest origin, especially in glazed stone or pottery, be, if possible, added to my collection. I concluded it was important that they should and continued my buying of every fine specimen of "Racca" or Babylonian glazed wares that proved obtainable.

Subsequently, Freer learned that excavations in Mesopotamia, Iran, and Egypt had introduced new evidence for the date and location of the earliest glazed ceramics. While the issue of chronological priority did not affect the appreciation of their beauty, Freer's letter continued, "it was important to know whether they had influenced the early Chinese wares or whether the Chinese wares had influenced those from Racca, Babylon and Sousa [Susa]." He pursued his study by poring over new publications and inspecting collections of ancient Greek, Assyrian, and Egyptian art at the Louvre and the British Museum (figs. 2.14 and 2.15).[23] Gradually, he wrote, "certain forms and colors of pottery and stone both glazed, and of early Egyptian make, seemed to me in certain suggestions, finer in spirit and older." At this point, he realized, he would have to intensify his study and reach his own conclusions.

FIG. 2.15 Fifth Egyptian Room, British Museum, London, ca. 1909. Photograph by Donald Macbeth. London, Courtesy of the Trustees of the British Museum, Central Archives.

It seemed to me that the question was too important to depend altogether upon the scanty ideas of others, for it was certain that a collection, such as mine would lose much of its interest to future scholars unless it was properly, and as accurately as possible, classified. I felt also the absolute necessity of having in my collection some specimens, at least, of the Egyptian wares, if after seeing the very best of them in their original home, they impressed me deeply in all points of beauty. These ideas I mentioned to no one, but then decided to go to Egypt with open mind and see for myself.[24]

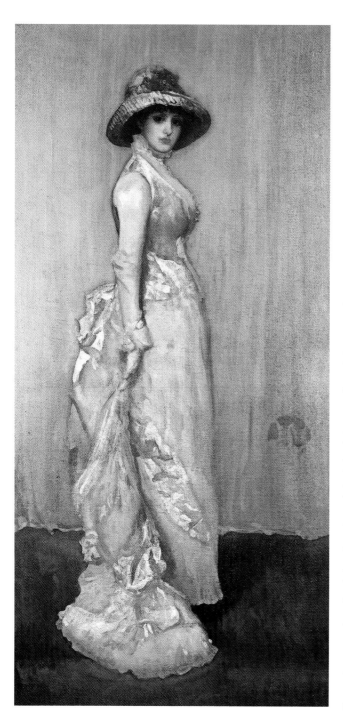

FIG. 2.16 James McNeill Whistler (1834–1903), *Harmony in Pink and Grey: Portrait of Lady Meux* (1882). Oil on canvas; 193.7 x 93.0. Copyright The Frick Collection, New York (18.1.132).

Freer's frequent and lengthy trips to London to meet with James McNeill Whistler and make new purchases might have provided opportunities to view private collections of Egyptian antiquities, in addition to the British Museum's extensive galleries. British interest in Egypt, which increased after Great Britain occupied the country in 1882, spawned a number of private collections and a brisk market, since many individuals who traveled or worked there sold some of their acquisitions when they returned home. Several key collections were represented at a major exhibition held in London at the Burlington Fine Arts Club in 1895 titled "The Art of Ancient Egypt." This ambitious undertaking drew from collections in museums in London, Liverpool, and Berlin, as well as from those in private hands. Among the London lenders were individuals whose collections were later judged among the finest: the Reverend William MacGregor, Captain W. J. Myers, F. G. Hilton Price, and Henry A. Wallis.[25] Freer purchased the exhibition's publication in August 1901, and his copy bears signs of careful examination. But no certain evidence suggests that he sought out any of the collectors.

Whistler did, however, form the unlikely link between Freer and one London collector of Egyptian antiquities. This was Valerie Susie Langdon Meux (ca. 1847–1910), wife of Sir Henry Bruce Meux (1858–1900), the heir to a brewery fortune. The artist had initially been commissioned to paint three portraits of Lady Meux, but in the end he completed only two, one of which now hangs in the Frick Collection in New York (fig. 2.16).[26] Lady Meux had acquired from

her husband's family a small collection of Egyptian antiquities, in which she took considerable interest. In 1893 she commissioned E. A. (Ernest Alfred) Wallis Budge (1857–1934), then acting keeper of Egyptian and Assyrian antiquities at the British Museum, to catalogue the collection. Two years later Budge purchased additional objects for her in Egypt, and a second edition of the catalogue appeared in 1896.[27] By then her collection consisted of some eighteen hundred objects, including many tiny items—about eight hundred scarabs and amulets, for example—but also sculptures, canopic jars, ushabti figures made of bronze, faience, and wood, and painted wooden coffins.[28] A few, such as the three painted coffins, were large-scale works. On 31 May 1902, Freer visited Theobald's Park, in Waltham Cross, Hertfordshire, one of Sir Henry's grand residences, to see Whistler's portrait of Lady Meux. But if Freer also noticed the Egyptian antiquities housed there, he failed to mention them in his diary. "Saw her portrait &c. &c.," he wrote. "Fine park."[29]

In fact, the large group of enthusiasts for Egyptian antiquities did not typically overlap with those who treasured Japanese or Chinese art or the arts of the Islamic world. Most collectors of Egyptian antiquities, American and British alike, were captivated by the Egypt of the pharaohs and the Bible: an Egyptian past that was understood and appreciated as part of the Western tradition. The British presence in Egypt encouraged many foreigners to travel there on a regular basis. In Egypt's large cities and at tourist sites, they could purchase antiquities from merchants' amply stocked shops. This popular appreciation for, and direct access to, the monuments of pharaonic Egypt enabled a group of authors, artists, and scholars that shared a passion for Egyptology to establish an organization devoted to investigating and preserving ancient sites and artifacts, and to furthering the study of language, history, and culture. The Egypt Exploration Fund (later Society) was founded in London in 1882, with the aim of conducting surveys and excavations in Egypt and publishing the results. The fund was the inspiration of Amelia A. B.

Edwards, a novelist and journalist who took up Egyptology and traveled to Egypt in 1873 to 1874. *A Thousand Miles Up the Nile*, the account of her journey first published in 1877, became a bestseller both in Great Britain and the United States. Convinced that an organized, ongoing effort was needed to protect archaeological monuments from widespread looting and destruction and to support scientific excavation and recording, Edwards set out to establish the fund. Later, she endowed a chair in Egyptology at University College London.

Initially, the fund sought to appeal to a broad constituency by concentrating on archaeological sites in the Nile Delta that were linked to the Hebrew Bible, but subsequently it expanded its mission to include all areas of Egypt and all periods of ancient Egyptian history. Its projects and publications were financed through subscriptions by individuals, libraries, museums, church groups, and other institutions, who received in exchange selected artifacts for building collections. In 1883 the fund hired as a field archaeologist William Matthew Flinders Petrie (1853–1942), one of the most influential figures in the history of Egyptian archaeology. Although lacking formal training in Egyptology, Petrie introduced to the fledgling discipline of archaeology more rigorous methods of survey and excavation together with a systematic approach to recording and classifying artifacts and their contexts.[30] The fund also found fertile ground for recruiting supporters in the United States, where a branch was set up, which in two years boasted 171 subscribers. The Egypt Exploration Fund, which still flourishes today as the Egypt Exploration Society, conducted systematic survey and excavation work at a score of sites beginning in the late nineteenth and early twentieth centuries, including Abydos, Amarna, Thebes, and the regions of the Delta and Nubia. The organization published an annual report as well as detailed volumes describing and illustrating its activities at particular sites.[31] Soon after his first trip to Egypt, Freer began to acquire the fund's publications, and he also received its annual report beginning in 1904.

FIG. 2.17 Tile depicting captive Libyan chief. Egypt, Tell al-Yahudiya, New Kingdom, Dynasty 20, reign of Ramesses III (ca. 1187–1156 B.C.E.). Polychrome faience (glazed composition); 31 x 9. Copyright The British Museum, Department of Ancient Egypt and Sudan (12337).

One of the few with close ties both to ancient Egyptian art and the arts of the Islamic world was Henry A. Wallis (1830–1916), a painter and author born in London, who belonged to the circle of British collectors, artists, and scholars active in Egypt at the end of the nineteenth and beginning of the twentieth centuries. Wallis was a founding member· of the Committee (later Society) for the Preservation of the Monuments of Ancient Egypt and, together with the painter Sir Edward John Poynter (1836–1919), served as its joint secretary.[32] He was among the lenders to the 1895 Burlington Fine Arts Club exhibition and had also lent objects to a landmark exhibition of Arab and Persian art held ten years earlier at the same location, establishing him among the pioneer enthusiasts for the arts of the Islamic world. An authority on Mediterranean and Near Eastern ceramics who both wrote and illustrated his numerous publications, Wallis was "the doyen of us all in this field," as Kelekian described him in 1910.[33] When Freer turned his attention to Egypt, Wallis had recently published two important contributions on the subject: *Egyptian Ceramic Art: The MacGregor Collection* (1898) and *Egyptian Ceramic Art: Typical Examples of the Art of the Egyptian Potter* (1900).[34] Freer owned both books, along with nearly every one of Wallis's numerous publications, including *Persian Lustre Vases* (1899) and *Byzantine Ceramic Art* (1907).[35]

Wallis's approach and selections for illustration perceptibly shaped Freer's understanding and appreciation of Egyptian glazed wares. The British author gave enthusiastic coverage to the polychrome glazed tiles recovered from the palace of Ramesses III (ca. 1187–1156 B.C.E.) at Tell al-Yahudiya in the

Nile Delta, a magnificent collection of which was housed in the British Museum. These artifacts illustrate a high point in the architectural use of faience reached by artisans of Dynasty 20, particularly in the rich range of colors effectively employed to capture details of the figures depicted (fig. 2.17, for one example). "All the resources of the art were employed on these splendid plaques," wrote Wallis. He remarked that the plaques employed both inlay and relief, and "a palette of the widest range: nothing can be imagined in ceramic art more masterly than the modelling of the human figures and animal forms; the lions especially are of sculpturesque dignity." Many tiles depict the conquered peoples of Ramesses's empire, whose exotic appearance was exuberantly captured—"seized with an accuracy which may be termed scientific; their costumes display a wealth of imaginative details worked out in schemes of colour so resplendent and harmonious as to be the delight of all artists."[36] Freer is likely to have seen the Tell al-Yahudiya tiles displayed in the British Museum, and he certainly saw examples in Cairo. On his first visit to the Egyptian Museum in Cairo, Freer noted them briefly in the back of his diary: "fragments of a negro prisoner having black face and white cap—14" high," he wrote. "Principal colors in these patterns are white, black, gray, purple, red, rose & yellow."[37] So keen was his interest that he even visited the site of Tell al-Yahudiya itself, a day's excursion from Cairo and a destination ordinarily of interest only to specialists.

Wallis brought into new prominence the great antiquity and high quality, both technical and aesthetic, of Egyptian ceramics, and attempted to establish a chronological classification. He also advocated the importance of fragments in the study of ceramic history, emphasizing technical features that helped to define particular ceramic groups and wares. Freer later wrote to Hecker that he "must, when possible, secure specimens if only of the smallest fragments" of Egyptian pottery "of early glazed kind."[38] Freer purchased several examples of the turquoise faience bowls of New Kingdom date decorated

FIG. 2.18 Bowls, Egypt, New Kingdom (ca. 1539–1075 B.C.E.). Faience (glazed composition) with paint; 7.7 x 20.9 x 20.9; 4.5 x 15.0 x 15.0; 4.6 x 15.7 x 15.7. Freer Gallery of Art, Smithsonian Institution, Washington, D.C., gift of Charles Lang Freer (F1909.71, F1909.145, F1909.144).

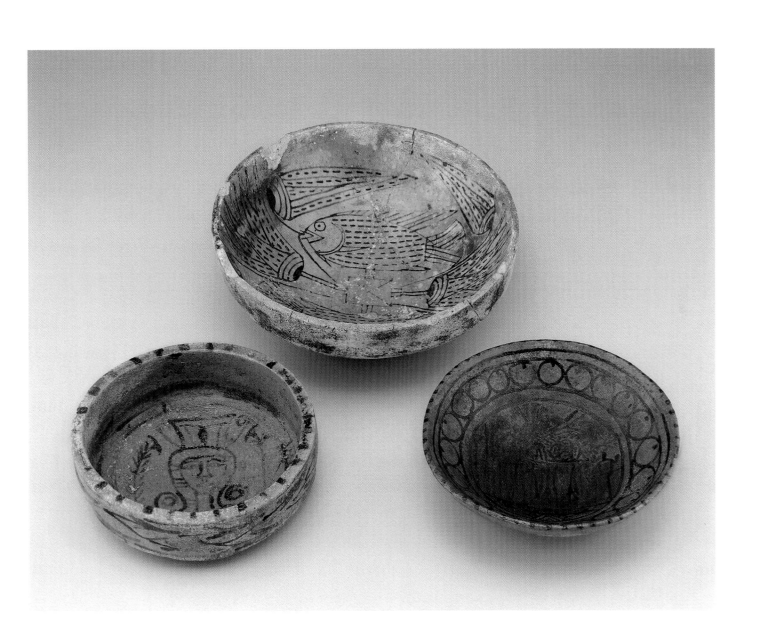

with motifs of the goddess Hathor, which were depicted in Wallis's publications and commonly acquired by other collectors of the time (fig. 2.18). Several other faience artifacts acquired by Freer also closely resemble works illustrated in Wallis's books.[39]

Freer's correspondence and book purchases reflect his growing interest in Egypt and the Near East and above all in their ancient civilizations. In the fall of 1906, he wrote to Charles J. Morse, a friend and fellow collector in Evanston, Illinois, that he wished to visit the museums "at Constantinople and Cairo, both of which are very rich in the Arts of Egypt and that part of Asia from which Syrian, Persian, Arabian, Assyrian and Babylonian Arts came."[40] Freer's library also documents this new direction, as he began around 1904 to order copies of the latest publications devoted to ancient Egypt and the Near East: H. V. Hilprecht's *Explorations in Bible Lands during the 19th Century* (1903), which included chapters on Egypt, Assyria, and Babylonia; R. F. Harper's edition and translation of the code of Hammurabi (1904); a translation of the ancient Mesopotamian epic titled *The Descent of Ishtar* (1904); and Jean Capart's *Primitive Art in Egypt* (1905). He also purchased Clarence S. Fischer's *Excavations at Nippur* (1905), a report on the field campaigns at this key site in southern Mesopotamia conducted by the Babylonian Expedition of the University of Pennsylvania. Nippur was investigated primarily for its remains and cuneiform tablets dating from the third millennium B.C.E., when it flourished as one of the important cities of ancient Sumer, but it had also yielded finds of the Parthian period.

When Freer made firm plans to set out for Egypt at the end of 1906, he met or corresponded with several colleagues and dealers familiar with the country, who offered advice on travel and accommodations, sightseeing, and where to shop for antiquities. One certain source of information was Dikran Kelekian, who by this time owned a shop in Cairo; he met up with Freer in Luxor and introduced him to dealers and private collectors. Freer visited the

dealer in New York on 3 October 1906, a few weeks before his departure. Another source was Gaston Migeon (1861–1930), whom Freer had met through Siegfried Bing. A pioneer collector and connoisseur of Islamic art, Migeon was appointed to the department of medieval art at the Louvre in 1893 and given the title of curator in 1902. In part as a result of his friendship with the Orientalist painter E. Dinet, Migeon became deeply attracted to the arts of China, Japan, and the Islamic world, and introduced them to the French national collections. In 1903, together with the collector and critic Raymond Koechlin (1860–1931), Migeon organized in Paris a large, wide-ranging exhibition devoted to the arts of the Islamic world. It was on the occasion of this landmark show that Migeon and Freer first became acquainted. Among other mutual interests, the two shared a passion for Raqqa ceramics.[41] Migeon was also familiar with Egypt, and in 1906 published a guidebook to Cairo and environs, which Freer would use during his travels later that same year.[42]

Just over two months before Freer departed for Egypt, he and Migeon met in New York, and, after a short trip to Boston, returned to Detroit and spent the next five days examining Freer's collection. During this visit, they made plans to meet in Cairo early in 1907.[43] Freer also hosted Louisine and Henry O. Havemeyer in Detroit on 25 and 26 September, less than a year after the Havemeyers' own trip to Egypt with Dikran Kelekian.[44] They, too, may have offered suggestions to Freer.

In October 1906, Freer ordered from Brentano's bookstore in New York a copy of Amédée Baillot de Guerville's *New Egypt* (1906), an entertaining account of the French author's impressions of Egypt during his travels the previous year. Freer also purchased *A History of Egypt*, written by the American Egyptologist James Henry Breasted, first published in 1905. Freer took the books with him when he sailed from New York on 15 November on the SS *Hamburg*, the voyage that began his Egyptian journey.

Travels in Egypt, 1906–1907

In the fall of 1906, Freer announced to several colleagues and friends his intention to visit Egypt and Asia later the same year. "I am now planning to leave Detroit about the middle of November and go via Naples direct to Cairo, spend a few weeks in Egypt, then go to Ceylon for a short stay, thence to Java, returning to America either next Spring or Summer," he wrote to Rosalind Birnie Philip, Whistler's sister-in-law, "my aim being to get to Egypt a little ahead of the season so as to avoid the crowd."[1]

Freer was accompanied by Dr. Frederick Wharton Mann (died 6 October 1926), a longtime Detroit friend who was also his personal physician (fig. 3.1). Mann lived at 69 Cass Avenue, only a few blocks from Freer's house at 33 Ferry Avenue, and was a member of several social clubs to which Freer and Hecker also belonged: the Detroit Club, the Lake St. Clair Fishing and Shooting Club, and the Yondotega Club.[2] Unlike Freer and Hecker, however, and several area physicians, Mann was not mentioned in *The Book of Detroiters*, a volume of biographical sketches published in 1908 that aimed to include "all those living men whose worth and work count for most in Detroit today."[3] Nonetheless, he appears to have enjoyed a highly successful practice. In 1900, he bought the house next to Freer's Villa Castello on the island of

FIG. 3.1 Freer and Mann in Cairo, January 1907. From left to right: Dr. Frederick W. Mann, Freer, Ibrahim Ali, and Ali Arabi. Photograph by P. Dittrich. Charles Lang Freer Papers, Freer Gallery of Art Archives, Smithsonian Institution, Washington, D.C.

Capri. Freer had purchased the villa in the same year with another old Detroit friend, attorney Thomas Spencer Jerome.[4] Not long before the two began their travels in Egypt, Mann had purchased "a very comfortable villa" at Alassio between Genoa and Nice. As Freer explained to Hecker, "when it is furnished he intends to receive, occasionally, selected patients of his who may want a place of rest and change of climates, or take such patients with him there personally."[5] Freer's letters to Hecker establish that the journey to Egypt was conceived as a rest and change of scenery for Mann as well as an opportunity for Freer to pursue new collecting interests. "As for our visit together, it has been perfect, he needs to rest and the climates and sights have pleased us both," Freer summed up shortly after their arrival in Cairo.[6] Freer apparently had no definite itinerary in mind before he left for Egypt and only gradually developed one after he arrived there. "I have no fixed plans but will likely spend the time up to Jan'y 20th in this attractive country," he wrote to Hecker a week after he and Mann reached Cairo. "We are thinking of going up as far as the 2nd Cataract; when and how we do this is as yet unsettled."[7]

Like Freer and Mann, most tourists from Europe and the United States sailed from France or Italy on a British P & O (Peninsular and Oriental Steam Navigation Company) liner or a North German Lloyd liner, arriving on Egypt's Mediterranean coast at Alexandria, in the western Nile Delta, or at Port Said, the Mediterranean terminus of the Suez Canal.[8] Many traveled with package tours such as those offered by Thomas Cook & Son, which propelled large groups along the Nile at a rapid clip. By contrast, Freer's sojourn was unhurried, although not precisely a holiday; in Cairo and elsewhere, his days were filled with visits to sites, museums, and the shops of antiquities merchants.

Around 1900, Cairo's population, spread out over about a dozen miles, numbered close to half a million people, of whom roughly twenty-five thousand were Europeans.[9] Americans comprised only a handful, as we learn from the diary of Thomas Skelton Harrison, agent and consul general of the

United States in Egypt from late autumn 1897 to spring 1899. He estimated that in 1899 there were roughly one hundred permanent American residents, "for the most part, missionaries and professional men." The tourist season, however, brought untold scores of others, whose presence was regularly made known to the resident consul general's attention through a variety of circumstances, including "Americans who are taken halfway up the Pyramids and deserted there, Americans whose landladies cannot get rid of them, Americans who want to be presented to the Khedive, Americans who speak only the English language, Americans whose trunks have disappeared, Americans who have disappeared themselves, and Americans who are collecting postage stamps."[10] Egypt was a surprisingly popular destination for Detroit's well-educated and well-heeled citizens. Coincidentally, several individuals Freer knew from Detroit were traveling in Egypt at the same time, and in Cairo at least two of them were simultaneously lodged in the same hotel.[11] Mr. and Mrs. Charles M. Swift, who hosted Freer and Mann on their first night in Cairo, were also friends from Detroit. A Judge Brown and his wife, evidently acquaintances from Detroit, were also in Egypt, but Freer and Mann missed seeing them in Aswan. Traveling from Aswan to Wadi Halfa on the SS *Nubia*, Freer and Mann met a lawyer from Detroit named George Moore.[12]

On Wednesday, 5 December, Freer and Mann sailed from Naples on the SS *Oceana*, in "perfect weather." They arrived in Alexandria early on Saturday, 8 December, and spent the day visiting major sights. Named for its founder, Alexander the Great (died 323 B.C.E.), Alexandria was the largest city in Egypt at the time of the Arab conquest in 641. Throughout Ptolemaic and early Roman Imperial rule, it flourished as the cultural and intellectual heart of the Greco-Roman world and, following the emperor Constantine's conversion to Christianity, its foremost theological center. With the beginning of Arab rule in the mid-seventh century, Cairo took the political and cultural

lead. During the nineteenth century, however, Alexandria once again developed into a small, thriving harbor city. The climate of this region of the Delta, less oppressive in summer than that of Cairo, encouraged settlement by British residents, and toward the end of the century attractive suburbs with amenities such as sporting clubs were built to house and entertain them. The major tourist attractions were the stone column still known today as Pompey's Pillar—actually a monument erected in the year 300 in honor of the Roman emperor Diocletian—and the "catacombs," underground burial chambers dating to the Roman Imperial period (100–200 C.E.). Freer and Mann also visited the Graeco-Roman Museum, built in 1895 to house artifacts primarily of Ptolemaic and Roman date that had been recovered during digging for modern building foundations and for a local railway. They stayed overnight at the Hotel Beau Rivage in Ramla, a fashionable suburb built around 1875, located several miles east of the main square in Alexandria.

At nine o'clock the next morning they departed for Cairo by train and reached the city at noon, where they were to lodge at Shepheard's Hotel. Although Cairo boasted several large hotels that catered to foreign tourists, Shepheard's was one of the truly grand establishments of the Victorian period, where guests could enjoy the spectacle of other guests, often celebrities, royalty, and the very wealthy. "At Shepheard's people put aside their guide-books for a while," observed Charles Dana Gibson, the American illustrator, who spent the winter of 1897 to 1898 in Egypt; "It is a play that requires no libretto."[13] First built by the Englishman Samuel Shepheard in the 1840s, the hotel had undergone several major changes in construction and plan, and in 1891 was completely rebuilt. In 1898 its great central courtyard became the Moorish Hall, furnished with a glass dome and decorated with mosaics and wrought chandeliers. Next door to Shepheard's was the Cairo office of Thomas Cook & Son, where Giovanni Dattari, who sold Freer his collection of ancient glass two years later, was then employed.

Freer's primary guidebook to the sights of Cairo and environs was *Le Caire, le Nil et Memphis,* published earlier the same year.[14] His copy was a gift from the author, Gaston Migeon, who has already been introduced as a prominent member of the Parisian circle of collectors and dealers that included Siegfried Bing, Dikran Kelekian, and Raymond Koechlin. Freer's annotated copies of Migeon's guide and of Breasted's *History of Egypt* note the dates he visited particular sites and often record his impressions and observations. These penciled comments help to document his itinerary and reveal the major sources for his understanding of ancient and medieval Egyptian history and art. Freer had a copy of Karl Baedeker's Egypt guide, which, judging by published accounts, was ubiquitous, and the entertaining *New Egypt* by the Frenchman Amédée Baillot de Guerville. In Cairo he purchased a copy of Flinders Petrie's *Ten Years Digging in Egypt: 1881–1891,* in its third edition published in 1900. Freer also studied Petrie's *Egyptian Decorative Art* (1895), which he received as a Christmas gift in 1906 from Thomas Spencer Jerome. Like many foreigners, Freer hired a dragoman, literally "translator," who made practical arrangements for visits to sites and functioned as interpreter and guide. The services of these individuals could be reserved in advance, but often tourists simply inquired at Cook's or in their hotels when they arrived at Port Said, Alexandria, or Cairo. Freer had high praise for his guide, Ibrahim Ali, who was headquartered at Shepheard's Hotel in Cairo; Freer hired him again on subsequent trips to Egypt and recommended him to others (see fig. 3.1).

With its breathtaking vistas and its brilliant expression of pharaonic, Christian, and Islamic traditions, Cairo was every tourist's destination. The modern city of Cairo embraces the capitals of several dynasties that ruled Egypt beginning in the mid-seventh century. Cairo itself was founded as the capital of the Fatimids, who invaded Egypt in 967. The site they chose was just north of several earlier capitals built by the Islamic dynasties that ruled Egypt successively beginning in the mid-seventh century. The Fatimids established a

famous university, al-Azhar, and built a large city with monumental gates whose walls enclosed mosques, palaces, markets, and parks. The Ayyubid dynasty, which conquered the Fatimids in 1169, ruled Egypt for only eighty years, but in that time exercised a profound influence on Cairo and its architecture. Salah al-Din (Saladin) extended the city's walls southward to enclose several earlier Islamic cities, including al-Fustat, built by the Arab conquerors of Egypt beginning around 641; al-Askar, founded by the Abbasids in 750; and al-Qatai, founded by Ahmed ibn Tulun in 870. The Mamluk rulers of Egypt contributed to Cairo a distinctive architectural complex typically consisting of a mosque, a madrasa (religious school), and a mausoleum. The mosque of Sultan Hasan, built in front of the Citadel, is one of the most spectacular complexes of this type.[15]

For two weeks at the beginning of his journey and four days at the end, Freer's time in Cairo was filled with visits to sites, museums, antiquarians, and private collectors.[16] The first three days in Cairo were devoted chiefly to Coptic, Fatimid, Ayyubid, and Mamluk monuments, and included many well-known tourist destinations. Like most of his contemporaries, Freer visited the Citadel, the vast enclosure east of the Nile that was largely the work of the sultan Salah al-Din (Saladin), founder of the Ayyubid dynasty, in the twelfth century (fig. 3.2). Virtually every itinerary included this large enclosure, together with visits to the mosques of Sultan Hasan ("superb doorway," commented Freer) and Muhammad Ali, the latter built in the mid-nineteenth century. Another standard stop was the Southern Cemetery (or Great Cemetery), which Freer and other Western visitors called "the tombs of the Mamlukes and Khalifs." Tourists customarily also took in the bazaars, the ninth-century mosque of Ibn Tulun (then often known as the Great Mosque), and several Mamluk complexes: the mosque and khanqah (Sufi mystic lodge, or hospice) of Sultan Farag and tomb of Sultan Barquq; and the madrasa and mausoleum of Sultan Qayt Bay. The Aqsunqur or Ibrahim Agha mosque, which Europeans referred

FIG. 3.2 Egypt, Cairo, Citadel. Photograph by Photoglob, Zurich, ca. 1900. Courtesy of the Middle East Department of the University of Chicago Library.

to as the Blue Mosque, was a Mamluk construction of the mid-fourteenth century. It received its wall of blue tiles when it was rebuilt in 1652 by Ibrahim Agha Mustahfizan, who constructed his mausoleum next to it.[17] Freer also visited sites found on few tourist itineraries. Twice in one week, and again during his brief stay in 1909, he saw the al-Burdayni mosque, a Mamluk-style structure built in 1694, located near the Museum of Arab Art and Khedival Library. The building's well-preserved interior decoration of multicolored marbles arranged in elaborate geometric panels particularly appealed to Freer, who noted its "very fine mosaics" in his copy of Migeon's guide (fig. 3.3).

"Old Cairo" designated Fustat, the settlement founded by Egypt's Arab conqueror, Amr ibn al-'As, from which he successfully besieged the Byzantine fortress opposite the Nile island of Rhoda. Separated from modern Cairo by deteriorating streets and enormous mounds formed by the rubbish of

generations of the city's inhabitants, Fustat was home to Greek and Coptic churches clustering around the site of the Byzantine settlement and the mosque of Amr ("Amrou," in the accounts of the time). Freer visited the mosque of Amr, built in the time of the Arab conqueror and Egypt's oldest, although in its present state dating mainly from the fourteenth century. Freer's tour of Old Cairo also took in Abu Sergah, the thirteenth-century Church of St. Sergius (often called St. Mary's Church), built on one of the sites traditionally associated with the Holy Family's flight into Egypt. The island of Rhoda usually merited a brief visit to walk in the old gardens and inspect the Nilometer, a device to measure the river's ebb and flow, which had been set up in the ninth century. An excursion to Old Cairo customarily extended to the site of ancient Heliopolis, with its pink granite obelisk, some twenty-two meters high, built during the reign of the Middle Kingdom pharaoh Sesostris I (ca. 1919–1875 B.C.E.). Originally one of a pair that stood in front of the temple of Re Horakhty, built by the pharaoh's father, Amenemhet I (ca. 1938–1909 B.C.E.), the obelisk is the only one remaining in Cairo. In the nearby village of Matariah, tourists were invariably taken to the Virgin's Well and the Virgin's Tree, a sycamore fig long associated with Mary, Jesus' mother, according to a Coptic tradition that she and her infant remained hidden here for a month after fleeing from Herod's soldiers. (The original tree

had died in 1672; its replacement apparently collapsed in 1906, but Freer expressed no disappointment with his visit.)

Cairo had recently acquired two major buildings to house its vast treasures of ancient (pharaonic) and Islamic art. The collection of antiquities had moved from Giza Palace, opposite Rhoda, to its present location at Qasr al-Nil, where the Egyptian Museum officially opened on 15 November 1902 (fig. 3.4). Reviews of the new edifice were mixed. The irascible Flinders Petrie found nothing to praise: "the worst building I ever saw made for such a purpose," he wrote in his journal. "Half of it is too dark to be used at all, and much of it is scorched with sun through enormous skylights. The scale of it is far too large, and dwarfs the largest statues, making them look like dolls."[18] At the end of 1907, Frederick N. Finney, an engineer from Milwaukee, Wisconsin, judged it a "huge affair . . . quite new, fire proof, and well designed and already

FIG. 3.4 Egypt, Cairo, Egyptian Museum. Photograph by P. Dittrich, ca. 1903. Courtesy of the Middle East Department of the University of Chicago Library.

582. Musée des Antiquités P. Dittrich

nearly full."[19] A detailed guide to the collections written by Gaston Maspero, the French director of the Egyptian Antiquities Service, appeared almost immediately, and nearly as quickly was translated into several languages. Those who know the museum as it looks today may find it difficult to imagine the staggering displays without the treasures from the tomb of Tutankhamun, which now occupy most of the north and east corridors of the second floor. But the famous discovery of the tomb by Howard Carter and Lord Carnarvon did not take place until November 1922. In the 1907 edition of his guide to Egypt, Budge of the British Museum provided a list of twenty-three objects and displays that visitors were not to miss. The list began with the painted tomb doors and statues of Dynasties 4 to 6 and ended with the most recent addition, the Cow of Hathor, discovered by Édouard Naville at Deir al-Bahri in 1906. It included both individual monuments (statues of the Dynasty 4 pharaohs Khafre and Menkaure, the "green slate object of Narmer," and the Fayum Papyrus) as well as entire tomb assemblages and "typical examples of all the painted coffins."[20] In December 1906, another recently installed display consisted of the splendid finds recovered in 1905 from the Theban tomb of Yuya and Tuya, the parents of Queen Tiy, favorite wife of the pharaoh Amenhotep III (ca. 1390–1353 B.C.E.); this was another entry on Budge's "must see" list. Freer's diary mentions the contents of only one particular case, as already described: polychrome faience plaques from the palace of Ramesses III at Tell al-Yahudiya (see fig. 2.17). But he was overwhelmed by the monumental statuary in wood and stone, as he later described to Frank Hecker: "I now feel that these things are the greatest art in the world, greater than Greek, Chinese or Japanese."[21] Freer's heavily annotated copy of Breasted's *History of Egypt* leaves little doubt that he was especially drawn to the wood, stone, and metal statuary of the Old Kingdom, originally fashioned to inhabit the tombs of royalty and nobles. Freer noted with particular enthusiasm the life-size metal statue of Meryre Pepy I (ca. 2338–2298 B.C.E.), a pharaoh of Dynasty 6, and

the wooden statue commonly known, then and now, as the "Sheik el-Beled." This nearly life-size statue of a lector-priest, actually named Ka-aper, is dated to the beginning of Dynasty 5 (ca. 2500–2350 B.C.E.).[22] Freer also admired the Old Kingdom tomb paintings displayed in the museum, including those from the tombs at Maidum south of Giza.

The museum that Freer called the Arab Museum and Library was another new building, erected in 1903 to house the collection of Islamic art formed around 1880, and the Khedival Library (now the Dar al-Kutub in Bulaq). Known today as the Museum of Islamic Art, its official name in 1906 was the Museum of Arab Art and Khedival Library. The collections had been organized under the auspices of the Commission for the Preservation of Arab Art, headed by an architect of Austro-Hungarian origin named Max Herz. Herz Bey, as he was known, wrote catalogues of the collection and oversaw its transfer to the new location near the mosque of al-Hakim at Bab al-Khalq.[23] Few foreign tourists stopped to see this museum; Wallis Budge reported in 1907 that annual attendance numbered about two thousand. Those who did manage a stop were usually impressed by the displays of wood, metalwork, textiles, and above all the splendid glass lamps, arranged by medium in sixteen galleries. Freer acquired two of Herz's guides to the collections, which he visited several times during his stay in the city. He also admired the library, housed in the lower portion of the building, which consisted of over fifty thousand manuscripts and a unique collection of Korans.[24]

Before leaving Cairo, Freer and Mann posed with Ibrahim Ali and the Giza antiquities dealer Ali Arabi for a photograph at P. Dittrich's studio (see fig. 3.1). One of a number of established studios in Cairo, Dittrich's was photographer to the Egyptian khedive and recognized both for its portraits and its scenes of Cairo and her monuments. In his book *New Egypt*, A. B. de Guerville enthusiastically recommended Dittrich's studio. By this time, nearly every American tourist brought along a Kodak "Brownie" camera, which George

Eastman had introduced in 1900 at the price of one dollar; it soon became a standard piece of tourist equipment. Freer made no mention of this recent invention, however, and it seems that he never adopted the habit of taking a camera with him on his overseas travels.

Freer and Mann also made several day trips to sites outside Cairo. Friday, 14 December, was devoted "to the Pyramids and surroundings" at Giza, followed by visits to dealers' shops ("antiquarians") and lunch at the Mena House Hotel. An outing to the Pyramids, followed by lunch at Mena House, was a favorite pastime of foreign tourists as well as seasonal residents. On 21 December, they visited the southern Delta site of Tell al-Yahudiya, "Mound of the Jews"; they may have journeyed by rail, as Freer also mentioned the place name Shibin al-Qanatir and identified it as the rail station closest to the site. His diary noted further that the Egyptologists Édouard Naville and F. Llewellyn Griffith explored the site "during the season of 1886–87" and that "the mound of Tell el-Yahudiya is probably the site on which was once built— the city allowed the Jews by Ptolemy Philadelphus." Naville and Griffith found little at the site and soon moved on to the more rewarding Tukh al-Qaramus. But Freer had two reasons for his particular interest in the site. First, he was attracted by the polychrome faience architectural tiles recovered from a palace of Ramesses III at Tell al-Yahudiya, examples of which had caught Freer's attention in the Egyptian Museum. Undoubtedly he wished to explore the site in the hopes of finding fragments to purchase. Second, shortly after his arrival in Cairo, Freer had purchased the Greek manuscripts later known as the Washington Manuscripts. These included early manuscripts of the Greek Bible, or Septuagint, the earliest and most influential Greek translation of the Hebrew scriptures created in the third century B.C.E. for the widely dispersed Jewish communities, whose common language was Greek. The Septuagint was commissioned by Ptolemy II Philadelphos (285–246 B.C.E.) for the Jewish population of Alexandria. It was a later ruler, Ptolemy VI Philometor

(180–164 B.C.E., 163–145 B.C.E.), who allowed a number of Jewish emigrants to enter Egypt from Palestine and permitted the building of a Yahweh temple at Tell al-Yahudiya (then known by its Greek name, Leontopolis). Freer greatly enjoyed the excursion to Tell al-Yahudiya, writing to Hecker that he "was up at six o'clock yesterday morning and accompanied by Dr. Mann and our extraordinarily competent dragoman was off for a twenty mile trip to an old temple site in the country. And so our days go, each one different and if possible finer than its predecessor."[25]

On Sunday, 23 December, their last full day in Cairo, Freer and Mann set out for sites just south of the city, stopping at Helwan en route to Memphis and Saqqara. Capital of Egypt during the Old Kingdom and during at least part of the Middle and New Kingdoms, Memphis was one of the country's greatest cities throughout the pharaonic era. It also maintained a certain importance in Ptolemaic times, when Alexander established Alexandria as the chief urban center. Memphis was the center for the worship of Ptah, patron deity of craftsmen; his temple was rebuilt and embellished by numerous pharaohs, although little now remains of the once vast complex. Here Freer and Mann observed the colossal statues of Ramesses II (ca. 1279–1213 B.C.E.), originally over twelve meters in height, which had been repositioned at the site by British engineers in 1888.

Saqqara is the vast cemetery complex west of Memphis, extending to the edge of the Western Desert. It was home to royal burials, including some of the earliest pyramid-style structures, and hundreds of tombs of the type known as mastaba, "bench," from their resemblance to these modern forms. Mastaba tombs consist of subterranean structures that include a central burial chamber and surrounding storerooms for food and other provisions; above the timber roofs are above-ground chambers, typically made of stone, used for offerings to the deceased. Today, Saqqara's most dramatic highlight is the Step Pyramid complex of King Djoser, built in the early part of Dynasty 3 (ca. 2675–2625 B.C.E.). In Freer's day, however, the complex had not been fully

FIG. 3.5 Henry Bacon (1839–1912), *The Step Pyramid at Sakkarah at Noon*, ca. 1903. Watercolor over graphite on cream wove paper mounted on board; 35.5 x 53.4. Worcester Art Museum, Worcester, Massachusetts, Gift of Mrs. Frederick L. Eldridge in memory of Henry Bacon (1943.29).

excavated; visitors saw the tomb monument itself in isolation, and it was not always billed as Saqqara's chief attraction (fig. 3.5). Freer's diary does not mention it. The brilliant, blue-green faience tiles that lined the underground passage of one of the tomb chambers were apparently discovered during subsequent excavations.[26] The rich color and great antiquity of the tiles would surely have appealed to Freer.

Many tourists began their tours of Saqqara with a visit to the Serapeum, the famous burial place of the Apis bulls, which Freer called the tomb of Osiris. From early times in Egypt, Apis bulls were held as sacred, representations of the soul of the god Ptah and connected with the god Osiris as deliverers of oracles. One of the chief deities of ancient Egypt, Osiris was king of the dead and judge of the underworld. Osiris-Apis in Saqqara increasingly became the giver of authoritative decisions for the people of Memphis. The Serapeum is a temple built by Ptolemy I Soter I (323–282 B.C.E.), who gave the oracle the Greek name Serapis. Below the building are underground rock-cut chambers housing the bull sarcophagi, which tourists then explored

by candlelight. At Saqqara they also saw the tomb of Ptahhotep II, which had been cleared and recorded several years earlier. This is a mastaba tomb for Ptahhotep II and Akhethotep, possibly his father, officials who can be dated to Dynasty 5. Tourists often visited the mastaba of Ti, another Dynasty 5 tomb of a noble with beautifully carved and painted reliefs depicting life on the noble's estate.

On their first evening in Cairo, Freer and Mann dined with "Mr. and Mrs. CM Swift" and met "Mr. and Mrs. Bacon and Mr. Potter." The hosts were Charles M. Swift and his wife, Clara, Detroit friends whose names frequently appear in Freer's diaries among the visitors to his Ferry Avenue home. Swift was an attorney and fellow member (with Freer and Mann) of the Detroit Club, the Yondotega Club, and the Detroit Racquet and Curling Club.[27] On the following day, Freer lunched with the Swifts and saw Bacon's paintings in the afternoon. This new acquaintance was surely Henry Bacon (1839–1912), an oil and watercolor painter born in Haverhill, Massachusetts, who by then had spent several winters in Egypt and produced a series of watercolors depicting ancient Egyptian monuments as well as contemporary country and urban landscapes (see figs. 3.5 and 3.7). Bacon had served as a field artist for *Leslie's Illustrated Weekly* during the Civil War. Wounded in action, he left Massachusetts in 1864 to study in Paris with the celebrated artists Jean-Léon Gérôme and Alexandre Cabanel. From 1866 to 1867, Bacon studied with Pierre Édouard Frère at Écouen, a village immediately north of Paris. Other American expatriates, including Mary Cassatt and Eliza Haldeman, were among the Écouen friends and fellow students of Bacon and his first wife, who was also an artist.[28] From 1868 to 1896, when Bacon again lived in Paris, he exhibited almost every year in the Paris Salon.[29] Around 1891, he married Louisa Lee Andrews, and in 1897 the two began to travel widely in Greece, Italy, Sicily, Ceylon, and Egypt. During the winter of 1899 to 1900, they spent several weeks on a dahabiya (houseboat) near Aswan, an account of which Lee

Bacon published in the following year.[30] A few years later, the Bacons moved to Paris and wintered regularly in Egypt until Bacon's death in 1912.[31] In a formal ceremony on 4 February 1898, Bacon was presented to the khedive by Consul General Harrison, along with several other distinguished Americans: Charles Dana Gibson (1867–1944), the well-known illustrator for *Collier's Weekly*, and Hamilton Fish, son of the New York state assemblyman of the same name, were among them.[32]

Freer and Mann left Cairo for Luxor at half past six on the evening of Sunday, 23 December, and arrived at nine o'clock the next morning. Train service through to Luxor was relatively new, initiated in 1898 by an Egyptian branch of the Compagnie Internationale des Wagons-Lits. The Egyptian White Train, as it was known, offered comfortable sleeping compartments and a dining car. Freer and Mann chose the overnight train instead of the Nile cruise from Cairo to Luxor, a trip of nearly 450 miles, which took several days by steamer and often much longer by sailboat. In Luxor, Freer and Mann stayed at the Savoy Hotel, a new, seventy-two-room establishment that offered an alternative to the grand Winter Palace Hotel, which had opened in 1905 with over two hundred rooms overlooking splendid gardens. Located just outside the ancient Luxor Temple, the Savoy was owned and managed by the proprietors of the Hotel Beau Rivage near Alexandria, where Freer and Mann had spent their first night in Egypt.[33]

Luxor takes its name from the Arabic al-Qusur, "the palaces," in recognition of the vast ancient building complexes whose ruins line the Nile on both eastern and western banks. Settled in early times, it was throughout pharaonic history one of the two greatest cities of Egypt. Thebes was the city of the god Amun, where the early kings of Dynasty 11 (ca. 2081–1938 B.C.E.) established their capital. Already in the Middle Kingdom Amun was identified with the sun god Re as Amun-Re, and by the New Kingdom (ca. 1539–1075 B.C.E.), the god was worshiped as the imperial deity of Thebes and the

pharaoh's personal god. Thebes rose to its greatest height in that period, witnessing the construction of massive temple complexes on the Nile's east bank, and the elaborate burials of some of Egypt's most famous and powerful rulers in the Valley of the Kings on the west bank.

Freer and Mann remained in Luxor for five days on their trip up the Nile, and an additional five

FIG. 3.6 Egypt, Luxor, Luxor Temple, Court of Amenhotep III (ca. 1390–1353 B.C.E.), ca. 1910–1915. Courtesy of the Photograph Collection, Department of Egyptian, Classical, and Ancient Middle Eastern Art, Brooklyn Museum of Art, Brooklyn, New York.

days on the return from Wadi Halfa. On the upstream journey, Freer's diary lists visits to a number of sites in Luxor and environs. His penciled notes in his copy of Breasted's *History of Egypt* document more fully the monuments he saw and admired during Christmas week, 1906, which they spent in Luxor. Several days were devoted to the Luxor and Karnak temples, which by then had been largely cleared of fallen blocks and other debris but were still under excavation. Luxor Temple is oriented north-south, parallel to the Nile River. It was dedicated to Amun-Min, the fertility aspect of the god, worshiped here along with Mut and Khonsu, the other great divinities of Thebes. Freer was entranced by the beautifully carved lotus capitals of the court of Amenhotep III, and the well-preserved, painted decoration that covered many of the columns and ceiling beams (fig. 3.6). Northeast of the temple lies the vast Karnak Temple complex, likewise dedicated to the Theban triad but dwarfing its southern neighbor (and, indeed, all other buildings on earth). Although

initially constructed in the Middle or perhaps even the Old Kingdom, the sprawling complexes that survive are chiefly the work of the New Kingdom pharaohs, to which rulers of Dynasties 22 to 30 added substantially. Freer spent several days viewing the temples (fig. 3.7).

In 1907, tourists reached the west bank of Thebes by small sailboats (the famous feluccas), then proceeded by donkey from the river's edge to ancient temples, tombs, and other monuments. Some years earlier, Thomas Cook & Son had built a rest house near Deir al-Bahri, where tourists typically took their lunch. The monuments had recently been furnished with additional amenities; as chief inspector of Upper Egypt for the Antiquities Service from 1899 to 1904, Howard Carter had taken steps to protect the monuments and ensure the safety of visitors to western Thebes, installing electric lights in tombs and building a donkey park near the Valley of the Kings.[34] Like most tourists, Freer and Mann visited the Ramesseum, a temple dedicated to Ramesses II and a form of the god Amun. The "tomb of Ozymandias" and the fallen colossus made famous by Percy Bysshe Shelley's poem "Ozymandias"

were well known for the lotus bud capitals and engaged statues of Ramesses II depicted as Osiris, and the fragmentary colossal figures lying nearby. Further south, at Medinet Habu, is the mortuary temple of Ramesses III, an immense building dwarfed only by the Karnak Temple. It was a standard stop on tours of Luxor, along with the "Colossi of Memnon," the enormous seated statues of Amenhotep III that stood in front of his ruined mortuary temple. On another day, Freer and Mann toured New Kingdom royal tombs in the Valley of the Kings, of which about half a dozen were regularly open to tourists (fig. 3.8). Freer saw the ones most visited by tourists at the time—those of Amenhotep II (ca. 1426–1400 B.C.E.), Sety I (ca. 1290–1279 B.C.E.), and Ramesses III—and also inspected the mortuary temple of Sety I at Qurna. At Deir al-Bahri, the archaeologist Édouard Naville was completing the final season of clearing the magnificent terraced temple of Queen Hatshepsut (ca. 1479/72–1458 B.C.E.) for the Egypt Exploration Fund. Freer expressed great enthusiasm for the temple and its elaborate painted decoration. All of these sites merited a return visit when Freer and Mann again stayed in Luxor following their journey to Wadi Halfa. Freer much enjoyed the splendid architecture, although the early glazed ceramics, his chief quarry,

Thebes - Inscription in the tomb N. 4

Stephen, merry christmas to yourself & family

ABOVE AND BELOW

FIG. 3.8 Postcard depicting detail of inscription, Tomb no. 4 (Tomb of Ramesses XI, ca. 1104–1075 B.C.E.), Egypt, Luxor, Valley of the Kings. Charles Lang Freer to Stephen J. Warring, postmarked 16 December 1906. Charles Lang Freer Papers, Freer Gallery of Art Archives, Smithsonian Institution, Washington, D.C.

were never entirely out of his mind: "very fine blue glazed pottery was made at Assasif ('Assa savé') near Der el-Bahri," he noted in the back of his diary, referring to al-Asasif, the burial area below Deir al-Bahri. Contemplation of Ramesses's massive, ruined monuments prompted Freer to reflect on the futility of mortal ambition, as it has likewise moved countless other visitors to Thebes. "Rameses II destroyed after their death, the work, in part, of his predecessors by most dastardly

vandalism, and then devoted lots of fine artistic effort to the erection of great temples to commemorate his victories in many fields," he mused in a letter to Hecker a few days later. "But who now cares for his victories? His vandalism today is of greater importance. . . . Overwork is actually over-vanity or something near to it—or, at least, that's what I read in these mountains of labor and in the unending flow of the undying Nile."[35]

An ancient tradition divides the land of Egypt horizontally into two regions along a boundary unmarked by any specific feature of the landscape, but which reflects significant cultural as well as geographical differences. Lower Egypt, the northernmost region, encompasses the Delta and the Cairo environs. Upper Egypt designates the vast expanse of the Nile Valley south of Saqqara. In practical terms, for the foreigner of Freer's time, it effectively extended to the Second Cataract at Wadi Halfa, just south of Egypt's modern border with the Republic of the Sudan. Registering a modern distinction between those regions, Freer voiced his relief at escaping the oppressive social life of Cairo's foreign community, an observation echoed in remarks by other Americans. "Upper Egypt delights me," Freer wrote Hecker from Luxor. "It differs greatly from Cairo and the Delta. The people are different, the scenery finer, the art greater, the visitors far more intelligent and life simpler. Here fashion and silly gowns are laid aside, tradition, history and early civilization are respected."[36] Freer's complaints about the oppressive social atmosphere of Cairo's foreign community echoed a theme found in the writings of other, independent-minded Western travelers and residents beginning as early as the 1860s. By 1906, Luxor was established as a principal tourist destination and by no means lacking in the comforts and familiar institutions of British society. Several new hotels had opened between 1902 and 1905 to accommodate the heavy tourist traffic that now accompanied the winter season. Freer went to the races in Luxor with Dikran Kelekian, the Paris-based dealer from whom he had first purchased Egyptian and Near

Eastern antiquities, and Kelekian's friend, identified somewhat mysteriously as "Maggiore of Alexandria."

Through Kelekian, Freer also had ties to a much wealthier American set that frequented Egypt in the early 1900s. One of the most prominent was Theodore M. Davis (1837–1915), an American businessman, philanthropist, and amateur archaeologist who first traveled to Egypt in 1889. That year, Davis met the Orientalist Archibald Sayce and the Egyptologist Percy E. Newberry, two British scholars who interested the American in Egyptian antiquities and in financing Newberry's excavations of private tombs at Thebes. From 1903 to 1912, Davis was one of very few individuals granted permission to excavate in the Valley of the Kings opposite Luxor. In 1906, he had recently completed investigation of the Dynasty 18 tomb of Yuya and Tuya, parents of Queen Tiy, whose magnificent finds were newly installed in Cairo's Egyptian Museum. At the time of Freer's visit, the artist and archaeologist Howard Carter (1874–1939) was living in Luxor and was occasionally a guest of Davis's entourage. Carter was working on the illustrations of finds from the tomb of Yuya and Tuya for the final publication, which would appear in the following year.[37]

Davis's wider circle of dealers and collectors included others acquainted with Freer: Dikran Kelekian and Mary Cassatt were guests on the Davis dahabiya, the *Bedawin,* when they traveled in Egypt in 1911. Emma B. Andrews, a cousin of Mrs. Davis and his constant (and much gossiped-about) companion in Egypt, provides a glimpse of the Newport millionaire and his archaeological activities in her diary recording their travels aboard the *Bedawin* during seventeen trips up the Nile.[38] In the winter of 1906 to 1907, when Freer and Mann traveled up the Nile between Luxor and Wadi Halfa, Davis and Mrs. Andrews were moored at Luxor.

Another Luxor resident that same winter was Joseph Lindon Smith (1863–1950), an American artist who early won the patronage of Phoebe Apperson Hearst and Isabella Stewart Gardner. Smith specialized in copies of

archaeological monuments rendered in oil on canvas (see fig. 3.13); he worked extensively with the archaeologist George Reisner and later with the Egyptian expeditions organized by the University of Chicago's Oriental Institute. Smith and Freer had met in Detroit, and a few years later Freer purchased from Smith two paintings of ancient monuments in southeast Asia.[39] But there is no record of Freer's meeting any of the Davis circles during the winter of 1906 to 1907.

On Sunday, 30 December, Freer and Mann journeyed from Luxor to Aswan on the *Mayflower*, one of the vessels of the new Hamburg and Anglo-American Nile Steamer Company. The small town of Aswan, over one hundred miles south of Luxor, was located on the Nile's east bank astride the First Cataract, a series of rapids that extended for three miles south to the island of Philae. Between Aswan and Philae, the river drops over sixteen feet. Tourists often continued south to Wadi Halfa above the Second Cataract, a stretch of rapids more than 125 miles in length over which the Nile drops more than two hundred feet. Aswan lay at the gateway to ancient Nubia, the region of the Nile

TEMPLE OF DEBOD, NUBIA Stephen,
Shall I fetch one of this kind?
3/1/07 C.L.F.

Valley that extended south to the Sixth Cataract north of Khartoum, in central Sudan. Nubia was subdivided into Lower Nubia, between the First and Second Cataracts, and Upper Nubia, which extended south to the Sixth Cataract.

The overnight steamer trip from Luxor to Aswan regularly stopped at Edfu and Kom Ombo, two important Ptolemaic-Roman temple sites south of Luxor, both of which had recently benefited from conservation and repair. At Edfu lies the large temple of Horus, dedicated to the falcon and sky god, and the most complete of all Egyptian temples. In its final form a Ptolemaic rebuilding of an earlier sanctuary, the temple's well-preserved, densely carved and painted reliefs made Edfu a favorite tourist stop. Efforts to uncover debris from the temple began in the 1860s, but the adjacent birth house (where the birth of a young deity was depicted and ritually enacted) and enclosure wall had been cleared only a few years before Freer's visit. The *Mayflower* remained at Edfu overnight, attracting some local company: "antiquarians by moonlight," Freer reported. The next day they visited the temple at Kom

Ombo, located at the river's edge several kilometers further up the Nile. Dedicated to Horus and to Sobek, the crocodile god, this temple was constructed during the Ptolemaic and Roman periods.

On 1 January 1907, Freer and Mann arrived in Aswan and departed the same day on the maiden voyage of the SS *Nubia*, another ship of the Anglo-American line. Of all tourist itineraries dating before 1960, the stretch between Aswan and Wadi Halfa perhaps arouses the most curiosity among travelers today, for all of the monuments located there have either been moved or destroyed by the construction of the Aswan High Dam between 1960 and 1971. Lake Nasser, the enormous reservoir created by the dam's impounding of the Nile's waters, now covers the vast stretch between Aswan and Abu Simbel. Most of the forty monuments rescued by an international team were relocated to sites that remained above the floodwaters. The Isis temple on the island of Philae was moved to nearby Agilqiyya Island. The two monuments at Kalabsha, a temple built by the Roman emperor Augustus and the rock-cut temple of Amun-Re built by Ramesses II at Beit al-Wali, were also moved to Aswan. Others were awarded to distant locations in return for assistance in rescuing them from the waters raised by the dam. The temple of Isis at Dabod, formerly just south of Aswan, was given to the Spanish government and is now in Madrid (fig. 3.9). The temple Augustus built at Dendur now resides in the Metropolitan Museum of Art in New York.

Freer and Mann spent eight nights on board the *Nubia*, which stopped at many temple sites along the Nile. These monuments are largely the legacy of Nubian expansion under the last of the Ptolemies and the early Roman emperors: Dabod, Kalabsha (ancient Talmis), Dendur, Dakka (ancient Pselchis), Korosko, and Amada.[40] At Abu Simbel was the spectacular rock-cut temple built by Ramesses II and dedicated to the gods Re-Horakhty, Amun, and the deified king himself. The temple's facade, with its colossal seated statues of the ruler, was a favorite among tourists for climbing and taking

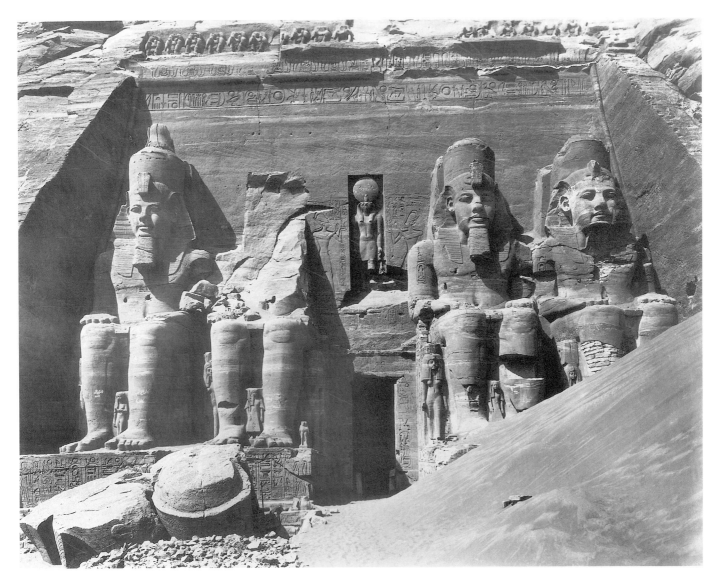

snapshots (fig. 3.10). As the Antiquities Service's chief inspector for the region, Howard Carter had recently installed electric lights here, aided financially and otherwise by Thomas Cook & Son: "temples by daylight & electricity," Freer reported.[41] A brief visit to the Second Cataract and a monument Freer described only as "old temple on west bank of river," near Wadi Halfa, completed the trip. The "old temple" was probably the remains of a structure built by Thutmose II (ca. 1493–1479 B.C.E.) and restored by Thutmose III (ca. 1479–1425 B.C.E.), which recently had been newly cleared and enclosed with a

FIG. 3.10 Egypt, Abu Simbel, facade of the great temple of Ramesses II (ca. 1279–1213 B.C.E.), 1905–06. Courtesy of the Oriental Institute of the University of Chicago.

wall and light roof.[42] In his letters Freer repeatedly stated how much he enjoyed this portion of his Egyptian journey. "Egypt continues to delight us and we are charmed with our glimpses of Nubia & Soudan," he wrote to Hecker shortly after their return to Aswan.[43]

During his brief stay in Abu Simbel, Freer met a painter whom he identified in his diary as Mr. Newman. This was undoubtedly Henry Roderick Newman (1843–1917), an American watercolor painter who in those years divided his time between Egypt and Florence (fig. 3.11). Born in Easton, New York, and educated in New York City, Newman exhibited his work at the National Academy of Design in Manhattan and the Brooklyn Art Association every year between 1861 and 1870. In 1864, he was elected a member of the Association for the Advancement of Truth in Art, a group also known as the American Pre-Raphaelites. This small, short-lived association was devoted to reforming American art by following the principles of truth to nature advocated by the influential English art critic John Ruskin.[44] Ruskin admired Newman's work; he purchased several of his watercolors and traveled with him in Italy in pursuit of illustrations for Ruskin's books. Newman's attempt to study in Paris with Jean-Léon Gérôme, a well-known Salon and Orientalist painter, was almost immediately interrupted by the Franco-Prussian War of 1870. Newman moved to Florence and later to Venice. In 1883 he married an English woman named Mary Watson Willis, and the two settled in Florence.

Like Freer, Newman had traveled extensively in Japan in the mid-1890s. Newman and his wife arrived in Japan in the summer of 1896, and the artist spent most of the following year working in Yokohama, Nikko, Kamakura, and Kyoto. The artistic results of Newman's Japanese residence, however, would almost certainly not have impressed Freer. The Fine Art Society of London hosted an exhibition of the painter's Japanese pictures in July 1899. Not a single work sold from this, Newman's only single-artist show, although the Museum of Fine Arts in Boston later agreed to purchase four of

FIG. 3.11 Henry Roderick Newman (1843–1917), *Temple on the Island of Philae*, 1894. Watercolor; 66.3 x 43.5. Yale University Art Gallery, bequest of Mrs. Nathan Baldwin, April 10, 1906 (1906.09).

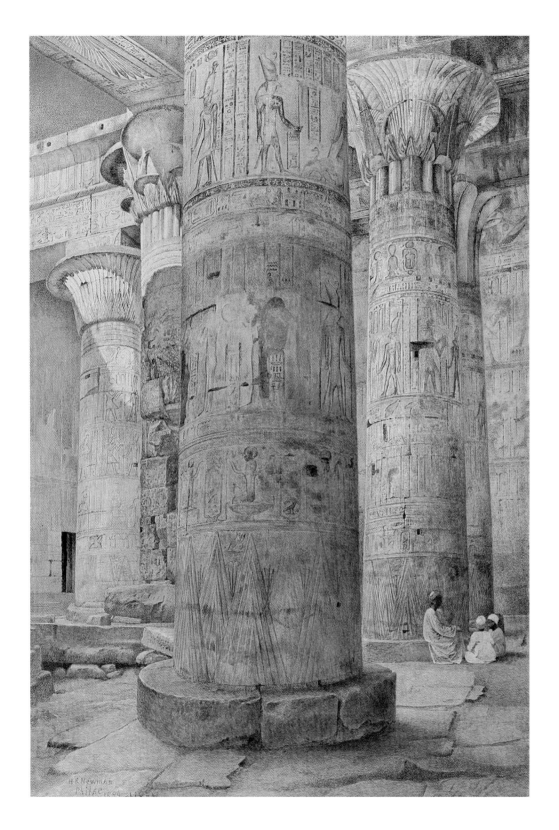

the Japanese pictures. The Newmans also collected Japanese art during their stay in Japan, the results of which would probably also have earned them little of Freer's esteem.[45]

Beginning in 1888, the Newmans regularly wintered in Egypt, where the artist eventually produced dozens of watercolor paintings depicting ancient Egyptian monuments. Nubian sites were his favorites, among them Abu Simbel, Kom Ombo, and, above all, the Isis temple on the island of Philae. The Isis temple, a much admired and well-preserved monument dating from the Ptolemaic and Roman periods, was widely acclaimed in the nineteenth century as "the pearl of Egypt" (see fig. 3.11).

Joseph Lindon Smith's account of Newman, whom he encountered in Egypt in 1898, paints a portrait of an eccentric, somewhat cantankerous man. In his published memoirs, Smith relates that his Boston mentor, Harvard University art instructor Denman W. Ross, had given him Newman's name and that he had telegraphed Newman of his plans to visit Aswan. But by the time Smith came to compose his memoirs, he and Newman had long ceased to be on speaking terms, and his superficially bland account contains an unmistakably patronizing and distant tone. Newman was "a strange sight at work," wrote Smith, who must have known that the older artist had long suffered poor health. "Both his face and hands were abnormally pallid, and he wore gloves without fingers. He seemed extremely nervous and obviously was disturbed by my unannounced approach to him in his tent. In spite of the heat, he had on a heavy overcoat with the collar turned up, and a muffler."[46] Smith wrote that he was already familiar with Newman's watercolors of Philae, "painted with a tightness of technique and lacking in clear tones, and with such minute details that he frequently worked on the same study for several seasons. Denman Ross told me that they had a great vogue and that he sold them at large prices to clients who were lords and other rich people."[47] One of those "rich people" was Theodore M. Davis, to whom Smith ordinarily displayed considerable

deference. Davis had first met Newman in Egypt in 1890, and in 1893 purchased a watercolor from him for 200 pounds sterling.[48] Newman's titled clients may have included acquaintances of Lady William Cecil, whose diary of her 1901 trip to Egypt noted that Newman's "wonderfully elaborate pictures" of sites near Aswan would gain in value after the opening of the British dam scheduled for the following year, an event which was destined to flood the island of Philae during the winter months. "They will be priceless in years to come, when as everyone says Philae will be more or less under water," she wrote.[49] Newman's success was also tracked by Frances Waldo Ross, Denman Ross's mother, who wrote to Joseph Lindon Smith in 1893 with a report from Mary Newman that "Henry . . . has done so much work, & it is all sold."[50]

Freer does not mention how he learned of Newman, his paintings, or his presence at Abu Simbel. Newman lived much of the year in Italy, and Freer may have heard about him while in Naples or Capri, en route to Egypt, where he had stopped to visit his friends Thomas Spencer Jerome and the expatriate artist Charles Caryl Coleman. Another of Coleman's friends in Italy (and acquaintance of Freer) was fellow expatriate artist Elihu Vedder, who certainly knew Newman's work, and did not much care for it; he found in the painter's devotion to painting Egyptian temples a depressingly narrow focus.[51] But Newman was captivated by the magnificent colors of the temple's well-preserved painted decoration, which mesmerized many others as well. Emma Andrews wrote breathlessly of her first visit to the temple with Davis and Newman, that "everywhere it has been brilliantly painted—and the well known capitals are still brilliant with color—such lovely greenish blue, the predominating color—pure as the sky—such delicate red pinks and tender greens—it must be the despair of any artist to attempt in fresh color, to represent these tints worn by time to such soft brilliancy."[52] Since 1892, Newman had wintered on his dahabiya, the *Hapi*, named for the ancient deity of the Nile's annual flood. Newman and his wife had themselves become something

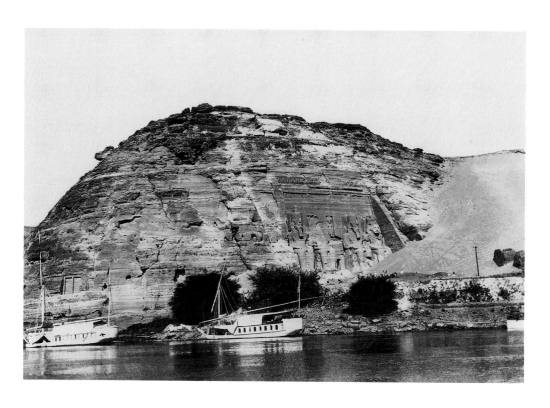

of a fixture in Upper Egypt (fig. 3.12). On Christmas Eve, 1906, shortly before Freer met the painter at Abu Simbel, Emma Andrews noted in her diary that the Newmans' dahabiya "was there as usual."[53]

Freer's diary records that he met "Mr. Newman, painter" on Friday, 4 January 1907, and the next evening "called upon Mr. Newman & saw his pottery." Perhaps this is a simple error, for Newman was well known for his paintings, and Freer would have taken particular interest in the painted decoration the artist delighted in recording. It seems difficult to imagine that Newman stored on a relatively small houseboat for a few months of the year any significant collection of pottery. The visit was in any case a brief one, as the *Nubia* departed at five o'clock the following morning. The return voyage from Abu Simbel stopped at Wadi al-Sebua, "valley of the lionesses," named for the avenue of carved sphinxes that led to the partly rock-cut temple of Ramesses II. Freer was disappointed: "poor," he commented. From al-Sebua they returned to Kalabsha, Philae, and the granite quarries outside Aswan.

Aswan was already well established as a winter resort, initially for those suffering from a variety of ailments; it was "the farthest outpost of invalid colonisation in Egypt," observed one Englishman in 1897.[54] Tourists often admitted that it was chiefly suited to "loafing." "Assuan is a fine place for an invalid, but an able-bodied person might find it a trifle monotonous," concluded one American in 1908.[55] At Aswan Freer and Mann also saw a camp of the nomadic peoples called the Bisharîn, whose exotic appearance and woven tents made of goat hair or reeds had established them as one of the town's more colorful tourist attractions.

In addition to its ancient monuments, Aswan also boasted a new one: the large dam begun by the British in 1898, which officially opened in December 1902. Virtually all tourists of the time mention a visit to the dam, which they typically called the Great Dam. At the time of its construction it was the largest dam in the world, and was ranked among the marvels of British engineering.[56] The project was conceived as a means of gaining more effective control over the Nile within the boundaries of Egypt. Barrages across the river already existed near Cairo and Asyut, as noted by tourists whose steamers had to wait for them to open; others had been erected north of Cairo, across the Rosetta and Damietta branches in the Delta. Through the Aswan project the British sought to control more effectively the annual flooding which broke the Nile banks and flooded the valley while leaving the countryside dry for the remainder of the year. The dam and its associated reservoir were intended to furnish an abundant and predictable supply of water throughout the year, and the resulting higher water levels would yield new agricultural land from the desert margins.[57] One consequence of this massive enterprise, long foreseen, was the annual flooding of the Isis temple on the island of Philae. The flooding of archaeological sites in the vicinity of Aswan and farther south also prompted renewed interest in the ancient monuments of Lower Nubia. At the time of Freer's visit, archaeologists were conducting

intensive archaeological surveys of the region, under the direction of the Egyptian Antiquities Service.

At Aswan Freer and Mann left the *Nubia* and again boarded the *Mayflower*, "the same steamer we took from Luxor to Assouan, and are due to reach Luxor on our return tonight," Freer reported to Hecker. "The Hamburg and Anglo-American steamers are new and very comfortable—they are giving the Cook's a race for patronage and are certainly making their guests very content."[58] They stopped at Esna to see the temple of Khnum, a Ptolemaic and Roman structure dedicated to the god of creation, which was popular with Nile cruises. Freer and Mann reached the Savoy Hotel in Luxor late in the afternoon, and remained there for six nights.

During that week they returned to several monuments they had already visited on the voyage upstream, including Luxor and Karnak temples. Rarely mentioned in tourists' accounts, however, were the private tombs of Dynasty 18 nobles, situated in the burial area known as Sheikh Abd al-Qurna. Freer and Mann saw those of Nakht, Rekhmire, Menna, "and others," and thus perhaps most of the private tombs open to tourists at the beginning of 1907. Like some of the royal tombs, the private ones were equipped with electric lights, so the beautiful painted interiors would have been readily visible. At Deir al-Medina, they would probably have toured the small temple built by Ptolemy IV Philopator (222/1–205 B.C.E.), the last of a series of temples built on the same site that probably began in Dynasty 18. The workmen's village for which Deir al-Medina is chiefly known today had not yet been excavated.

Their final four days in Luxor were largely occupied by visits to dealers—the ubiquitous "antiquarians"—and private collectors, among them Reverend Colin Campbell, a clergyman who often wintered in Egypt. There were also social occasions; they paid a call on Mr. and Mrs. Ramsdell, "of steamboat fame," a couple from Newburgh, New York, whom they had met on board the *Nubia*. Dikran Kelekian arrived with a friend Freer identified as

Maggiore of Alexandria, and on 10 January, Freer spent "all day with Kelekian at antiquarians and the races." On Monday, 14 January, Freer and Mann departed Luxor by an early morning train and reached Qena in a little over an hour, then toured the temple of Hathor at Dendera until noon. This well-preserved temple from the Ptolemaic-Roman period was extremely popular with tourists, whose Nile steamers moored nearby.

The following morning, Freer and Mann continued on to Baliyana, where they met up with Colin Campbell to visit Abydos, a trip of some two-and-a-half hours by donkey. Known through ancient sources as a center for the cult of Osiris, Abydos had recently been the site of extensive excavations conducted by Flinders Petrie on behalf of the Egypt Exploration Fund. Petrie had uncovered tombs of some of the earliest rulers of ancient Egypt, dating from the Early Dynastic Period (ca. 3000–2675 B.C.E.).[59] But the chief tourist attractions, both in Freer's time and now, are the temple of Ramesses II and especially the great temple begun by Sety I and completed by Ramesses II. Its gracefully carved and brilliantly painted reliefs, whose fresh and vivid colors tourists frequently singled out for special admiration, establish it as one of Egypt's most beautiful monuments (fig. 3.13). At nine-thirty on the evening of 15 January, Freer and Mann boarded the train at Baliyana, returning to Cairo, and Shepheard's Hotel, early the next day.

On Wednesday, 16 January, Freer and Mann spent the evening with Gaston Migeon and his wife and enjoyed their company on several subsequent occasions. They visited the Migeons again on the following afternoon at the Hotel d'Angleterre, and on Saturday accompanied them to the Egyptian Museum. Freer's diary for this day also records that he met Giovanni Dattari, "Cook's man, the collector," and therefore it might have been Migeon who introduced them. Two years later, Freer purchased from Dattari a large collection of ancient glass which included some of Freer's finest and most important Egyptian acquisitions. On Friday, 18 January, Freer and Mann dined with the

Migeons and Mr. and Mrs. Garnier, "the collector and watch-maker." Paul Casimir Garnier (1834–1916), a civil engineer who manufactured clocks and precision instruments for the French Navy and the French National Railways, belonged to the Paris circle of collectors and dealers with whom Freer was acquainted. To his collection of watches and clocks Garnier had added bronzes of the sixteenth and seventeenth centuries and Gothic ivories, about which Migeon had recently written in *Les Arts,* a journal to which Freer subscribed.[60]

On 20 January, Freer's last day in Cairo, he recorded a meeting with "Pasha Brugsch" at the Egyptian Museum. A German Egyptologist who had been appointed keeper in 1883, Émile Brugsch (1842–1930) was the younger brother of Heinrich Brugsch, also a distinguished Egyptologist, to whom the khedive had likewise granted the title of Pasha, the highest rank of civil and military administration. Freer was required by the laws governing the export of antiquities to clear his purchases through the director of the museum, and the experience left an indelible memory. Brugsch was "a terror," Freer wrote to his office manager, and extremely reluctant to approve export of two of

Freer's purchases. In the end, Brugsch gave his approval, but Freer would not learn of his final decision until he reached Port Said a few days later to set sail for Ceylon. Freer's final activities in Cairo consisted of a trip to the Museum of Arab Art and Khedival Library "with Migeon & party," apparently followed by a festive luncheon for all.

On 21 January 1907, Freer and Mann arrived in Port Said by a late morning train from Cairo, a trip of about four hours. The cool weather they left behind in the Egyptian capital turned cold and stormy on the Mediterranean coast. Late that afternoon, Mann boarded a P & O steamer for the return voyage to Italy. Freer remained overnight at the Continental Hotel in Port Said. The following day he "saw the town—very uninteresting," bid farewell to his guide, Ibrahim Ali, and sailed on the North German Lloyd liner the *Princess Alice* through the Suez Canal and the Gulf of Aden, en route to Ceylon. Thus ended Freer's only extended journey in Egypt. When he returned in 1908 and 1909, his brief trips were devoted almost exclusively to acquiring antiquities for his collection, now destined to reside in a new museum in Washington, D.C.

FIG. 3.13 Joseph Lindon Smith (1863–1950), American, *Kneeling Figure of Seti Making Offering*, date unknown. Painting of a detail from the temple of Sety I at Abydos. Oil on canvas; 190.5 x 106.7. Courtesy of the Museum of Fine Arts, Boston; anonymous gift (39.601).

In Pursuit of Antiquities

Ten days before Freer first arrived in Egypt, a Cairo dealer sent a letter to one of his regular foreign clients. "Will you kindly tell us if you intend coming to Cairo this year, for the purpose of trying to have s'thing good to show you," Panayotis Kyticas wrote to E. A. Wallis Budge, keeper of Egyptian and Assyrian antiquities at the British Museum. "The antiquities as you can well imagine are extremely rare this year."[1] Kyticas may have sought strategically to lower expectations about the supply of choice pieces, but his statement probably contained a good deal of truth. By the beginning of the twentieth century, organized excavations conducted under the auspices of European and American museums and other institutions had begun to alter Egypt's antiquities market. Foreign institutions granted permission to conduct excavations in Egypt were allowed to keep a share of the finds they unearthed, thereby permitting museums and universities to assemble large collections. The opportunity to build collections in this way might have been thought to slake foreign thirst for looted artifacts sold through private dealers.[2] And yet demand, and prices, remained high. An influx of American millionaires, buying for themselves or as museum benefactors, created a new market for Egyptian antiquities. In November 1904, the New York financier J. Pierpont Morgan became

FIG. 4.1 Cup, Egypt, Meroitic period (2d–4th century C.E.). Earthenware with paint; 9.5 x 8.5 x 8.5. Freer Gallery of Art, Smithsonian Institution, Washington, D.C., gift of Charles Lang Freer (F1907.633).

president of the trustees of the Metropolitan Museum of Art in New York. Morgan offered his vast resources toward Egyptian acquisitions on behalf of Albert M. Lythgoe, who became the museum's curator of Egyptian art in 1906. In Cairo and Luxor, prices were adjusted accordingly. In December 1906, as Freer began his visits to dealers, the artist Joseph Lindon Smith reported to Isabella Stewart Gardner that Lythgoe had arrived in Egypt with Morgan, "purse in hand, which has made the price of antiquities skyrocket."[3]

Foreigners in search of antiquities ran the social gamut from wealthy collectors like Morgan to those of modest means traveling with package tours or church groups. As a result, demand was met at a variety of levels. Objects were offered for sale in Alexandria, Cairo, Luxor, and Qena, and at virtually every major tourist attraction. Well-established shops run by more or less knowledgeable proprietors catered to the wealthier set and tended to build up a regular clientele through personal introductions. These higher-end establishments were found in the larger cities, prominently located for foreigners. Dikran Kelekian's Cairo shop initially operated out of the Hotel Continental, then moved to Shepheard's Hotel, the grand hotel patronized by many well-heeled foreigners, and where Freer himself stayed during his three trips to the city. Another prominent Cairo dealer was Maurice Nahman (1868–1948), a local banker with Crédit Foncier who sold antiquities to many important collectors and museums.[4] Muski Street, Cairo's bazaar, was home to several dealers, including Dimitri Andalft, E. Hatoun, and Joseph Cohen, who was especially well known among American and British visitors and residents. Ali Arabi's place was at Giza, near the Pyramids (and Mena House Hotel); Freer addressed letters to Arabi in care of the Giza Post Office. Luxor, a principal tourist destination, boasted a number of shops, the most prominent of which was owned by Muhammad Mohassib.[5]

Many dealers (and collectors) were Greeks, members of a large and prosperous community that resided chiefly in Alexandria and Cairo. Panayotis

Kyticas's shop, which opened in 1879, was located nearby, between Shepheard's and the Grand Continental hotels. Kyticas was a chief supplier for Budge of the British Museum, as their surviving correspondence indicates.[6] In Qena, Freer bought from another established proprietor, Tanios Girgis (with whom he also did business in Cairo), and visited the shop of Morgos Chanher. Freer's diary mentioned "antiquarians" at virtually every step of his travels, but he was no doubt also advised on where to shop by Kelekian and Migeon, both of whom he saw in Egypt in January 1907. Other Cairo shops he patronized were owned by Alexander Dingli, Kalebjian Frères, Michael Casira, and Hajji Muhammad Mohassif, along with unnamed others.[7] In addition to established businesses, entrepreneurship made antiquities available in many locations. Tourists often complained that locals spoiled their visits to sites by pestering them to buy antiquities and trinkets. The Arabs were "really a great nuisance," declared Dr. Maltbie Davenport Babcock, a Presbyterian minister, describing his visit to the Pyramids in 1901. "When we wanted to be still, and abandon ourselves to the pleasures of sight and reflection in a spot so unique, in surroundings so unparalleled, we could barely get a moment free from their importunities concerning scarabs, and necklaces, and sungods, and pieces of mummies, and little Rameses in stone, and a dozen other impertinences."[8]

Information about the dealers and their merchandise appears in Freer's and other collectors' records. Archaeologists and curators who frequented the shops also kept track of sale items and prices. Flinders Petrie, one of the most active archaeologists working in Egypt in this period, regularly called on antiquities dealers in Cairo, Luxor, and Qena. Petrie wanted to keep abreast of market prices, because he habitually paid his workmen for reporting finds during excavations in order to discourage clandestine sales. But he also purchased items for himself and for the member institutions of the Egypt Exploration Fund.[9] Dealers' inventories also provided valuable clues about which archaeological sites were being plundered to supply the antiquities trade. The French

Egyptologist Auguste Mariette founded the Egyptian Antiquities Service in 1858 to protect the ancient monuments of Egypt, and in 1899 his successor, Gaston Maspero, appointed two European inspectors to patrol monuments, report damage, and recommend appropriate action. As chief inspector for Upper Egypt from 1899 to 1904, and for the region around Cairo from 1904 to 1905, Howard Carter found it informative to visit dealers on a regular basis. Like other archaeologists of the time, Carter also purchased from dealers for various private clients, including Lord Carnarvon, who later financed the excavations of Tutankhamun's tomb, and for the collections of the Cleveland Museum of Art and the Detroit Museum of Art (now the Detroit Institute of Arts).[10]

The early years of the twentieth century also witnessed a growing demand for Egyptian antiquities from American philanthropists of substantial means, both on behalf of major museums and for their own collections. Theodore M. Davis, the Newport millionaire whose circle included Dikran Kelekian and Mary Cassatt, was one of few individuals granted an excavation permit by the Egyptian Antiquities Service. From 1903 to 1912 he explored Dynasty 18 royal tombs in the Valley of the Kings, including those of Hatshepsut, Thutmose IV, and Horemheb, and the tomb of Yuya and Tuya, parents of Queen Tiy. Most of the objects unearthed during these excavations went to the Egyptian Museum in Cairo; finds from the tomb of Thutmose IV were also given to the Metropolitan Museum of Art in New York and the Museum of Fine Arts in Boston. In addition, Davis purchased items for his own collection, which he later gave to the Metropolitan Museum of Art.[11] J. Pierpont Morgan became interested in Egyptian art especially toward the end of his life, and until his death in 1913, it remained his primary collecting concern. The splendid Egyptian galleries that opened at the Metropolitan Museum of Art in 1913 showed to advantage the results of his efforts.[12] Another American businessman and philanthropist who sought Egyptian

antiquities on behalf of a burgeoning museum collection was Edward Everett Ayer (1841–1927). A principal founder of the Field Museum of Chicago, Ayer served as its president from 1893 to 1898 and as a trustee until his death in 1927; beginning in the 1890s, he purchased Egyptian antiquities for the museum.[13] In 1911, Freer described the Field Museum as one of the three major American institutions housing Egyptian art, along with the Metropolitan Museum of Art and the Boston Museum of Fine Arts.[14] This era also saw the development of significant collections at the Brooklyn Museum of Art, the University Museum of the University of Pennsylvania, the Detroit Museum of Art (now the Detroit Institute of Arts), the Cleveland Museum of Art, and the Drexel Institute in Philadelphia.[15]

Freer's diary preserves names and dates and intermittently comments on his acquisitions; his correspondence occasionally furnishes fuller descriptions of these transactions. In the case of the biblical manuscripts he bought on 19 December 1906, which rank among the most important acquisitions he ever made, his diary provides only a skeletal account: "Bought manuscripts in forenoon & paid for them during afternoon." His letter to Frank Hecker, however, supplies a richer version. The normally circumspect Freer admitted that he was "carried completely off" his feet, spent two days examining the manuscripts with the aid of two local Greek scholars, and "fell by the wayside."[16]

In addition to Egyptian antiquities, dealers (especially those in Cairo) offered objects from other parts of the world. The range of merchandise reflected a cosmopolitan clientele, many of whom traveled regularly between Europe, Egypt, and India. It was also a bountiful legacy of Cairo's far-ranging contacts that began with the Arab conquest in 641; ongoing digging in the rubbish heaps of Fustat yielded large quantities of pottery from China, Spain, Syria, Iraq, and Iran.[17] Kyticas advertised "objets d'art anciens & modernes en porcelaines, faiences, étoffes, argenteries, bronzes, émaux, etc.," and "objets d'art de Chine & Japon." Indeed, one of his invoices to Budge of the British

Museum, dated February 1906, listed "2 silver vases, 1 pair cloisonné vases, 1 pair Java (?) vases, 1 square China vase, 1 square Perse [*sic*] vase." In 1907, Budge bought from the same dealer a Satsuma dog.[18] Tourists reported a wide array of textiles, metalwork, and other merchandise for sale in Cairo shops. Freer's purchases in Egypt consisted overwhelmingly of Egyptian antiquities, but he also bought Egyptian, Syrian, and Persian ceramics of medieval date, most of them allegedly recovered from the ruins of Fustat. A scholar Freer met in Cairo, whom he identified as Professor Arvantakis, purchased Persian book covers from Ali Arabi, the Giza antiquities merchant.[19]

In addition to shops owned by Greek, Italian, and Egyptian "antiquarians," resident foreigners formed another source for antiquities. Four private collectors Freer met in Egypt—Randolph Berens, Colin Campbell, Giovanni Dattari, and Daniel Fouquet—all lived in Cairo for significant periods of their lives, and occasionally sold objects from their collections. Many foreign collectors maintained a serious interest in Egyptology, biblical studies, or Mediterranean antiquities more broadly, publishing notes on inscriptions and works of art, or taking an active role in translating and popularizing scholarly works. Dr. Daniel Marie Fouquet (1850–1914) was a French physician who settled in Cairo in 1881. His help was sought by Gaston Maspero (head of the Egyptian Antiquities Service) in examining the cache of Dynasty 19 royal mummies discovered in 1881 at Deir al-Bahri.[20] While modern scholars may find much to criticize in Fouquet's work on ancient embalming practices, his antiquities collection was well known, and he had lent objects to the Egyptian exhibition held at the Burlington Fine Arts Club in 1895. He was particularly respected for his research on medieval Egyptian, Syrian, and Persian ceramics, of which he had assembled a sizable collection composed chiefly of sherds retrieved from the rubbish mounds of Fustat. It was surely Fouquet's latter expertise that most intrigued Freer. In August 1905, the Detroit collector had purchased a copy of Fouquet's monograph on Near Eastern ceramics, for which

Marie Nordlinger provided an English translation.[21] Kelekian, himself a leading dealer in Near Eastern ceramics, considered Fouquet one of the principal researchers in the field.[22] Fouquet's study drew on an impressive range of evidence, including artisans' signatures and technical observations on fabric and decoration, in defining schools and centers of production for the large ceramic collections unearthed through extensive digging in the mounds of Fustat. These objects, consisting overwhelmingly of sherds, encompassed locally made wares and imitations, and also genuine imports from Syria, Iran, and China. Fouquet was also intrigued by the prior history of ceramic production in Egypt, and in particular in the technical characteristics of ancient Egyptian faience. In addition to his considerable ceramic holdings, Fouquet also owned faience vessels, limestone "sculptors' models," vessels and figurines made of hard stones, and wooden sculptures ranging in date from the New Kingdom to the Ptolemaic period.[23] Freer met Fouquet for the first time and saw his collection on 16 December 1906. The two collectors then met again on 17 May 1908. On the former occasion, Fouquet presented Freer with an inscribed copy of his monograph devoted to Near Eastern ceramics. In 1922, several years after Fouquet's death, his collection was sold in Paris and dispersed among museums and private collections.[24]

On his first trip to Egypt, Freer also saw the collection of the Reverend Randolph Humphrey Berens (1844–1922). Himself the son of an English clergyman, Berens married a wealthy woman and was thereby able to retire from his clerical position. He traveled in Egypt, collecting coins and antiquities, but he was also known for his cuneiform tablets acquired from several dealers and published by the Assyriologist Thomas W. Pinches. His Egyptian collection was auctioned in London in 1923, the year following his death.[25]

The Reverend Colin Campbell (1848–1931) was another British clergyman who spent considerable time in Egypt and assembled significant holdings of Egyptian antiquities, including many cones and ostraca (inscribed sherds

FIG. 4.2 Head and bust of male figure, Egypt, Middle Kingdom (ca. 1980–1630 B.C.E.), face later recarved. Limestone; 58.1 x 45.7 x 27.4. Freer Gallery of Art, Smithsonian Institution, Washington, D.C., gift of Charles Lang Freer (F1907.3).

OPPOSITE: LEFT
FIG. 4.3 Shrine, originally housing a small image of a deity, perhaps the figurine that accompanied the shrine when purchased (see FIG. 4.4), Egypt, Ptolemaic period (305–30 B.C.E.). Wood (sycamore fig) and gesso; 56.3 x 36.7 x 48.1. Freer Gallery of Art, Smithsonian Institution, Washington, D.C., gift of Charles Lang Freer (F1907.4a–b).

OPPOSITE: RIGHT
FIG. 4.4 Figurine of Horus, Egypt, Ptolemaic period (305–30 B.C.E.). Wood and gilt; 44.5 x 10.5 x 25.3. Freer Gallery of Art, Smithsonian Institution, Washington, D.C., gift of Charles Lang Freer (F1907.4c).

and pieces of limestone). Educated at the University of Glasgow, Campbell served from 1882 as minister of Dundee and as chaplain to Queen Victoria. His collection is now dispersed among several museums, chiefly the Hunterian Museum in Glasgow, the Royal Scottish Museum in Edinburgh, and the Oriental Museum in Durham.[26] Campbell published works on the Gospels and translated lectures by Édouard Naville, the distinguished Swiss Egyptologist, on the subject of Egyptian religion. He also wrote a number of semi-popular books on Theban tombs and may well have been working on one of them at the time he met Freer, for *Sen-nofer's Tomb at Thebes* was published in the following year.[27]

In 1907, Campbell sold Freer a stone sculpture of a cloaked male figure of Middle Kingdom date (ca. 1980–1630 B.C.E.), whose face had been recarved in antiquity (fig. 4.2). Although scholars today would scarcely judge it to be an exceptional work, Freer had considerable difficulty in persuading the Egyptian Museum officials to approve its export. Freer himself was highly enthusiastic about the object. The "great bother" of having the object approved for export was worthwhile, he declared, given his desire to compare the piece with Chinese and Japanese painting and sculpture. "I now think it surpasses either, but I am not sure. Study alone can finally convince me," he wrote to J. M. Kennedy at his office in Detroit.[28]

Freer immediately busied himself with the task of acquiring "specimens" of glazed ceramics and stone, although he volunteered little concerning the precise nature of his collecting mission even to "Freddie" Mann and Ibrahim Ali: "they [Mann and Ali] know and helped me to gather scraps of glazed stone and pottery and they know that the fragments are for study," he confided to Hecker, "but beyond this the particulars in details are unknown."[29] Freer picked up small items at various sites, including Tell al-Yahudiya, for nominal sums, as his diary records. He purchased a lot comprised of seventy-two fragments of faience artifacts, primarily amulets and other small items,

and several examples of faience vessels (see fig. 2.13). Freer's interest in obtaining "specimens" of early ceramics extended also to wares lacking glaze; he acquired samples of painted Meroitic earthenware, which he later described as "unglazed, but decorated" (see fig. 4.1, page 88).

Soon after arriving in Cairo, Freer made the momentous decision to purchase four Greek parchment manuscripts offered by Ali Arabi. These, it was later verified, consisted of manuscripts of Deuteronomy and Joshua, the Psalms, the Gospels, and the Epistles of Paul, dating variously from the late fourth to the sixth century; they comprised four of the five manuscripts later known as the Washington Manuscripts. The Gospels were enclosed in painted wooden covers dating from the seventh century (see fig. 1.2).

In the last few days before his departure from Egypt, Freer obtained from Arabi one of his most remarkable ancient Egyptian acquisitions: a rare, elaborately painted wooden shrine housing a gilded wooden Horus figure, perhaps its original occupant (figs. 4.3 and 4.4). The shrine and accompanying figurine appealed to Freer in part because he thought them to be quite early. Freer penned a brief note in his diary that "the shrine & figure from Old Ali came from Akmene [Akmim] & is of 12 Dynasty"; otherwise, he seems to have mentioned it in correspondence only in connection with its shipment to Detroit. "I am negotiating for an old wooden figure in an old rickety shrine and shall probably buy it before sailing on the 21st," he wrote to Kennedy on 19 January 1907. "It's another specimen of early sculpture and painting for study."[30] Freer later encountered serious obstacles in obtaining permission to take it out of the country: "I had a red hot fight with Pasha Brugsch but won out," he wrote to Kennedy on the day he sailed from Port Said to Ceylon.[31] On Thursday, 17 January, Freer met with Lewis M. Iddings, who had presented his credentials as the United States consul general and diplomatic agent on 23 December 1905. Freer needed to obtain Iddings's signature on customs papers in order to export both his antiquities purchases and the books he wished to ship to Detroit (fig. 4.5).

Freer returned from his world travels in July 1907 to an America grappling with a financial crisis set off by a stock market crash in mid-March. The Panic of 1907, which lasted for most of the year, compelled Freer to reduce spending on his collection. He did, however, purchase a few objects from dealers in London and from Dikran Kelekian, including a small bronze coffin surmounted by a falcon (fig. 4.6) and a faience amulet depicting the facade of a shrine (fig. 4.7).

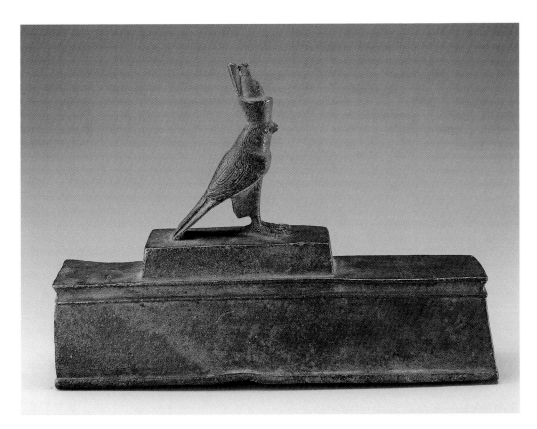

FIG. 4.6 Miniature coffin sur-mounted by falcon wearing double crown, Egypt, Dynasty 26 (664–525 B.C.E.) or later. Bronze; 16.8 x 5.8 x 24.3. Freer Gallery of Art, Smithsonian Institution, Washington, D.C., gift of Charles Lang Freer (F1907.154).

FIG. 4.7 Pectoral amulet depicting Anubis, Egypt, New Kingdom, Dynasties 18–19 (ca. 1539–1190 B.C.E.). Faience (glazed composition); 6.6 x 8.6 x 0.8. Freer Gallery of Art, Smithsonian Institution, Washington, D.C., gift of Charles Lang Freer (F1907.152).

In the fall of 1907, Freer began a serious quest for advice concerning the biblical manuscripts acquired the previous winter. He contacted Francis Kelsey of the University of Michigan, with whom Freer had long enjoyed a close friendship. A past president of the American Philological Association and cur-rent president of the Archaeological Institute of America, Kelsey was well acquainted with experts in classics and biblical studies. He recommended a young Michigan faculty member, Henry A. Sanders, to examine the manu-scripts and undertake their publication. In December 1907, Sanders presented preliminary reports at professional meetings, which generated considerable excitement in the scholarly world as well as in the popular press.[32] Several weeks later, Freer hosted a meeting devoted to the new discoveries for the Detroit Society of the Archaeological Institute of America. On this occasion, Kelsey's diary reports that at a small afternoon gathering before the evening event, he and a few others were allowed a closer examination: "Separated leaves of mss. of Deuteronomy and Joshua. Looked at other 3 mss., especially

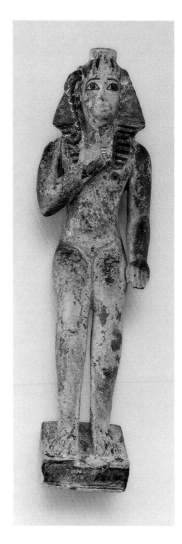

FIG. 4.8 Figurine of Horus the Child, Egypt, Dynasty 26 (664–525 B.C.E.). Bronze, gold, copper, silver, and black paint; 15.0 x 4.1 x 3.3. Freer Gallery of Art, Smithsonian Institution, Washington, D.C., gift of Charles Lang Freer (F1908.48).

latter part of gospels, End of Mark. . . . With an ivory paper knife I loosened one cover, then the leaves of the mss.; all opened up—wonderfully fresh and clear."[33] A few days later, Kelsey and Freer outlined a comprehensive plan to publish the manuscripts first in facsimile form, to be followed by detailed scholarly monographs in the Humanistic Series of the University of Michigan Studies. On his next trip to Egypt, Freer promised to investigate further the source of the manuscripts as well as the availability of comparable works.

On the Asian journey he undertook beginning in the spring of 1908, Freer was above all eager to see the homeland of Raqqa pottery and add to his now sizable holdings. "My quest to the 'Holy Land'—Racca pottery," he wrote to Hecker. "You know that I have invested pretty heavily in this line of 'fayence' and I consider it necessary to learn what I can."[34]

In May 1908, Freer reached Egypt by the same route he had followed on his first trip: via Naples and a visit to his friends Tom Jerome and Charles Caryl Coleman. This time he traveled alone, but he again arranged for Ibrahim Ali to serve as dragoman. On Sunday, 10 May, Freer boarded the SS *Orient*, which arrived in Port Said before noon on Thursday, 14 May, where Ibrahim Ali met him and escorted him to Shepheard's Hotel. As promised the previous year, Freer rewarded his excellent service with the gift of a gold pocket watch. For the next two weeks, Freer made daily trips to dealers' shops and occasional visits to museums and private collections. Once again he called on Lewis M. Iddings, who was then in his third year as United States consul general. On this trip, Freer directed that certain purchases be shipped directly to the Smithsonian Institution in Washington, D.C., in order to simplify the process of obtaining permission to export his purchases.

Among his acquisitions, obtained chiefly from Nahman and Arabi, were bronze figurines of Egyptian deities, including one of Horus the Child (fig. 4.8). Another, depicting the god Anubis, was alleged by its seller to date to the "Fourth Dynasty," but it is certainly much later, perhaps of the Saite

Dynasty 26 (664–525 B.C.E.) (see fig. 1.1). Freer also bought examples of the carved limestone reliefs made during the Saite and Ptolemaic periods (fig. 4.9). These objects are often interpreted as sculptors' models, but some, particularly those of the later era, may have been made for temple dedication. Another purchase was an inscribed stone relief exemplifying a well-known type of stela depicting Horus standing on crocodiles and holding the animals of the god Seth—snakes, scorpions, lions, oryx—from which the owner sought protection (fig. 4.10). Hieroglyphic inscriptions embodying magical spells to ward off the noxious creatures cover the reverse of the stela.[35]

To augment his faience collection Freer bought additional examples, chiefly amulets, from Arabi and Nahman (fig. 4.11). Small amulets made of faience, stone, ceramic, metal, or glass were common possessions in ancient Egypt. They were most often fashioned in the form of gods, goddesses, and animals sacred to the deities. Amulets gave their owners magical protection from a wide variety of ills and evil forces, including sickness, infertility, and death in childbirth. Often they were worn as necklaces. Some amulets were made to place on the body of the deceased in order to protect the soul in the hereafter.[36] Deities and animals represented in Freer's collection are among

FIG. 4.9 Sculptors' models, Egypt, Dynasty 26 (664–525 B.C.E.) or later. Limestone; 8.3 x 12.5 x 1.6; 17.9 x 18.8 x 3.6; 14.7 x 16.3 x 2.0. Freer Gallery of Art, Smithsonian Institution, Washington, D.C., gift of Charles Lang Freer (F1908.58, F1909.374, F1908.61).

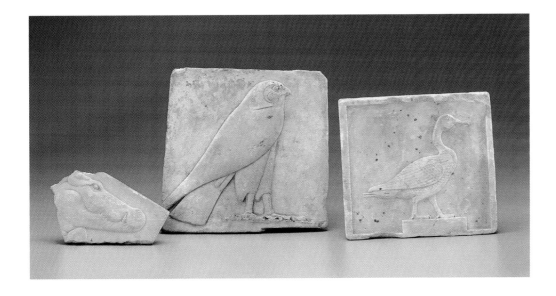

FIG. 4.10 Stela (cippus) of Horus, Egypt, Ptolemaic period (305–30 B.C.E.). Chlorite schist; 19.4 x 11.6 x 4.0. Freer Gallery of Art, Smithsonian Institution, Washington, D.C., gift of Charles Lang Freer (F1908.65).

the most favored subjects of ancient Egyptian amulets. Taweret, the hippotamus-headed goddess, and Bes, the dwarf god who wears tall plumes, protected women during childbirth. Cats often symbolized Bastet, a goddess of fertility. Other deities include Sakhmet, the lioness-headed goddess; the ram-headed Khnum, god of creation; and Thoth, god of wisdom, who appears as an ape or vervet monkey. Amulets specifically intended to protect the soul after death often depict Anubis, the jackal-headed god of embalming and guardian of the cemetery, or Duamutef, the jackal-headed son of Horus who protected the stomach.

A major aim of the 1908 trip was to ferret out the source of the biblical manu-scripts acquired in December 1906.[37] Since the beginning of the year, Freer and Kelsey had met and corresponded frequently about the publication of the manuscripts and the desirability of learning more about their provenance. Kelsey offered to enlist in advance the support of two British scholars, Frederic G. Kenyon and David G. Hogarth, should Freer require expert advice while contemplating purchases in Egypt. Kenyon, of the British Museum, was a distinguished specialist in the Greek Bible and paleography. Hogarth, a highly experienced field archaeologist, had excavated in Egypt with a British Museum expedition and also contributed to the Egypt Exploration Fund's *Fayum Towns and Their Papyri* (1900). Freer thanked

FIG. 4.11 Four amulets depicting Egyptian deities. The goddess Sakhmet; the dwarf god, the goddesses Isis and Nephthys, the god Nefertum; the god Duamutef, jackal-headed son of Horus; the goddess Isis and the child god Horus. Egypt, Third Intermediate Period (ca. 1075–656 B.C.E.); Dynasty 26 (664–525 B.C.E.) or later (far right). Faience (far left, faience and gilt); 4.0 x 1.0 x 1.4; 4.4 x 2.2 x 1.6; 6.5 x 1.7 x 1.0; 4.0 x 1.2 x 2.0. Freer Gallery of Art, Smithsonian Institution, Washington, D.C., gift of Charles Lang Freer (F1908.83, F1908.87, F1908.73, F1908.99).

Kelsey, but declined: "I am a little in doubt as to the wisdom of letting it be known in Museum circles, that I anticipate visiting Egypt, as one can never measure the competition that may spring up if it is known a real search is being made for rareties." His letter continued with the same reservations:

> *Of course there is little of any chance of finding really rare things in the market, but if they exist, and dealers or others should learn that I was making the search, the acquisition of possible things would be very much more troublesome. Because of these facts, I deem it wiser to keep as secret as possible, my future movements.*
>
> *If any thing attractive should be found, I will obtain an option before inviting the assistance of experts. In early years I lost many good chances through lack of secrecy. Now I believe in 'still hunting.'*[38]

Freer wrote to Kelsey long and entertaining accounts of his adventures with Ali Arabi to track down the source of the manuscripts, in which the Giza dealer

eventually produced as witnesses the looters themselves. Freer admitted in a letter to Hecker to "enjoying the quest greatly. . . . Poker and all other games are as nothing. It's real living, real experience—and beats winning a big contract for cars quite out of sight."[39]

Freer purchased from Arabi the important Coptic manuscripts of the Psalter and the homily on the Virgin. From Nahman he bought Greek and Coptic fragments.[40] He also acquired from Arabi fifty fragments of letters and other documents from the Cairo Geniza, the collection of medieval written materials produced by the city's Jewish community, located near the synagogue of Fustat.[41] Freer did seek advice from certain experts on this trip, but they were, as before, local scholars employed at the Greek College and the Khedival Library. In his diary for 26 May 1908, Freer mentions a Mr. Thompson both in connection with the museum and as a guest of Mr. Jean Askar, who may have been a local businessman. In Egyptological circles, the most prominent individual with the surname Thompson was Sir Herbert Thompson (1859–1944), a distinguished specialist in Coptic and Demotic texts. Thompson's sole visit to Egypt took place in 1907–08, and it is possible that he was asked for advice on Coptic questions or ancient manuscripts more broadly.[42] Jean Askar may also have been a dealer or collector, but seems to have eluded the records left by other travelers and archaeologists. Nor is he listed among the sources of Freer's purchases.

Freer's third and final trip to Egypt took place in the summer of 1909, en route to Shanghai. Most tourists today would attempt to avoid Egypt's heat in July and August, but Freer reported "delightful weather" on board the SS *Schleswig* from Naples to Alexandria. When he landed in Alexandria on Monday, 26 July, he headed for Cairo and Shepheard's Hotel. Freer observed that the city had expanded since his last visit and remarked on the novel experience of visiting Egypt in the off season. "Tell Louise that old Shepheards remains as dirty and attractive as ever," the fastidious Freer wrote to Hecker,

"but new hotels and buildings have sprung up like toad stools since her time, and now, in summer, are empty and ghostly as the ancient ruined mosques."[43]

For just over a week, Freer frequented dealers' shops and returned to the Egyptian and Arab museums. He devoted a day to sightseeing, taking in "the oldest Coptic church at old Cairo," probably meaning the Church of St. Sergius, and returned to al-Burdayni, his favorite mosque (see fig. 3.3). He also visited the madrasa of Sultan Barquq and the adjacent tomb and madrasa of Sultan Qalawun, built in 1285–86, two impressive examples of Mamluk architecture. Freer had not yet seen the nine objects from a cache of Byzantine metalwork known as the "Gold Treasure," for which he had authorized payment to Nahman earlier the same year (see fig. 1.3). Walter Dennison (1859–1917), a professor of Latin at the University of Michigan, had seen the objects while attending an archaeological congress in Cairo and sent Freer a telegram enthusiastically recommending acquisition. Allegedly, the cache had originally consisted of thirty-six objects, which were dispersed to several private collections; the study and publication of the treasure would occupy Dennison for another eight years.

From Arabi and Nahman, his principal suppliers, Freer made a variety of purchases, including additional fragments of a Coptic Psalter and Byzantine paintings from an eleventh-century manuscript of the *Heavenly Ladder*, a popular Byzantine monastic composition (see fig. 1.5).[44] Having just spent fifteen thousand dollars for two Persian ceramic vessels in Paris and a larger sum for other examples in London, the collector confided to Hecker that he was worried about the high cost of antiquities. "Nahman has an ancient wood head, a superb Egyptian pottery figure and tile and two bowls which I should buy, also two great stone Hawks which would nobly defend my little group of Egyptian art when permanently housed but his prices frighten me—I must think and make haste slowly. To buy them would mean bothering you too again with my finances and borrowing from the bank," Freer wrote.[45] In the

FIG. 4.12 Face from coffin, Egypt, New Kingdom, Dynasty 18 or 19 (ca. 1539–1190 B.C.E.). Wood (sycamore fig) and glass; 20.3 x 16.1 x 8.4. Freer Gallery of Art, Smithsonian Institution, Washington, D.C., gift of Charles Lang Freer (F1909.143).

end, Freer did purchase all of them, along with many more (figs. 4.12–4.15; see also fig. 2.18). As in the previous year, he arranged for Nahman to send these purchases, together with the glass collection he also acquired, directly to the Smithsonian Institution rather than to his Detroit home.

Freer's most important acquisition on this trip was the collection of 1,388 glass objects bought from Giovanni Dattari on 30 July 1909 for twenty-five hundred pounds sterling. The Italian Dattari was a serious collector of

coins and antiquities, highly regarded for his numismatic publications. When Freer and Dattari first met in January 1907, perhaps through Gaston Migeon, Dattari was employed at Thomas Cook & Son's Cairo office; he was later a purveyor to the British Army in Egypt. Dattari's collection was well known, especially for its large and comprehensive holdings of Greek and Roman coins. Egyptologist Percy Newberry, who examined it in 1900, published a brief account of Dattari's "splendid collection": "Besides an unique series of Greek and Roman coins, he possesses a remarkable number of beautiful specimens of Egyptian art, but his inscribed objects are not numerous."[46] A few weeks before Freer's arrival in 1909, Dattari had confided to Newberry that he was struggling to decide whether to sell his collection. "Selling little by little I would perhaps not feel so much sorrow but I am afraid not to be able to get ready [rid] of my minor important pieces which are the majority," he wrote.[47] Dattari also asked Freer to help identify an appropriate university home for a gift of coins from his important collection. Freer immediately notified Kelsey, who was delighted with the prospect of adding to the numismatic resources available to students at the University of Michigan. Now housed in the museum in Ann Arbor that bears Kelsey's name, this outstanding collection consists mainly of Egyptian coins dating from just before the founding of Alexandria by Alexander the Great to the middle of the fourth century.

Glass technology seems to have arrived in Egypt from neighboring Syria around 1500 B.C.E. and developed into a sophisticated, high-status production, perhaps initially a royal monopoly. Egypt's dry climate has favored the excellent preservation of ancient glass, which is seldom found in such pristine condition in the countries of southwest Asia where it was also produced in quantities. From the New Kingdom on, glass was used to fashion small objects such as jewelry, amulets, and miniatures. Glass was also used extensively in

FIG. 4.13 Inscribed block statue, Egypt, Dynasties 25–26 (ca. 760–525 B.C.E.). Faience; 15.8 x 7.5 x 9.7. Freer Gallery of Art, Smithsonian Institution, Washington, D.C., gift of Charles Lang Freer (F1909.146).

FIG. 4.14 "Sculptor's model," depicting kneeling king offering pots of wine, Egypt, Dynasty 26 (664–525 B.C.E.) or later. Limestone; 18.9 x 16.5 x 3.9. Freer Gallery of Art, Smithsonian Institution, Washington, D.C., gift of Charles Lang Freer (F1909.142).

conjunction with other materials, often metal or wood. Colored glass inlays formed in molds adorned a variety of objects, including jewelry, furniture, and coffins. From the New Kingdom (ca. 1539–1075 B.C.E.) through the Roman period (30 B.C.E.–395 C.E.), for example, the eyes and brows of faces on coffins made of wood, plaster, and other materials were often inlaid in glass (see fig. 4.12). Inlays could also be made from mosaic glass, in which long rods of colored glass were heated and fused to create a multicolored image or design. The resulting cane (or mosaic cane) was then cut into a number of sections, each

bearing the same design, to form vessels or other objects. Dattari's collection was particularly rich in examples of mosaic glass and small inlays dating to the Ptolemaic period (305–30 B.C.E.) (fig. 4.16).[48]

But the crowning glories of Dattari's glass collection are the twenty vessels dating to Dynasty 18 (ca. 1539–1295 B.C.E.), an internationally distinguished group perhaps rivaled only by the examples housed in London's Victoria and Albert Museum (figs. 4.17–4.19; see also fig. 1.4).[49] The rich blues and blue-greens and lustrous surfaces that so attracted Freer were also prized by ancient Egyptian artisans, who sought to imitate in glass the colors and

FIG. 4.15 Pair of falcons, Egypt, Ptolemaic period (305–30 B.C.E.). Inscriptions on front of bases refer to the Greek deities Herakles and Aphrodite; allegedly found at Aboukir, near Alexandria, in the Nile Delta. Stone; 54.7 x 25.4 x 49.1; 57.1 x 26.6 x 54.1. Freer Gallery of Art, Smithsonian Institution, Washington, D.C., gift of Charles Lang Freer (F1909.141, F1909.140).

appearance of favored gemstones, particularly turquoise and lapis lazuli. The vessels were made by winding threads of molten glass around a core made of sand, clay, and mud. These small vessels were fashioned as containers for costly perfumed ointments, scented oils, and cosmetics. Comparison of these objects with vessels and fragments excavated from royal glass workshops suggests that many of the Freer examples were made during the reigns of the pharaohs Amenhotep III (ca. 1390–1353 B.C.E.) and Amenhotep IV, later called Akhenaten (ca. 1353–1335 B.C.E.). They may likewise be products of royal workshops.[50]

Two years later, citing straitened finances, Dattari sought Freer's advice on identifying an American purchaser for the remainder of his collection, with the exception of the coins. "Do you think that in America I might find purchasers better than Paris or London? If yes, may I ask you if you would mind to recommend my name to some of your friends or museums."[51] In May 1911, Freer had apparently been the victim of a stroke, and suffered periods of partial paralysis during the following months. A few weeks after Dattari's letter arrived, Freer replied. "I am sure that the articles you wish to sell will find a ready market in Paris or London, much better believe me than they would in America. I do not know of any private collectors in America of Egyptian art, except myself and at the present time I am all together too ill to look into the matter, all of which I sincerely regret." He listed as the American museums with collections of Egyptian art the Metropolitan Museum of Art, the Boston Museum of Fine Arts, the Field Museum in Chicago, "and a few minor museums, none of which have the necessary funds to purchase objects of the kind in your collection."[52] Dattari thanked Freer for his suggestions, reiterated his indecision about disposing of his collection, and promised that he would notify Freer if he should decide to sell. "Last year has been a good year for antiques and bankers," Dattari added, "but no pieces were very extraordinarily beautiful. Should I happen to see something really worth for your collection I will take it

FIG. 4.16 Inlays, Egypt. Apis bull, symbol of the creator god Ptah (Ptolemaic to early Roman period, ca. 200 B.C.E.–100 C.E.); ankh (sign of life) holding scepters (Ptolemaic period, 305–30 B.C.E.); female portrait (Ptolemaic to early Roman period, ca. 200 B.C.E.–100 C.E.); profile inlay of royal figure (New Kingdom, Dynasty 18, ca. 1539–1295 B.C.E.; profile inlay of jackal-headed god Anubis (New Kingdom, ca. 1539–1075 B.C.E.). Glass; 3.5 x 2.7 x 2.3; W1.4; H. 2.2; H. 7.0; 3.3 x 2.7. Freer Gallery of Art, Smithsonian Institution, Washington, D.C., gift of Charles Lang Freer (F1909.530a–b, F1909.441, F1909.496a, F1909.539, F1909.773).

BELOW, LEFT
FIG. 4.17 Vessel, Egypt, New Kingdom, Dynasty 18 (ca. 1539–1295 B.C.E.). Glass; 9.2 x 5.7 x 5.7. Freer Gallery of Art, Smithsonian Institution, Washington, D.C., gift of Charles Lang Freer (F1909.412).

BELOW, RIGHT
FIG. 4.18 Flask, Egypt, New Kingdom, Dynasty 18 (ca. 1539–1295 B.C.E.). Glass; 8.4 x 6.7 x 3.8. Freer Gallery of Art, Smithsonian Institution, Washington, D.C., gift of Charles Lang Freer (F1909.416).

and keep it at your disposal."[53] Either Dattari did not approach the museums Freer suggested or he did not find a buyer, for the rest of his collection was sold in the following year through Kelekian at the Hôtel Drouot in Paris: "The Egyptian things sold very cheap," Kelekian wrote to Percy Newberry.[54]

It seems curious that Freer did not mention to Dattari the avid Egyptian collecting of J. Pierpont Morgan, who habitually spent several weeks in Egypt during the winter accompanying the archaeological expedition Morgan sponsored for the Metropolitan Museum of Art, which was directed by curator Albert Lythgoe. Like Freer, Morgan had purchased a portion of the Byzantine "Gold Treasure" dispersed in Cairo in 1909, and Freer and Kelsey subsequently corresponded concerning Morgan's acquisition of Coptic

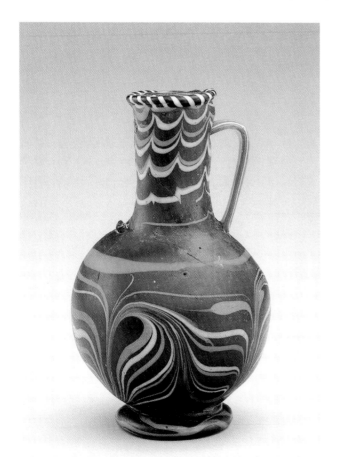
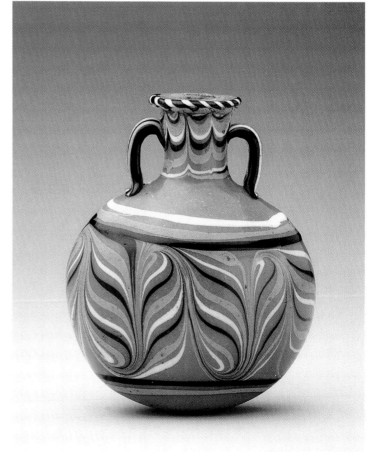

manuscripts. Morgan's curator, the extraordinary Belle da Costa Greene, exchanged letters with Freer on several occasions and accompanied the art critic Bernard Berenson and his wife Mary on their visit to Freer's home in 1914.[55] Perhaps Freer considered Morgan's collecting efforts to fall within the purview of his patronage of Lythgoe and the Metropolitan Museum of Art. But it appears a striking omission, since Freer himself was now in effect collecting for a future museum in Washington, D.C.

Freer made only a few acquisitions from Cairo dealers after 1909, usually with the assistance of intermediaries. In 1912, he purchased nine additional Coptic fragments, and in 1916 a fifth Greek manuscript, the text of the Minor Prophets, was bought by Dr. David L. Askren from Nahman. Askren was a missionary and physician who worked in the Fayum district south of Cairo during World War I, appointed by Kelsey to purchase antiquities on behalf of the University of Michigan. At the time Askren purchased the Minor Prophets for Freer, he also obtained Coptic manuscripts for the Pierpont Morgan Library, and the entire group of manuscripts remained in Cairo until 1920, victims of the perilous state of Mediterranean shipping brought about by World War I.[56] By 1916, the circumstances surrounding the market in antiquities had altered considerably since Freer's final visit in 1909. Regulations governing the sale of antiquities in Egypt had long been in effect, requiring authorized dealers to obtain official licenses and keep records of their stock, which were subject to inspection by members of the Antiquities Service. Although enforcement was not typically rigorous, antiquities for export were supposed to be approved by the museum in Cairo

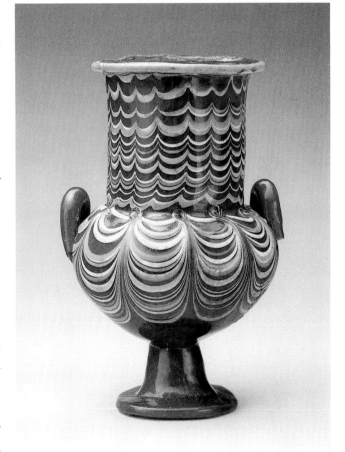

FIG. 4.19 Jar, Egypt, New Kingdom, Dynasty 18 (ca. 1539–1295 B.C.E.). Glass; 9.4 x 6.2 x 5.6. Freer Gallery of Art, Smithsonian Institution, Washington, D.C., gift of Charles Lang Freer (F1909.421).

and could be confiscated without any compensation to dealer or purchaser. Placards posted in numerous public places reminded tourists that the export of antiquities was forbidden.[57] On 1 July 1912, a new and more stringent antiquities law took effect, under which "antiquities" covered virtually every possible find. All dealers were now required to obtain a license, and the procedures governing export permits were more rigorously enforced.[58]

Although Freer complained repeatedly to Hecker about the difficulties he encountered with Egyptian merchants, his feelings were inconsistent and complex. "Business practices here are shocking," he declared on his first trip. However passionately he wanted to pursue certain objects, he found it difficult to overcome his disgust with local traditions of conducting business and impatience with the regulations governing antiquities export. "Now comes the great hurdle and how to get over it," he wrote to Hecker at the end of his first trip.

> *If my head and heart keeps bowing to the line and form of the dynasties 2nd, 3, 4, 5, 6, 12th, 18th, 19th, 20th, 21st and 25th and if one or more of these periods of Egyptian life produced the best art of the world according to my humble thinking, must I not secure for my collection a few specimens even if by lieing [sic] with Egyptian liars, making my hands and soul as dirty as theirs or die in the attempt—Query?*[59]

In the following year he wrote Hecker, "In dealing with these Eastern devils one's imagination is really stirred."[60] Years later, Freer observed to Francis Kelsey that

> *there seems to be some sort of microbe in all parts of Egypt that penetrates into the physical and mental machinery of every foreigner who attempts to collect Egyptian art. The earliest symptoms of the working of the microbe is the craze to get hold of the other fellows money and Dr.*

Askren, although a friend of yours, is, I fear, already suffering from the ravages of the microbe.[61]

Yet some tourists, at least, reported pleasant excursions to the Cairo shops of Joseph Cohen and E. Hatoun. Moreover, Freer seemed to find business practices "shocking" no matter where in Asia or Egypt he traveled.[62] Clearly, this was an aspect of his overseas collecting transactions that he never succeeded in resolving, either intellectually or emotionally.

Freer also complained bitterly about the difficulty he encountered in exporting his acquisitions at the end of his first trip to Egypt in January 1907. "It's a hellish place in which to do any business," he fumed in frustration over the bureaucratic hurdles.[63] "The red tape in this land surpasses that of all other countries. And as for getting antiquities out of Egypt, it's worse than getting oneself out of Hades."[64]

But purchasing antiquities in Egypt was also fraught with worries of a different kind for both novice and veteran collectors: an industry in forgeries already flourishing at the beginning of the twentieth century. In his *Forged Egyptian Antiquities*, published in 1912, T. G. Wakeling took it upon himself to make known the alarming situation regarding this industry. He described current forgeries in a wide range of media and forms, including gold ornaments, figurines of wood, alabaster, and faience ("porcelain"), scarabs, stone vessels, mummies and mummy cases, and even an entire forged tomb. In a chapter devoted to "The Makers and Sellers of Forged Antiquities," he identified regional specialties: "At Qus lives the maker of gold reproductions. Most of the wooden forgeries come from Gurna [Qurna] and the scarabs from Luxor. In the villages near to Deir-el-Bahari are made the porcelain [faience] vases and figures, whence come also the stone heads and statuettes. A number of composition figures are made in the Delta, and may be met with at Zagazig and Benha."[65] Wakeling alerted his readers to various methods by which he

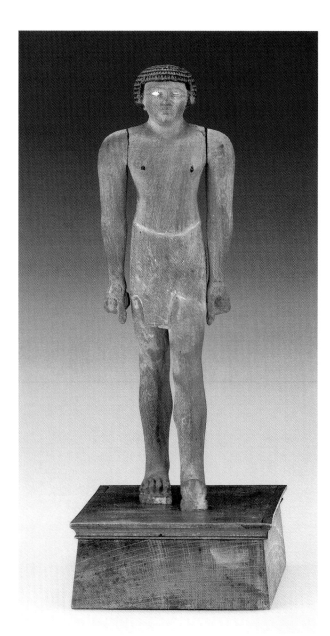

had learned to detect forgeries, and warned that the industry was even more widespread than his book suggested: "I have purposely refrained from describing the gold forgeries made and sold by Europeans in Egypt, preferring to keep entirely to the Egyptians and their work."[66] The thriving industry in forgeries, he insisted, resulted from the insatiable foreign demand for Egyptian antiquities: "It does not seem to occur to the general public that so great has been the demand for antiquities on the part of foreign museums, private collectors, and learned societies all over the world that the supply may threaten to give out; that the districts in which the relics lie are carefully watched; and that the Cairo museum is a jealous guardian."[67]

Like many of his contemporaries, Freer did not escape this pitfall, and his collection includes probable or certain fakes made in several different media. A wooden statuette, acquired in 1908, is highly questionable on grounds of both type and style (fig. 4.20). Purchased from Maurice Nahman, the statuette was attributed to Dynasty 11 (ca. 2081–1938 B.C.E.) and had reportedly been found at Asyut.[68] Certainly of recent manufacture is a turquoise glazed bowl imitating the popular category of New Kingdom faience bowls decorated in black with images and inscriptions associated with the goddess Hathor (fig. 4.21; compare fig. 2.18). A thermoluminescence test conducted in 1995 determined that the bowl had been fired approximately one hundred fifty years earlier, perhaps not many decades before Freer purchased it early in 1907.[69] Freer bought several other intact or fragmentary examples of this type, and subsequently came to suspect that some—although not this one—were not genuine. A stone head and bust of a

female figure, purchased in Qena from Tanios Girgis in January 1907, leaves little room for doubt (fig. 4.22). In a letter to Girgis acknowledging its arrival in Detroit several months later, Freer reiterated his satisfaction with this purchase: "The more I see of the object the better it appears," he wrote.[70]

Pleased as he professed himself to be with his Egyptian acquisitions, one sought-after collection eluded Freer entirely. In May 1908, he visited on two occasions the collection of Mrs. Constantin Sinadino, one of the prosperous Greek families of Alexandria.[71] Freer understood that the owners were willing to sell works from the collection. Although he was attracted by only a few objects, his repeated references suggest that he was desperately eager to buy them. Apparently, however, he was abruptly refused; as Freer bitterly poured out his frustration to Hecker, it was now the Greeks' turn to be condemned as vile traders:

FIG. 4.21 Bowl, modern forgery. Earthenware with glaze and paint; 4.3 x 17.3. Freer Gallery of Art, Smithsonian Institution, Washington, D.C., gift of Charles Lang Freer (F1907.14).

. . . yesterday, I had my hands upon one of the great prizes of the whole world of pottery and another of bronze equally wonderful—owned by a wealthy Greek family and in the finest private collection in Egypt. But it was all too sudden, too great! My desire must have been apparent to the wise Greeks . . . for one hour they were practically mine, and the next hour millions would seemingly not be considered by the Greeks. You see, my wishing had been too hurried and not deep enough! No museums in the world can match these two pieces! I shall wish and wait!!! The Greeks beat the Japs as traders![72]

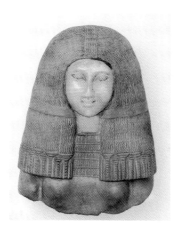

FIG. 4.22 Head of female, modern forgery. Stone; 17.3 x 13.2 x 8.6. Purchased by Freer from Tanios Girgis, January 1907. Freer Gallery of Art, Smithsonian Institution, Washington, D.C., gift of Charles Lang Freer (F1907.6).

From Freer's pen, this was a serious charge. In the summer of 1909, Freer made another attempt, already establishing in June, while in London, that the Sinadino collection would again be offered to him.[73] "Day after tomorrow, I shall reach Cairo," he wrote Hecker en route from Bremen,

and there awaits selections made for me from the famous Sinadino Collection—the very best private one in Egypt—now being dispersed. I saw the whole collection intact last year and selected and purchased a number of its masterpieces—but when the matter of parting with the things came up—the sons of the mother-owner objected, and I had to go on empty handed. This year, I am told delivery for cash, will surely happen if prices can be mutually agreed upon. What a temptation!!![74]

But once again Freer met with defeat. A few days later, he informed Hecker that the collection had again been withdrawn from the market for the remainder of the year and speculated cynically on the family's motives: "I fancy that with true Oriental genius, they are encouraging experts and collectors to come here in expectation of securing a few of the treasures, while in fact, their actual motive is to thoroughly advertise the collection, in advance of some great public sale hereafter in Paris or London." By this time, however, he was apparently resigned to the loss: "It is very amusing nevertheless, and in a way instructive."[75]

What were these treasures that repeatedly slipped from Freer's grasp? Although no detailed description appears to have survived, the summary list prepared for the March 1936 sale of Mrs. Constantin Sinadino's collection hints intriguingly at what Freer coveted.[76] Over twenty lots consisted of metal figurines depicting Horus, Isis, and other Egyptian deities, seven made of silver and the rest of bronze. Other lots included terracotta statuettes and a small marble head, all Ptolemaic or Roman; glass, both ancient and medieval;

Egyptian faience vessels and amulets; and a sizable collection of jewelry of pharaonic, Roman, Byzantine, and later date. If there were exceptional objects in the Sinadino collection, they seem to have disappeared from the collective memories of Egyptologists and specialists in the arts of Islamic Egypt. But Freer clearly thought he lost a rare opportunity to obtain choice objects. We can sympathize with his keen disappointment.

"Those Who Have the Power to See Beauty"

Freer's final trip to Egypt in 1909 by no means concluded his involvement with matters Egyptian. In the ten years before his death in 1919, he purchased Egyptian antiquities on several occasions and continued to support study and publication of the Greek and Coptic manuscripts acquired in Cairo. He also perused his holdings periodically, both to improve his understanding of their correct identification and to assess their contribution to the harmonious whole that comprised his collection. And he began to formulate ideas for their display in the museum that would bear his name.

Beginning early in 1908, Freer devoted considerable attention to the ambitious program of research and publication that he and Francis Kelsey had devised for the Greek and Coptic manuscripts and fragments initially acquired in 1906 and 1908. Freer purchased Frederic G. Kenyon's *Our Bible and the Ancient Manuscripts* (1898) and Bernard P. Grenfell's *Fayum Towns and Their Papyri* (1900), which offered up-to-date accounts of research. Kelsey energetically recruited specialists to study and publish the material, initially in facsimile form and subsequently in scholarly monographs that appeared in the University of Michigan's Humanistic Series; Freer underwrote their research as well as the costs of publication. Thanks to Kelsey's capable efforts, Professor

FIG. 5.1 Jar with wide mouth, perhaps a klepsydra (water clock), Egypt, Roman Imperial period (ca. 100–200 C.E.). Faience (glazed composition); 22.9 x 26.9. Freer Gallery of Art, Smithsonian Institution, Washington, D.C., gift of Charles Lang Freer (F1909.134).

Henry A. Sanders completed facsimile editions of the Washington Manuscripts of Deuteronomy and Joshua, and of the Gospels, which were published in 1910 and 1912 together with scholarly commentaries on the texts. Sanders went on to complete his studies of the manuscripts of the Psalms and the Epistles of Paul, which appeared in 1917 and 1918. Freer's diary reveals that Sanders was a frequent guest at the collector's home in Detroit to pursue research on the manuscripts. William H. Worrell (1879–1952), a young specialist in Semitic languages appointed to the University of Michigan faculty, was charged with publishing the Coptic manuscripts and fragments.

Through a lively correspondence as well as occasional visits and telephone calls between Detroit and Ann Arbor, Kelsey consulted Freer on every aspect of the project: the selection of authors, plans for research and publication, and details of book design and photographic reproduction. Freer responded promptly and with equally meticulous attention to detail. When Kelsey sent Freer a sample of the Coptic font that would be used in Worrell's publication, Freer replied that it seemed to him "very artistic," having the quality of "'*Notan*,' a Japanese term expressing light and dark. I am sure the forthcoming publication will be admired by all who have a chance to study it, especially those who have the power to see beauty."[1] Freer's replies were invariably thoughtful and gracious, and he extended extraordinary courtesy and generosity to the young scholars who undertook the research and publication. When Sanders and Worrell traveled to Egypt and Syria, Freer provided advice on hotels and other practical matters and wrote letters of introduction to dealers and consular officials with whom he had established relationships on his own journeys. In response to a request from Kelsey, Freer supported Worrell's research travels in Egypt and the Levant and more than once expressed solicitude for the young scholar's well-being. In warmly avuncular fashion, Freer offered to obtain for him a specially outfitted medicine case similar to one made for Freer himself.[2] In turn, the young scholars visited dealers to examine

potential acquisitions of Greek and Coptic works and, with Freer's consent, occasionally made purchases on the collector's behalf. Freer acknowledged that his ignorance of ancient languages left him completely at the mercy of antiquities dealers. "You see I am at a great disadvantage! When Ali [Arabi] pulls from his cellar floor a ms in Coptic and calls it demotic or something else I am sitting in hot soup because I don't know the difference," Freer wrote to Kelsey.[3] In 1913, Sanders bought a fragment of a Coptic Psalter from the Cairo dealer Maurice Nahman.[4] The second part of Worrell's publication of the Coptic texts appeared in 1923, the year the Freer Gallery of Art opened its doors in Washington, D.C.

Freer and Kelsey also exchanged letters concerning the "Gold Treasure," the cache of Byzantine precious metalwork acquired from Nahman in 1909 on Walter Dennison's recommendation (see fig. 1.3). Freer owned nine objects, about one quarter of what was allegedly an original total of thirty-six items. The remainder had been dispersed to private collectors in the United States, Great Britain, and Germany: J. Pierpont Morgan, Mrs. Walter Burns, and Friedrich von Gans. Dennison, a professor of Latin at the University of Michigan, pursued his study of these artifacts for publication in the Michigan Humanistic Series. The multiple ownership of the "treasure" required Dennison, Freer, and Kelsey to coordinate plans for research and photography with the other collectors and their curators, and, to complicate matters still further, the objects changed hands on more than one occasion. In 1916, Mrs. Burns's portion was given to the British Museum, London. Morgan's share was later presented to New York's Metropolitan Museum of Art, and those belonging to von Gans went to the Emperor Frederick's museum, now the Staatliche Museen in Berlin.[5]

Other circumstances also slowed Dennison's progress on the publication. A more cautious climate regarding the acquisition of antiquities now prevailed in Egypt, which resulted from large-scale buying by foreigners and

more stringent restrictions on the trade that had gone into effect on 1 July 1912. New pressures to enforce the regulations were evidently felt by Gaston Maspero, the French Egyptologist who served as director of the Egyptian Antiquities Service. Kelsey notified Freer in 1913 that Albert Lythgoe, head of the Egyptian Department at the Metropolitan Museum of Art, had advised Dennison "to put off the publication of the gold treasure a little on account of the cloud that has fallen on Maspero in Egypt; that the publication of so valuable and unique a collection of rich objects would show that Maspero had been negligent in allowing it to be exported from the country."[6] Dennison completed the manuscript shortly before his premature death from pneumonia, at the age of forty-eight. *A Gold Treasure of the Late Roman Period* appeared in the following year, joining Sanders's volumes devoted to the Washington Manuscripts and Worrell's *Coptic Psalter* already published in the same series. Meanwhile, Charles R. Morey had completed his study of Byzantine paintings bought in Cairo in 1909, which appeared in 1914 as *East Christian Paintings in the Freer Collection*. After Freer's death, Kelsey continued his able stewardship of the publication of the Greek and Coptic manuscripts. The final volume was published in 1927, the year of Kelsey's death.

Freer himself was also hard at work, diligently pursuing the self-imposed task of classifying his collections. He combed meticulously through scores of fragments labeled "Egyptian pottery," attempting to identify and date each one. Inventories prepared for the transfer of objects to the Smithsonian Institution reproduce the information he had obtained from dealers at the time of acquisition, including alleged provenance and attribution. To assist in his research he added many new books to his library, including general reference works and detailed excavation reports on individual sites and monuments. The roster of titles attests to his determination and industriousness. General treatments of history, art, and culture included L. W. King and H. R. Hall's *Egypt and Western Asia in the Light of Recent Discoveries* (1907), W. M.

Flinders Petrie's *The Religion of Ancient Egypt* (1908), and Gaston Maspero's *Art in Egypt* (1912). Freer also obtained many of the Egypt Exploration Fund's publications of surveys and excavations; among these were Flinders Petrie's three-volume publication of the fund's excavations at Abydos (1902–04), along with his *Royal Tombs of the First Dynasty* (1900); T. Eric Peet's *The Cemeteries of Abydos* I–III (1913–14); Édouard Naville's *Temple of Deir El-Bahari*, I–III and V (1907, 1910, and 1913); Norman de G. Davies's *The Rock Tombs of El Amarna* (1908); and Edward R. Ayrton and W.L.S. Loat's *Pre-Dynastic Cemetery at El Mahasna* (1911). In addition, Freer received the fund's annual archaeological report every year from 1904 through 1912. Freer continued to prepare lists of the objects that would eventually be transferred to the Smithsonian Institution, adding comments as he periodically reviewed his holdings in the light of new acquisitions.

Whistler's Peacock Room was an early setting for the display of Egyptian antiquities and biblical manuscripts, along with other objects from Freer's collection. Freer had purchased the Peacock Room in 1904 and installed it at his house in Detroit. Photographs taken in 1908 and 1909 show that Freer placed on the shelves lining the walls of the room vessels made of bronze and ceramic representing diverse cultural regions, including Egypt. In November 1912, in an exhibition at Freer's house, the Peacock Room's shelves housed "ancient potteries from Egypt, Persia, Mesopotamia, China, Corea [Korea] and Japan"; a glass case in the room contained two of the Washington Manuscripts, those of Deuteronomy and Joshua and of the Gospels, the latter "with wood covers belonging thereto" (see fig. 1.2).[7] In 1910, the University of Michigan hosted a loan exhibition drawn from Freer's collection to celebrate the opening of the university's Alumni Memorial Hall. The exhibition included Japanese screens and lacquer, Chinese paintings, American paintings, and Japanese and Mesopotamian pottery, and was accompanied by a catalogue, which drew for its text on contributions from eminent scholars of Chinese and Japanese art.

This elaborately installed show attracted an impressive number of visitors: Kelsey wrote Freer that daily attendance averaged about twelve hundred.[8] In 1912, a much larger exhibition surveying Freer's collection was held at the Smithsonian Institution from mid-April to mid-June. By now Freer's holdings numbered over seven thousand objects, more than triple the size of the gift accepted by the Smithsonian in 1906. Berthold Laufer, a curator at the Field Museum in Chicago and the foremost authority on Chinese jades, assembled the catalogue for the display that included Japanese and Chinese paintings, Chinese bronzes, Persian and Mughal paintings, and Chinese, Korean, Persian, and Mesopotamian ceramics. Although the ceramic display seems not to have included any of his Egyptian examples, seven pieces of ancient Egyptian glass were shown in a separate case.[9] Only thirty-five of the one hundred seventy-five works in the exhibition were American paintings, yet they were among its most popular attractions. "The crowd in front of the Whistlers was in places so thick that it was difficult to get a good view," Kelsey informed Freer. "There were fewer people on the opposite side—I don't believe the Washingtonians have had much Oriental Art here."[10]

If many visitors to the Smithsonian exhibition failed to appreciate fully the aesthetic correspondences linking these works of Asian and American art, Freer was determined that the permanent display in Washington would allow "those who have the power to see beauty" to do precisely that. From 1909 onward, he was deeply engaged with the design of the new museum in Washington, for which Charles Adams Platt (1861–1933) was eventually chosen as architect. Trained in Paris as an artist, Platt's experience in designing buildings was almost exclusively confined to summer residences; he showed a special talent for Italianate villas with splendid vistas. By the time Freer turned his attention to the Washington building, he and Platt had been acquainted for more than a dozen years. They initially met through a mutual interest in Italian villas and gardens, a subject on which Platt was extremely

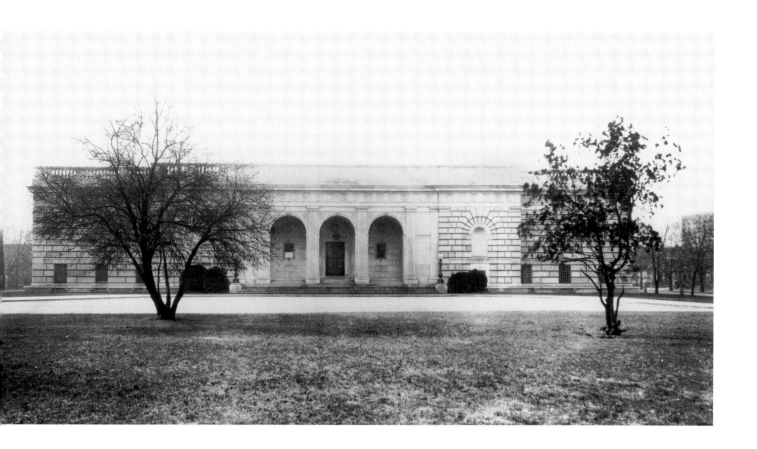

FIG. 5.2 The Freer Gallery of Art,
ca. 1923. Freer Gallery of Art
Building Records, Freer Gallery of
Art and Arthur M. Sackler Gallery
Archives, Smithsonian Institution,
Washington, D.C.

knowledgeable. Over the years, the two had worked together on several proj-
ects involving landscape and garden design. In October 1912, Freer sought
Platt's advice on plans for the new museum; early in the next year, he was pre-
sented with a design for a building in Italian Renaissance style. Pleased with
Platt's initial suggestions, Freer brought him to Detroit to view the collections,
and by December Platt had prepared an elevation that included several fea-
tures retained in the final design: a triple-arched portico, a high basement, and
a balustraded parapet (fig. 5.2).[11]

From the outset, Freer intended for the new edifice to be furnished
with spaces set aside for study, for he believed firmly that the museum should
show "special regard for the convenience of students and others desirous of an
opportunity for uninterrupted study."[12] One favored plan consisted of a central
block of galleries for American art flanked by outer wings for the Chinese and
Japanese collections, the three units connected by a long corridor lined with

cases of ceramics. A sketch Freer made around 1912 of one variation on this plan shows study rooms located adjacent to galleries devoted to Thayer, Dewing, Tryon, and the "miscellaneous" American artists represented by only one or two paintings, such as Winslow Homer, John Singer Sargent, and others (fig. 5.3). The study rooms were clearly distinguished from storage rooms, for which provision was made alongside the blocks of galleries reserved for Japanese and Chinese art. Freer and Platt eventually settled on a two-story building housing exhibition galleries on the first floor and study and storage rooms below. Later, in 1915, when a different site on the Mall was chosen for the building, Platt revised his plans to suit the smaller space and incorporated changes Freer wished to make. Among other alterations, Freer asked that the study rooms be made "more important, and possibly better lighted."[13] A plan of the galleries dating around 1916 indicates that Freer envisaged a separate gallery for Persian and Egyptian art—one for each, of equal dimensions (fig. 5.4).

Around 1911, Freer's annotated inventories began to distinguish a group of objects intended specifically for study, an important role for the ancient Egyptian collections in particular. This new category seems to have evolved

FIG. 5.3 Sketch by Charles Lang Freer of a proposed floor plan for the Washington building, ca. 1912. Charles Lang Freer Papers, Freer Gallery of Art Archives, Smithsonian Institution, Washington, D.C.

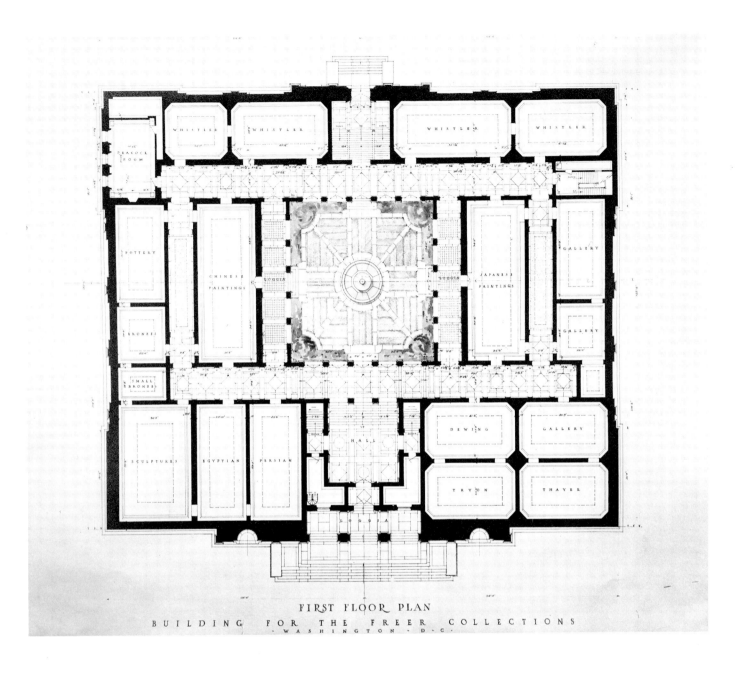

FIRST FLOOR PLAN
BUILDING FOR THE FREER COLLECTIONS
· WASHINGTON · D·C ·

from the repeated process of "weeding and improving" his collection, first undertaken in 1906. Through the practice of assigning a separate accession number to each object, modern museum registration methods have inadvertently homogenized what Freer understood as a range of function and significance among the works comprising the Egyptian collection. His handwritten comments on dated inventories prepared for the Smithsonian Institution

FIG. 5.4 Plan for first floor, "Building for the Freer Collections," ca. 1916. Freer Gallery of Art Building Records, Freer Gallery of Art and Arthur M. Sackler Gallery Archives, Smithsonian Institution, Washington, D.C.

FIG. 5.5 Reconstruction of Freer's proposed arrangement for a case of amulets, small sculptures, and vessel fragments, Egypt, New Kingdom (ca. 1539–1075 B.C.E.) through Roman period (30 B.C.E.–395 C.E.). Faience (glazed composition); height of tallest object 15.8. Freer Gallery of Art, Smithsonian Institution, Washington, D.C., gift of Charles Lang Freer (F1908.73, F1908.87, F1908.85, F1907.163, F1907.21, F1907.30, F1909.146, F1908.108, F1908.70, F1907.162, F1908.107, F1908.88, F1908.103).

richly document the evolution of his thinking as he periodically revised his holdings, keeping in mind the entire collection as a tightly integrated whole. With each new set of purchases, it seems, he reviewed earlier acquisitions and reconsidered their proper labeling, thoughtfully appraising the significance of many Egyptian objects and their appropriate location and context in the museum. "Interesting. Exhibit in case," he wrote of the painted wooden shrine

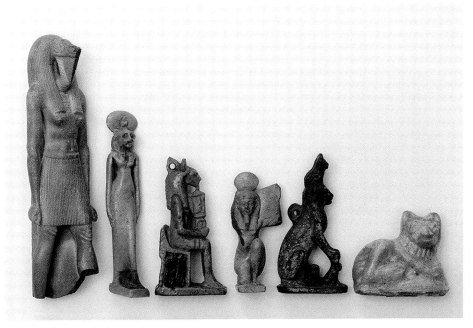

housing a gilded wooden figurine (see figs. 4.3 and 4.4). "Unusually large spec-imen," he commented with regard to a turquoise glazed jar; "Exhibit in indi-vidual case, C" (see fig. 5.1, page 120). Freer also experimented with larger groupings of objects, specifying their precise arrangement in display cases. One detailed set of notations establishes that he and his close friend and advisor, Katherine Nash Rhoades, tried out the proposed configuration in November

IMAGES ACROSS BOTTOM
OF THE PAGE

FIG. 5.6 Reconstruction of Freer's proposed arrangement for a case of Egyptian amulets, small contain-ers, and vessel fragments, case floor, Egypt, New Kingdom (ca. 1539–1075 B.C.E.) through Roman period (30 B.C.E.–395 C.E.) and modern forgery (F1907.153). Faience (glazed composition); height of tallest object 16.7. Freer Gallery of Art, Smithsonian Institution, Washington, D.C., gift of Charles Lang Freer (F1908.98, F1908.94, F1908.95, F1908.102, F1907.29, F1907.152, F1908.79, F1907.153, F1907.10, F1908.81, F1907.28, F1908.86, F1908.101, F1907.13).

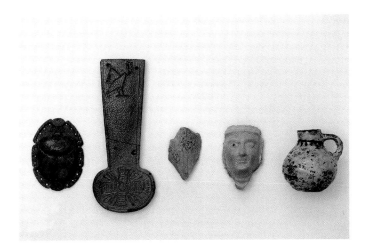

1918. It consisted of two rows of objects, one on a shelf and the other on the floor of the case. In the center of the upper row was the block statue purchased in 1909 (see fig. 4.13); it was flanked by faience amulets depicting Egyptian deities, including Anubis, Taweret, Sakhmet, Thoth, and Horus (fig. 5.5). In the row on the case floor, a faience tile depicting the goddess Hathor occupied the center; it was likewise flanked by amulets representing other deities and by small vessels or fragments of vessels made of faience (fig. 5.6).

Other objects were designated "study only," or "for study room," which Freer apparently envisaged in the form of group displays. "For study but not for individual case exhibition," he wrote of a two-handled jar with dark green-blue glaze (fig. 5.7). "Greek and Roman influence simply expressed. For study room only," he commented on a fragmentary turquoise glazed statuette depicting a form of Aphrodite (fig. 5.8). Freer also began to doubt the authenticity of some of his Egyptian possessions, as he did certain objects from other areas of the collection. Several items in the pottery list bear handwritten comments such as "consult expert," "note poor quality of glaze," and "dubious." Other artifacts, while considered authentic, apparently struck him as either too fragmentary or not sufficiently important to display in the main gallery. A glazed bowl fragment was judged "a genuine specimen of early ware but too much broken to exhibit in gallery. Keep for study." A handsome rim fragment of a bowl with painted decoration, he concluded, was "a genuine fragment of a fine example, but not important enough to exhibit in gallery. For students only." The inventory dated May 1917 adds to the study list over one hundred objects—chiefly tiny faience amulets and vessel fragments—not designated as such six years earlier. Still other objects were given away, to friends, relatives, schools, and museums. Three terracotta female figures labeled "Grecian" or "in Grecian costume," probably examples of the popular Tanagra figurines of Hellenistic date, were given to the children of his curator, Stephen J. Warring, in August 1912.

FIG. 5.7 Jar, Egypt, Roman Imperial period (ca. 100–200 C.E.). Faience (glazed composition); 24.7 x 18.8. Freer Gallery of Art, Smithsonian Institution, Washington, D.C., gift of Charles Lang Freer (F1907.280).

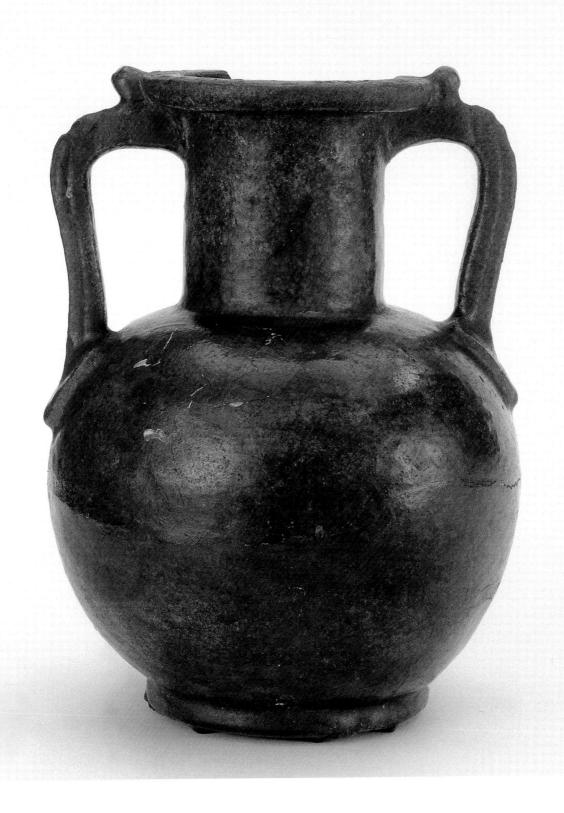

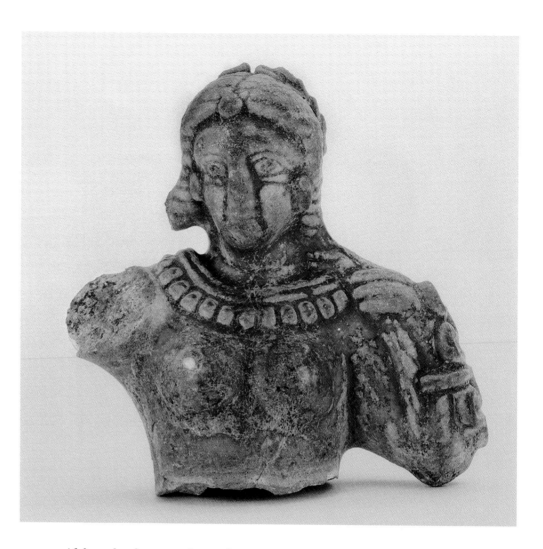

FIG. 5.8 Figurine of the Aphrodite Anadyomene type, fragmentary, Egypt, Roman Imperial period (ca. 100–200 C.E.). Faience (glazed composition); 10.2 x 10.3 x 4.9. Freer Gallery of Art, Smithsonian Institution, Washington, D.C., gift of Charles Lang Freer (F1908.104).

Although the creation of a separate study category might imply a hierarchy among the objects, Freer did not conceive of his collection as divisible. For him it was an integral unit, and this principle governed his thinking about every object he contemplated for acquisition. "I regard my collections as constituting a harmonious whole," he had written to Secretary Samuel P. Langley during discussions of his proposed gift to the Smithsonian Institution. "They are not made up of isolated objects, each object having an individual merit only, but they constitute in a sense a connected series, each having a bearing upon the others that precede or that follow it in point of time."[14] At the center of the enterprise was James McNeill Whistler, the artist whose work Freer regarded as universal.

In January 1904, when the Peacock Room purchase was under consideration, Freer wrote the art dealer Gustav Mayer of his conviction that the universality of Whistler's work would become widely acknowledged when the "intelligent few" would be able to compare certain of Whistler's paintings and prints with "the best specimens of Babylonian pottery, Greek and Egyptian sculpture and the paintings of the masters of the Sung [Song] period."[15]

Many of Freer's contemporaries in the world of artists, scholars, and collectors likewise perceived aesthetic connections among the arts of civilizations far removed from one another in space and time. The art critic Bernard Berenson compared a painting by the French Impressionist master Édouard Manet with Egyptian sculptures of the Old Kingdom. "This portrait of his mother by Manet is a colossal thing," Berenson wrote to Isabella Stewart Gardner, referring to the artist's *Madame Auguste Manet.* "It partakes of the directness of the 'Schoolmaster of Boulak' or the 'Scribe of the Louvre,' and other grand things of early Egyptian dynasties."[16] Conceivably, of course, Manet was well acquainted with the Louvre's key holdings of Egyptian sculpture, but such aesthetic affinities were recognized in works linked to masterpieces their artists could not possibly have known. According to Edmond de Goncourt, one of the leading figures in the late-nineteenth-century Paris circle of collectors and critics, all arts—Eastern and Western, fine and decorative—were related and should be classified, in Siegfried Bing's words, "not according to local schools but according to affinities of sentiment."[17]

One scholar who most clearly articulated these relationships was Ernest Francisco Fenollosa (1853–1908), the eminent American expert on Buddhism and Buddhist art. For nearly a decade, Freer had profited greatly from his ongoing friendship with the Boston scholar, who periodically reviewed Freer's acquisitions, especially in the field of Japanese art. In November 1907, Fenollosa again visited Freer in Detroit to examine the latest purchases and assess the collection as a whole. Fenollosa subsequently published an essay

reaffirming Whistler's central significance and effectively stating the collector's guiding principles. Freer had earlier introduced Fenollosa to Whistler's work in February 1903, only a few months before the artist's death. Later the same year, Fenollosa published an appreciation of the artist's unique contribution and introduced the metaphor of glazed ceramics in describing Whistler's art. Fenollosa concluded that in "deliberately yielding himself for a time into the Japanese spirit, Whistler was throwing himself into the universal current, in making his individual feeling the sole test of his constructive schemes, reaching new power in dramatic moment and poignancy of line, in subtle contrapuntal marshalling of his silvery grays, and in cooler and more normal ranges of color harmony, like translucent films of glaze in pottery."[18]

In his article on Freer's collection written in 1907, Fenollosa drew on the same metaphor, remarking on "the kinship between Whistler's painting, and warmly glazed ceramics."[19] Alvin Langdon Coburn's photograph depicting Freer, a Syrian glazed jar, and Whistler's painting titled *Venus Rising from the Sea* (ca. 1869–70) illustrates precisely this set of relationships (see fig. 2.11). Writing in January 1907, the art critic Leila Mechlin discerned a similar set of correspondences, commenting that certain of Whistler's canvases looked as though they had been "dipped, like a piece of pottery, in translucent glaze" (fig. 5.9).[20]

Egypt, too, could furnish examples of aesthetically harmonious works. In October 1908, the Cairo dealer Nahman sent Freer photographs of six Egyptian painted portraits to consider for purchase. These were examples of the "Fayum" portraits dating to the Roman Imperial period, which began to appear in large numbers on the antiquities market in the late nineteenth century. The Fayum, a region south of Cairo, had yielded hundreds of these works through Flinders Petrie's excavations at Hawara and illicit digging.[21] Although Freer decided not to purchase any of them, he expressed his desire to make his collection consist of examples of early Chinese and Japanese painting, together

FIG. 5.9 James McNeill Whistler (1834–1903), *Venus Rising from the Sea*, ca. 1869–70. Oil on canvas; 59.8 x 49.1. Freer Gallery of Art, Smithsonian Institution, Washington, D.C., gift of Charles Lang Freer (F1903.174).

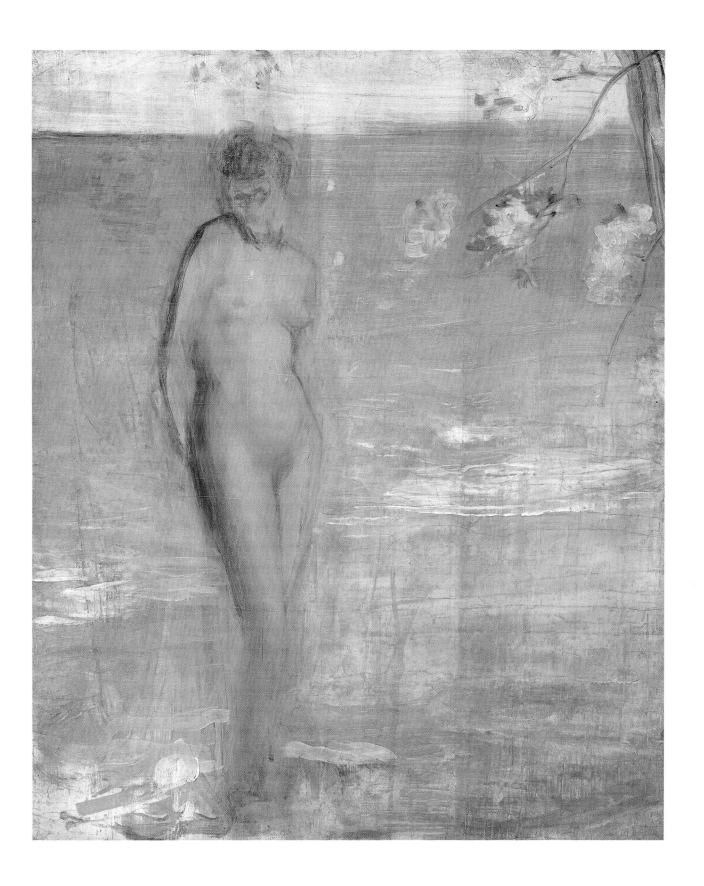

with the work of four modern American painters. "All of these pictures are related, by reason of certain harmony of composition, color and other technical qualities," he replied to Nahman. In Freer's opinion, the Egyptian portraits were not related closely enough to warrant acquiring more than one example, but he acknowledged them "as objects of rare importance" and "if kept together they will afford students a rare opportunity to compare them with other similar specimens extant." Freer singled out as "the most interesting technically" a portrait of a man, which seemed to him "more truly in sympathy with the great portraits of the early Chinese masters, than either of the other five."[22] In the following year, Albert Lythgoe purchased the six paintings for the Metropolitan Museum of Art. The one that most appealed to Freer is probably the portrait of a young man (fig. 5.10).[23] The "harmonious" Chinese portraits Freer had in mind were works such as the Song dynasty portraits preserved in the album *Five Old Men of Suiyang* (fig. 5.11). Freer was offered this painting in 1916, along with the other four that comprised the original album; forty years later, two were purchased by the Freer Gallery of Art.[24] Coburn's other portrait of Freer joins written testimony for the connections Freer perceived among the arts of ancient Egypt, Greece, and Whistler (see fig. 1.1). On more than one occasion, Freer linked the works of Whistler with ancient Greek and Egyptian art, discerning in the artist's late work "a certain dignity, amounting almost to solemnity, that keeps one while in its presence constantly reminded of the efforts of the early Greeks and Egyptians."[25] But Freer was also concerned with origins and influences, with beauty and chronology, and he comprehended Egyptian art as the source from which Greek art took root. "So far as Greece goes, that blessed land, so famous for its art, owes everything in beauty to Egypt," he wrote to Hecker early in 1907.[26] In Coburn's portrait, significantly, Egyptian art is represented not by glazed ceramics, but by works of sculpture, which Freer prized, yet which largely eluded him during the most intense period of his quest. Moreover, Freer thought the bronze

FIG. 5.10 Portrait of a young man, Egypt, probably from Akmim, Roman Imperial Period (ca. 100–200 C.E.). Encaustic on lime-wood; 39.4 x 19.3. The Metropolitan Museum of Art, Rogers Fund, 1909 (09.181.2). Photograph © 1998 The Metropolitan Museum of Art.

figurine of Anubis dated to Dynasty 4 (ca. 2625–2500 B.C.E.), the era of the Giza pyramids, which would have made it the oldest of his Egyptian holdings. Freer's ideas about the debt ancient Greek art owed to Egypt were also shaped by the opinions of Egyptologist James Henry Breasted, whose *History of Egypt* (1905) had been Freer's close companion during his travels in the winter of 1906 to 1907. Freer had marked several passages in which Breasted argued for the chronological priority, and sometimes the superiority, of Egyptian artistic and cultural achievements over those of classical Greece. Drawing attention to the sensitive and refined quality of private tomb carvings of Dynasty 18 (ca. 1539–1295 B.C.E.), Breasted observed that one example exhibited "that interpretation of life and appreciation of individual traits (often supposed to have arisen first among the sculptors of Greece), in which art finds its highest expression."[27] Considered in conjunction with Freer's own writings, Coburn's portrait therefore seems to express Freer's view that Whistler was heir to ancient Egypt, "the greatest art in the world," from which ancient Greek art had likewise descended.

駕部郎中致仕馮平八十七歲

In 1918, Freer purchased a painting titled *The White Lilacs: Portrait of the Robert Follett Gerrish House in Kittery Point, Maine* from the artist, American Willard L. Metcalf (fig. 5.12). Acknowledging the painting's safe arrival in Detroit, Freer took delight in informing Metcalf that the work was "now standing in one of our galleries in the midst of Egyptian, Mesopotamian and Chinese art objects which are under inspection, and it seems perfectly at home in the midst of old time influences and I wish that you were here to enjoy its beauty and to feel its relationship to Far Eastern productions."[28] If any Egyptian objects were "under inspection" in 1918, Freer declined to keep them. His final Egyptian acquisition was a fragmentary painted limestone relief dating to the Ptolemaic period (305–30 B.C.E.), which he purchased from Dikran Kelekian in 1916.[29] Yet Freer's words to Metcalf express perfectly his most cherished aspiration for visitors to his future museum.

In the end, Freer's wish to acquire for his collection examples of Egyptian sculpture in stone and wood, "the greatest art in the world," remained unfulfilled. His efforts in Egypt had been aborted by his failure to obtain selections from the Sinadino collection and his impatience with the "shocking" business practices of collectors and merchants in Cairo and Alexandria. After his last trip in 1909, a few offers came his way from other sources. In 1910, the Paris dealer Marcel Bing, the son of Freer's old friend Siegfried Bing, sent Freer a photograph of an Egyptian stone head, which had reportedly been owned by the collector Giovanni Dattari.[30] Freer declined to pursue it; nor, apparently, did he attempt to bid on any objects in the London auctions of two distinguished private collections, those of F. G. Hilton Price and Lady Meux, in 1911. Perhaps, as he had written to Dattari around the time the sales were held, his illness prevented his attention to these concerns. In theory, Freer also had the option of buying directly from Cairo dealers, as he had previously done. World War I effectively prevented the shipping of objects from Egyptian ports, however, and perhaps he found it easier for other reasons

FIG. 5.11 *Portrait of Feng Ping,* China, Northern Song dynasty (960–1127). Album leaf; color and ink on silk; 39.9 x 32.7. Freer Gallery of Art, Smithsonian Institution, Washington, D.C., purchase (F1948.11).

to rely on suppliers in the United States and Europe. Only a few years after Freer's death, many important Egyptian sculptures and other antiquities were sold at auction, as many private collections were dispersed in the troubled period following World War I. Between 1919 and 1923, London and Paris witnessed the sales of the Amherst, MacGregor, Berens, and Fouquet collections, among others, several of which Freer had known firsthand. These sales would lavishly benefit the Egyptian collections at the Walters Art Gallery (now Museum) in Baltimore, the Brooklyn Museum of Art, and those in other American cities.[31]

Given Freer's passionate convictions, it seems altogether fitting that the only work of ancient Egyptian art purchased by the Freer Gallery of Art since its founding is a life-size stone head of a pharaoh (fig. 5.13). This work is usually

dated to the latter part of the Old Kingdom (ca. 2675–2130 B.C.E.) and often specifically assigned to Dynasty 6 (ca. 2350–2170 B.C.E.).[32] The sculpture was acquired in 1938 from Marguerite Mallon, wife of the Paris-based collector and dealer Paul Mallon (1884–1975). Gaston Migeon, Freer's longtime colleague and friend, had published Mallon's collection of Chinese and Egyptian sculpture in 1912, and Freer himself corresponded briefly with Mallon in 1914 about an ancient Chinese bronze vessel the dealer had offered for sale.[33]

Many specialists would rank the Freer head among the most important works of Old Kingdom royal sculpture in North America. It forms a worthy addition to the collection Freer explicitly envisaged, in which the "intelligent few" would be able to compare certain of Whistler's paintings and prints with "the best specimens of Babylonian pottery, Greek and Egyptian sculpture and the paintings of the masters of the Sung [Song] period." Older, perhaps, than any Egyptian object acquired by Freer himself, this imposing royal portrait would surely have reminded the collector of the great monuments of ancient Egypt that so impressed him in their native land.

CHRONOLOGY OF EGYPTIAN HISTORY

Predynastic Period	(to ca. 3100 B.C.E.)
Dynasty "0"	(ca. 3100–3000 B.C.E.)
Early Dynastic Period	(ca. 3000–2675 B.C.E.)
Dynasty 1	(ca. 3000–2800 B.C.E.)
Dynasty 2	(ca. 2800–2675 B.C.E.)
Old Kingdom	(ca. 2675–2130 B.C.E.)
Dynasty 3	(ca. 2675–2625 B.C.E.)
At least five kings, including Djoser	
Dynasty 4	(ca. 2625–2500 B.C.E.)
Khufu, or Cheops	(ca. 2585–2560 B.C.E.)
Chephren, or Khafre	(ca. 2555–2532 B.C.E.)
Mycerinus, or Menkaure	(ca. 2532–2510 B.C.E.)
Dynasty 5	(ca. 2500–2350 B.C.E.)
Unas	(ca. 2371–2350 B.C.E.)
Dynasty 6	(ca. 2350–2170 B.C.E.)
Meryre Pepy I	(ca. 2338–2298 B.C.E.)
Dynasties 7–8	(ca. 2170–2130 B.C.E.)
First Intermediate Period	(ca. 2130–1980 B.C.E.)
Herakleopolitan Dynasties 9–10	(ca. 2130–1980 B.C.E.)
Theban Dynasty 11	(ca. 2081–1938 B.C.E.)
Nebhepetre Mentuhotep	(ca. 2008–1957 B.C.E.)
Middle Kingdom	(ca. 1980–1630 B.C.E.)
(The Middle Kingdom begins in Dynasty 11 in the reign of Nebhepetre Mentuhotep)	
Dynasty 12	(ca. 1938–1759 B.C.E.)
Amenemhet (or Ammenemes) I	(ca. 1938–1909 B.C.E.)
Sesostris (or Senwosret) I	(ca. 1919–1875 B.C.E.)
Amenemhet II	(ca. 1876–1842 B.C.E.)
Sesostris II	(ca. 1844–1837 B.C.E.)
Sesostris III	(ca. 1836–1818 B.C.E.)
Amenemhet III	(ca. 1818–1772 B.C.E.)

Dynasty 13	(ca. 1759– after 1630 B.C.E.)
Dynasty 14	(dates uncertain, but contemporaneous with later Dynasty 13)
Second Intermediate Period	(ca. 1630–1539/23 B.C.E.)
Hyksos Dynasty 15	(ca. 1630–1523 B.C.E.)
Dynasty 16	(contemporaneous with Dynasty 15
Theban Dynasty 17	(ca. 1630–1539 B.C.E.)
New Kingdom	(ca. 1539–1075 B.C.E.)
Dynasty 18	(ca. 1539–1295 B.C.E.)
Ahmose (or Amosis)	(ca. 1539–1514 B.C.E.)
Amenhotep (or Amenophis) I	(ca. 1514–1493 B.C.E.)
Thutmose (or Tuthmosis) I	(ca. 1493–1479 B.C.E.)
Thutmose II	(ca. 1493–1479 B.C.E.)
Hatshepsut (Regnant Queen, ca. 1479/72–1458 B.C.E.)	
Thutmose III	(ca. 1479–1425 B.C.E.)
Amenhotep II	(ca. 1426–1400 B.C.E.)
Thutmose IV	(ca. 1400–1390 B.C.E.)
Amenhotep III	(ca. 1390–1353 B.C.E.)
Amenhotep IV, later called Akhenaten	(ca. 1353–1335 B.C.E.)
Tutankhamun	(ca. 1332–1322 B.C.E.)
Horemheb	(ca. 1319–1292 B.C.E.)
Dynasty 19	(ca. 1292–1190 B.C.E.)
Ramesses (or Ramses) I	(ca. 1292–1290 B.C.E.)
Sety (or Sethos) I	(ca. 1290–1279 B.C.E.)
Ramesses II	(ca. 1279–1213 B.C.E.)
Merneptah	(ca. 1213–1204 B.C.E.)
Sety II	(ca. 1204–1198 B.C.E.)
Dynasty 20	(ca. 1190–1075 B.C.E.)
Ramesses III	(ca. 1187–1156 B.C.E.)
Ramesses IV	(ca. 1156–1150 B.C.E.)

Ramesses V	(ca. 1150–1145 B.C.E.)
Ramesses VI	(ca. 1145–1137 B.C.E.)
Ramesses VII	(ca. 1137–1129 B.C.E.)
Ramesses VIII	(ca. 1128–1126 B.C.E.)
Ramesses IX	(ca. 1126–1108 B.C.E.)
Ramesses X	(ca. 1108–1104 B.C.E.)
Ramesses XI	(ca. 1104–1075 B.C.E.)

Third Intermediate Period (ca. 1075–656 B.C.E.)

Tanite Dynasty 21 (ca. 1075–945 B.C.E.)

Bubastite Dynasty 22 (ca. 945–712 B.C.E.)
> About ten rulers, including Shoshenq I (ca. 945–924 B.C.E.), Osorkon II (ca. 874–855/30 B.C.E.), and Shoshenq III (ca. 835/30–783/78 B.C.E.)

Dynasty 23 (ca. 838–712 B.C.E.)
> (Rival rulers at Thebes and in various northern principalities)

Saite Dynasty 24 (ca. 727–712 B.C.E.)
> Bocchoris (or Bakenrenef) (ca. 719–712 B.C.E.)

Nubian or Kushite Dynasty 25 (ca. 760–656 B.C.E.)
> Piye or Piankhy (ca. 747–716 B.C.E.)
> Shabaka (ca. 716–702 B.C.E.)
> Tarhaqa (690–664 B.C.E.)

Late Period (664–332 B.C.E.)

Saite Dynasty 26 (664–525 B.C.E.)
> Psamtik (or Psammetichus) I (664–610 B.C.E.)
> Necho II (610–595 B.C.E.)
> Psamtik II (595–589 B.C.E.)
> Apries (589–570 B.C.E.)
> Amasis (570–526 B.C.E.)
> Psamtik III (526–525 B.C.E.)

Dynasty 27 (first Persian period: 525–404 B.C.E.)
> Eight rulers, including Cambyses (525–522 B.C.E.), Darius I (521–486 B.C.E.), Xerxes (485–465 B.C.E.), Artaxerxes I (465–424/23 B.C.E.), and Darius II (423–404 B.C.E.)

Dynasty 28 (404–399 B.C.E.)

Dynasty 29 (399–380 B.C.E.)

Dynasty 30 (381–343 B.C.E.)
> Nectanebo I (381–362 B.C.E.)
> Nectanebo II (362–343 B.C.E.)

Dynasty 31 (second Persian period: 343–332 B.C.E.)
> Three rulers, including Artaxerxes III, Ochus (343–338 B.C.E.), and Darius III, Codoman (335–332 B.C.E.)

Greco-Roman Period (332 B.C.E.–642 C.E.)

Macedonian Dynasty (332–305 B.C.E.)
> Alexander III, "the Great" (332–323 B.C.E.)

Ptolemaic Dynasty (305–30 B.C.E.)
> Ptolemy I Soter I (323–282 B.C.E.: as satrap, 323–305 B.C.E.; as king of Egypt 305–282 B.C.E.)
> Ptolemy II Philadelphos (285–246 B.C.E.)

Ptolemy III Euergetes I	(246–222/1 B.C.E.)
Ptolemy IV Philopator	(222/1–205 B.C.E.)
Ptolemy V Epiphanes	(209/8–180 B.C.E.)
Ptolemy VI Philometor	(180–164 B.C.E., 163–145 B.C.E.)
Ptolemy VII Neos Philopator	(145 B.C.E.)
Ptolemy VIII Euergetes II	(170–163 B.C.E., 145–116 B.C.E.)
Ptolemy IX Soter II	(116–110 B.C.E., 109–107 B.C.E., 88–80 B.C.E.)
Ptolemy X Alexander I	(110–109, 107–88 B.C.E.)
Ptolemy XI Alexander II	(80 B.C.E.)
Ptolemy XII Neos Dionysos	(80–58 B.C.E., 55–51 B.C.E.)
Cleopatra VII Philopator	(51–30 B.C.E.), at first with her brothers Ptolemy XIII and XIV
Ptolemy XV Caesarion	(45–30 B.C.E.)

Egypt as a Roman province (30 B.C.E.–395 C.E.)
> Constantine (306–337 C.E.)
> Theodosius (379–395 C.E.)

Egypt as a Byzantine province (395–640)

Conquest of Egypt by Amr ibn al-'As, first governor of Egypt (640/21)

Governors for Ummayad Caliphs (658–750/38–132)

Governors for Abbasid Caliphs (750–868/133–254)

Tulunids (868–905/254–92)
> Ahmad ibn Tulun declared independence (868)

Governors for Abbasid Caliphs (905–35/292–323)

Ikshids (935–69/323–58)

Fatimid Caliphs (909–1171/297–567)

Ayyubid Sultans (1169–1252/564–650)

Mamluk Sultans (1250–1517/648–922)
> Bahri line (1250–1390/648–792)
> Burji (Circassian) line (1382–1517/784–922)

Ottoman conquest (1517/923)

Pashas for Ottoman Sultans (1517–1805/923–1220)

French occupation under Bonaparte (1798–1801/1213–17)

Muhammad Alids (1805–1953/1220–1372)
> Muhammad Ali, Pasha (1805–48)
> Ismail, Pasha (1863–79)

British occupation (1882–1923)

Republic declared March 1953–

Note: The dates for periods preceding the Arab conquest of Egypt in 640 generally follow those given in William J. Murnane, "The History of Ancient Egypt: An Overview," in *Civilizations of the Ancient Near East*, ed. Jack M. Sasson et al. (New York: Charles Scribner's Sons, 1995), 712–14. Subsequent dates follow the chronology in Carl F. Petry, ed. *The Cambridge History of Egypt, 1: Islamic Egypt, 640–151* (Cambridge: Cambridge University Press, 1998), 517–20.

NOTES

CHAPTER 1

1. Charles Lang Freer to Frank J. Hecker, 3 February 1907, Charles Lang Freer Papers, Freer Gallery of Art Archives, Smithsonian Institution, Washington, D.C. Unless otherwise specified, citations of archival sources refer to these papers.

2. Warren R. Dawson and Eric P. Uphill, *Who Was Who in Egyptology,* 3d ed. (London: Egypt Exploration Society, 1995), 158.

3. Frederic G. Kenyon, *Recent Developments in the Textual Criticism of the Greek Bible,* The Schweich Lectures of the British Academy, 1932 (London: Oxford University Press, 1933), 92–94, 100–1; "Mr. Freer's splendid collection at Washington . . . has given America an important standing in respect of Biblical manuscripts. . . ." (94). See also Bruce M. Metzger, *Manuscripts of the Greek Bible: An Introduction to Greek Palaeography* (New York: Oxford University Press, 1981), 82–85, with further references.

4. Henry A. Sanders, *The Old Testament Manuscripts in the Freer Collection, Part I: The Washington Manuscript of Deuteronomy and Joshua; Part II: The Washington Manuscript of the Psalms,* University of Michigan Studies, Humanistic Series 8 (New York: Macmillan, 1917); *The New Testament Manuscripts in the Freer Collection, Part II: The Washington Manuscript of the Epistles of Paul,* University of Michigan Studies, Humanistic Series 9 (New York: Macmillan, 1918); William H. Worrell, ed., *The Coptic Manuscripts in the Freer Collection,* University of Michigan Studies, Humanistic Series 10 (New York: Macmillan, 1923); Henry A. Sanders and Carl Schmidt, *The Minor Prophets in the Freer Collection and the Berlin Fragment of Genesis,* University of Michigan Studies, Humanistic Series 21 (New York: Macmillan, 1927).

5. Charles Rufus Morey and Walter Dennison, *Studies in East Christian and Roman Art. Part I: East Christian Paintings in the Freer Collection; Part II: A Gold Treasure of the Late Roman Period,* University of Michigan Studies, Humanistic Series 12 (New York: Macmillan, 1914–18).

6. Birgit Nolte, *Die Glasgefässe im alten Ägypten,* Münchner Ägyptologische Studien 14 (Berlin: B. Hessling, 1968), esp. 86–147; Arielle P. Kozloff and Betsy M. Bryan, with Lawrence M. Berman, *Egypt's Dazzling Sun: Amenhotep III and His World* (Cleveland: Cleveland Museum of Art and Indiana University Press, 1992), 373–82.

7. Chief among these were G. I. Eisen, a specialist in ancient glass, and John D. Cooney (1905–1982), curator of Egyptian art at the Brooklyn Museum of Art and later at the Cleveland Museum of Art. Some objects files also preserve comments by Bernard Bothmer and Elizabeth Riefstahl, likewise members of the Brooklyn Museum's Egyptian Department.

8. Richard Ettinghausen, *Ancient Glass in the Freer Gallery of Art* (Washington, D.C.: Smithsonian Institution, 1962), 4–21.

9. Susan H. Auth, "Ancient Egyptian Glass from the Dattari Collection," *Apollo* 118, no. 258 (August 1983): 160–63; Thomas Lawton, "The Gold Treasure," *Apollo* 118, no. 258 (August 1983): 180–82; Gary Vikan, "Byzantine Art as a Mirror of Its Public," *Apollo* 118, no. 258 (August 1983): 164–67.

10. Freer to Hecker, 3 February 1907 (his emphasis).

11. Thomas Lawton and Linda Merrill, *Freer: A Legacy of Art* (Washington, D.C., and New York: Freer Gallery of Art, Smithsonian Institution and Harry N. Abrams, 1993), esp. 66–68, 74–75, and 80–81.

12. Martin R. Kalfatovic, *Nile Notes of a Howadji: A Bibliography of Travelers' Tales from Egypt, from the Earliest Time to 1918* (Metuchen, N. J.: Scarecrow Press, 1992), esp. 325–49.

13. On Freer and Whistler, see Linda Merrill, ed., *With Kindest Regards: The Correspondence of Charles Lang Freer and James McNeill Whistler, 1890–1903* (Washington, D.C.: Freer Gallery of Art, Smithsonian Institution and Smithsonian Institution Press, 1995), esp. 13–46, with further references.

14. Lawton and Merrill in *Freer: A Legacy of Art* admirably survey and richly document the growth of the collections and the development of the Washington museum, with additional references.

15. Freer to Samuel P. Langley, 27 December 1904.

16. Freer to Hecker, 3 February 1907.

17. Frances Weitzenhoffer, *The Havemeyers: Impressionism Comes to America* (New York: Harry N. Abrams, 1986), 169–70, mentions the Havemeyers' enthusiastic report on their visit to Freer's Detroit home. Bernard Berenson, *The Letters of Bernard Berenson and Isabella Stewart Gardner, 1887–1924, with Correspondence by Mary Berenson,* ed. Rollin van N. Hadley (Boston: Northeastern University Press, 1987), 326: ". . . have been spending all day seeing Mr. Freer's Oriental things—very fine" (Bernard Berenson to Isabella Stewart Gardner, 13 January 1904).

18. Lawton and Merrill, *Freer: A Legacy of Art,* 28–29.

19. Ibid., 185.

20. Peter Mansfield, *The British in Egypt* (New York: Holt, Rinehart, and Winston, 1971), esp. 81–178, provides a detailed, thoughtful account.

21. M. W. Daly, "The British Occupation, 1882–1922," in *The Cambridge History of Egypt, 2: Modern Egypt, from 1517 to the End of the Twentieth Century,* ed. M. W. Daly (Cambridge: Cambridge University Press, 1998), 243–44.

22. Edmund Swinglehurst, *Cook's Tours: The Story of Popular Travel* (Poole, Dorset: Blandford Press, 1982). John Pemble, *The Mediterranean Passion: Victorians and Edwardians in the South* (Oxford: Clarendon Press; New York: Oxford University Press, 1987), is a delightful survey of travel to Egypt in the broader context of Mediterranean journeys.

23. Royal W. Leith, *A Quiet Devotion: The Life and Work of Henry Roderick Newman* (New York: Jordan-Volpe Gallery, 1996), 50 n. 201. Nina Nelson, *Shepheard's Hotel* (New York:

Macmillan, 1960), 69, on the cholera outbreak of 1902.

24. Anthony Sattin, *Lifting the Veil: British Society in Egypt, 1768–1956* (London: J. M. Dent, 1988), offers an entertaining and insightful account.

25. James A. Field Jr., *From Gibraltar to the Middle East: America and the Mediterranean World, 1776–1882* (Chicago: Imprint Publications, 1991), 345–88 (missionaries); 389–435 (U. S. soldiers in Egypt).

26. Among many recent studies, the following also provide additional references: John Davis, *The Landscape of Belief: Encountering the Holy Land in Nineteenth-Century American Art and Culture* (Princeton: Princeton University Press, 1996), esp. 27–97; Kathleen Stewart Howe, *Excursions along the Nile: The Photographic Discovery of Ancient Egypt* (Santa Barbara, Calif.: Santa Barbara Museum of Art, 1994).

27. Blanche Mabury Carson, *From Cairo to the Cataract* (Boston: L. C. Page & Co., 1909), 29.

28. Richard A. Fazzini et al., *Ancient Egyptian Art in the Brooklyn Museum* (New York: The Brooklyn Museum and Thames and Hudson, 1989), vii–x; Arielle P. Kozloff, "Introduction: History of the Egyptian Collection of the Cleveland Museum of Art," in *Catalogue of Egyptian Art: The Cleveland Museum of Art*, Lawrence M. Berman with Kenneth J. Bohač (Cleveland: Cleveland Museum of Art, 1999), 1–29.

29. Nancy Thomas, Gerry D. Scott III, and Bruce G. Trigger, *The American Discovery of Ancient Egypt* (Los Angeles and New York: Los Angeles County Museum of Art and Harry N. Abrams, 1995); Nancy Thomas, ed., *The American Discovery of Ancient Egypt* (Los Angeles: Los Angeles County Museum of Art and American Research Center in Egypt, 1996).

CHAPTER 2

1. Freer to Siegfried Bing, 4 November 1904. On Bing, see Lawton and Merrill, *Freer: A Legacy of Art*, 114–23; Julia Meech, "The Other Havemeyer Passion: Collecting Asian Art," in *Splendid Legacy: The Havemeyer Collection*, ed. Alice Cooney Frelinghuysen,

et al. (New York: Metropolitan Museum of Art, 1993), 134, with further references. Although Bing is not now remembered for his trade in Egyptian antiquities, Freer later described him as active in this area in response to a question from Francis W. Kelsey. "Mr. Bing was the father and financial backer of 'Nouveau Art,' an association of artists which extended its influence almost universally during the last twenty years. . . . I cannot say how deep his knowledge of Egyptian Art went but I know that he dealt in it to a considerable degree and I also know that the leading French Egyptologists of Bing's day were intimate with him." (Freer to Francis W. Kelsey, 1 June 1914, Francis W. Kelsey Records, Kelsey Museum Archives, Bentley Historical Library, University of Michigan, Ann Arbor. Bing did sell at least one collection of ancient Egyptian art, the catalogue of which Freer owned: *Antiquités Égyptiennes, Grecques et Romaines appartenant à P. Philip et à divers amateurs, 10–12 Avril 1905* (Paris: 1905). Dawson and Uphill, *Who Was Who in Egyptology*, 333, note that Philip excavated in Egypt at Heliopolis in 1892–93, and died in 1905.

2. Freer to Bing, 14 December 1904. Freer bought the two examples of Raqqa pottery for $800. One of the items he returned might have been the bowl that Margaret S. Watson (later Mrs. Walter R. Parker) purchased from Bing only a few weeks later, on 27 February 1905, for $500; it is now in the University of Michigan Museum of Art (1948/1.116). John Siewert, "Whistler and Michigan: The Artist, Mr. Freer, and Miss Watson," in *Whistler: Prosaic Views, Poetic Vision*, ed. Carole McNamara and John Siewert (New York: Thames and Hudson, 1994), 11–21, describes the acquaintance and correspondence between Freer and Watson; 15, fig. 8, for a photograph of the vessel. Freer also declined to purchase Bing's collection of Japanese ukiyo-e paintings: Gabriel P. Weisberg, *Art Nouveau Bing: Paris Style 1900* (New York: Harry N. Abrams, in association with the Smithsonian Institution Traveling Exhibition Service, 1986), 41–42.

3. See, for example, Garrett Chatfield Pier, *Pottery of the Near East* (New York: G. P. Putnam's Sons, 1909), 1–32, a copy of which Freer purchased in 1910. Pier also wrote articles on Near Eastern ceramics for *Burlington*

Magazine, to which Freer subscribed: "Pottery of the Hither Orient in the Metropolitan Museum, I," *Burlington Magazine* 14, no. 68 (1908): 120–25; "Pottery of the Hither Orient in the Metropolitan Museum, II," *Burlington Magazine* 14, no. 72 (1909): 387–88.

4. Esin Atil, *Ceramics from the World of Islam*, Freer Gallery of Art Fiftieth Anniversary Exhibition, III (Washington, D.C.: Smithsonian Institution Press, 1973), publishes selected examples of medieval Syrian (nos. 64–67) and Persian (nos. 69, 71–77, 89–90, 92, 94–101) ceramics acquired by Freer. Jonathan M. Bloom, "'Raqqa' Ceramics in the Freer Gallery of Art, Washington, D.C.," (master's thesis, University of Michigan, 1975), provides a comprehensive catalogue and discussion.

5. St John Simpson, "Partho-Sasanian Ceramic Industries in Mesopotamia," in *Pottery in the Making: World Ceramic Traditions*, ed. Ian Freestone and David Gaimster (London: British Museum Press, 1997), 74–79; Nicole Chevalier, *Une mission en Perse: 1897–1912*, Musée du Louvre, Département des Antiquités Orientales (Paris: Editions de la Réunion des musées nationaux, 1997), 204–5, cat. no. 150.

6. The comment appears in Freer's handwriting on the collection inventory dated May 1917.

7. Thomas W. Brunk, *Painting with Fire: Pewabic Vessels in the Margaret Watson Parker Collection* (Ann Arbor: University of Michigan Museum of Art, 1995), esp. 8–9, with further references.

8. Freer stated in his letter that he was sending payment for the jar of $1,485 (the equivalent of 7,500 French francs): Freer to Bing, 5 February 1905.

9. This purchase consisted of a "Babylonian" bowl (F1905.250); a "Babylonian" tile (F1905.251); three "Egyptian dishes" (F1905.252–254); a "Babylonian" vase (F1905.255); a "Babylonian" cup (F1905.256); a "Racca" tile or headstone (F1905.257); and a "Racca" bowl (F1905.258). For Kalebjian Frères, which operated shops in Paris and Cairo, see *Les donateurs du Louvre* (Paris: Editions de la Réunion des musées nationaux, 1989), 240.

10. Lawton and Merrill, *Freer: A Legacy of Art*, 111–14, with further references; William R. Johnston, *William and Henry Walters, The Reticent Collectors* (Baltimore: Johns Hopkins University Press, in association with the Walters Art Gallery, 1999), esp. 144–47, 193–95, and 211–13.

11. Henry Walters's purchases at the 1893 exposition inaugurated a long and productive relationship with Kelekian, who was also the source of most of Walters's Egyptian acquisitions: Johnston, *William and Henry Walters, The Reticent Collectors*, 144. On Walters's purchases of Islamic art from Kelekian: see ibid., 145–46; and Marianna Shreve Simpson, " 'A Gallant Era': Henry Walters, Islamic Art, and the Kelekian Connection," *Ars Orientalis* 30 (2000): 91–112. Stephen Vernoit, "Islamic Art and Architecture: An Overview of Scholarship and Collecting, c. 1850–c. 1950," in *Discovering Islamic Art: Scholars, Collectors and Collections, 1850–1950*, ed. Stephen Vernoit (London: I. B. Tauris, 2000), 16, on Isabella Stewart Gardner's purchases in 1893.

12. Marilyn Jenkins-Madina, "Collecting the 'Orient' at the Met: Early Tastemakers in America," *Ars Orientalis* 30 (2000): 69–89, traces Kelekian's role in the collecting of Islamic art by the Havemeyers and other patrons of the Metropolitan Museum of Art.

13. Weitzenhoffer, *The Havemeyers: Impressionism Comes to America*, 164.

14. Alice Cooney Frelinghuysen, "The Forgotten Legacy: The Havemeyers' Collection of Decorative Arts," in *Splendid Legacy: The Havemeyer Collection*, ed. Alice Cooney Frelinghuysen, et al. (New York: Metropolitan Museum of Art, 1993), 107–10. The Havemeyers' bequest to the Metropolitan Museum of Art included two fine examples of Egyptian stone sculpture: Frelinghuysen, "Forgotten Legacy," 114–15 (entries by Dorothea Arnold); Ambrose Lansing, "The Exhibition of the H. O. Havemeyer Collection: Egyptian Art," *Bulletin of the Metropolitan Museum of Art* 25 (1930): 75–80.

15. Jenkins-Madina, "Collecting the 'Orient' at the Met," 72–73.

16. Vernoit, "Islamic Art and Architecture: An Overview of Scholarship and Collecting," 30, with further references. The first scientific exploration of the site was carried out in 1907

and published in Friedrich P. T. Sarre and Ernst E. Herzfeld, *Archäologische Reise im Euphrat- und Tigris-begiet*, vol. 1 (Berlin: D. Reimer, 1911), a copy of which Freer owned.

17. Sheila R. Canby, "Islamic Lustreware," in *Pottery in the Making: World Ceramic Traditions*, ed. Ian Freestone and David Gaimster (London: British Museum Press, 1997), 110–15, with further references.

18. Venetia Porter, *Medieval Syrian Pottery (Raqqa Ware)* (Oxford: Ashmolean Museum, 1981), esp. 9–13; Cristina Tonghini, *Qal'at Ja'bar Pottery: A Study of a Syrian Fortified Site of the Late 11th–14th Centuries*, British Academy Monographs in Archaeology 11 (Oxford: Council for British Research in the Levant and Oxford University Press, 1998), esp. 46–51, with extensive bibliography. The term fritware is often used to describe the ceramic material here called stonepaste.

19. Bloom, "'Raqqa' Ceramics in the Freer Gallery of Art," esp. 3–4, 18–48.

20. F1902.248, a fragmentary figure of Horus.

21. Henry Wallis, *Egyptian Ceramic Art: The MacGregor Collection* (London: privately printed, 1898), xxi, describes the composition as "mainly of silica, nearly nine-tenths of the mass, the rest being alumina with a small portion of lime and traces of magnesia," citing an "analysis given in Brongniart, *Traité des arts céramiques* (1877)." Freer may have been acquainted with these studies; he owned Wallis's publication and in August 1905 purchased a copy of the first edition of Alexandre Brongniart, *Traité des arts céramiques*, 3 vols. (Paris: A. Mathias, 1844).

22. Excellent discussions are found in Paul T. Nicholson, "Materials and Technology," in *Gifts of the Nile: Ancient Egyptian Faience*, ed. Florence Dunn Friedman (New York: Thames and Hudson, 1998), 50–64; Paul T. Nicholson, with Edgar Peltenburg, "Egyptian Faience," in *Ancient Egyptian Materials and Technology*, ed. Paul T. Nicholson and Ian Shaw (Cambridge: Cambridge University Press, 2000), 177–94.

23. Between 1900 and 1905 Freer purchased, among many other publications: Henry Walters, *Ancient Pottery* (1905); George Dalton, *Treasure of the Oxus* (1905); and Daniel Marie Fouquet, "Contribution à l'étude de la céramique orientale," *Mémoires de l'Institut Égyptien* 4 (1901):

1–164 (also issued as separate monograph with a publication date of 1900).

24. Freer to Hecker, 3 February 1907 (his emphasis).

25. Burlington Fine Arts Club, *The Art of Ancient Egypt: A Series of Photographic Plates Representing Objects from the Exhibition of the Art of Ancient Egypt, at the Burlington Fine Arts Club, in the Summer of 1895* (London: Burlington Fine Arts Club, 1895). Brief biographies of these collectors are found in Dawson and Uphill, *Who Was Who in Egyptology:* MacGregor (267–68), Myers (305), Price (343); Wallis is discussed later in this chapter. Stephen Spurr, Nicholas Reeves, and Stephen Quirke, *Egyptian Art at Eton College: Selections from the Myers Museum* (New York: Eton College, Windsor, and The Metropolitan Museum of Art, 1999), esp. 1–6, for additional information on Myers and his collection. In 1895, MacGregor's collection consisted chiefly of ceramic and faience objects, but later encompassed a much broader range of finds. Baltimore's Henry Walters, represented by Kelekian, acquired a number of objects from the MacGregor sale in 1922: Johnston, *William and Henry Walters, The Reticent Collectors*, 211–12.

26. Several sources tell the story of Whistler's portraits of Lady Meux, including Andrew McLaren Young, Margaret MacDonald, and Robin Spencer, *The Paintings of James McNeill Whistler*, vol. 1 (New Haven: Yale University Press, 1980), 128–30; and Richard Dorment and Margaret F. MacDonald, *James McNeill Whistler* (New York: Harry N. Abrams, 1995), 201–5. The other surviving portrait is now in the Honolulu Academy of Arts: Young, MacDonald, and Spencer, *Paintings of James McNeill Whistler*, 128–29, no. 228; vol. 2, pl. 157. Virginia Surtees, *The Actress and the Brewer's Wife: Two Victorian Vignettes* (Wilby, Norwich: Michael Russell, 1997), 105–59, provides a recent biographical sketch of this extraordinary individual.

27. Dawson and Uphill, *Who Was Who in Egyptology*, 285, with further references. For the collection: E. A. Wallis Budge, *Some Account of the Collection of Egyptian Antiquities in the Possession of Lady Meux, of Theobald's Park, Waltham Cross*, 2d ed. (London: Harrison & Sons, 1896).

28. Lady Meux's collection was sold at auction in 1911, the year following her death. Many objects were purchased by the American publisher and broadcast magnate William Randolph Hearst (1863–1951), who probably inherited an interest in Egyptian antiquities from his mother, Phoebe Apperson Hearst (1842–1919); she had financed George Reisner's excavations in Egypt for the University of California. See Dawson and Uphill, *Who Was Who in Egyptology*, 196–97 (Hearsts) and 351–52 (Reisner); and Nancy Thomas, "American Institutional Fieldwork in Egypt, 1899–1960," in Thomas et al., *American Discovery of Egypt*, 56–58.

29. Freer's description of the Whistler portrait at Theobald's Park leaves no doubt that he saw the one now in the Frick Collection, New York: "Life size figure—pinkish grey background—deep red carpet—grey gown . . . Face beautifully painted" (unnumbered memoranda pages, end of 1902 diary). He added: "Lady Meux has another portrait of herself in her Park Lane home and another in a mink skin suit and cap still in Mr. Whistlers hands begun over 20 yrs ago and still unfinished."

30. Margaret S. Drower, *Flinders Petrie: A Life in Archaeology*, Wisconsin Studies in Classics (Madison: University of Wisconsin Press, 1995), esp. 277–85.

31. T.G.H. James, ed., *Excavating in Egypt: The Egypt Exploration Society 1882–1982* (Chicago: University of Chicago Press, 1982), a collection of essays, describes the early years of the fund and surveys the sites and regions investigated under its auspices.

32. Dawson and Uphill, *Who Was Who in Egyptology*, 431, report that Wallis regularly visited Egypt, purchasing antiquities to sell to museums and collectors to pay his expenses. In 1898, Freer purchased two drawings of Whistler by Sir Edward Poynter. Eric Denker, *In Pursuit of the Butterfly: Portraits of James McNeill Whistler* (Washington, D.C., and Seattle: National Portrait Gallery, Smithsonian Institution, in association with the University of Washington Press, 1995), 33–35, discusses and illustrates Poynter's portraits of Whistler, including the two purchased by Freer (F1898.145–146).

33. Dikran K. Kelekian, *The Kelekian Collection of Persian and Analogous Potteries,*

1884–1910 (Paris: Herbert Clarke, 1910), preface, unnumbered pages. Freer's copy is inscribed "To Charles L. Freer, Esq., with compliments of Dikran Khan Kelekian."

34. Library vouchers, August 1901. Johnston, *William and Henry Walters, The Reticent Collectors*, 211–12, lists the objects that Henry Walters—represented by Kelekian—acquired from the MacGregor sale in 1922.

35. Freer's library also included two copies of Wallis's *Persian Ceramic Art in the Collection of Mr. R. F. du Cane Godman, F.R.S: The XIIIth Century Lustre Vases* (London: privately printed by Taylor & Francis, 1891) and one of *Typical Examples of Persian and Oriental Ceramic Art* (London: Lawrence and Bullen, 1893).

36. Wallis, *Egyptian Ceramic Art*, xvii.

37. 1906 diary, unnumbered memoranda pages at end, "#475." Gaston Maspero, *Guide to the Cairo Museum,* trans. J. E. and A. A. Quibell, 3d ed. (Cairo: French Institute of Oriental Archaeology, 1906), 302, Case J: "Enamels from Tell el-Yahudieh . . . We may notice a pretty border of lotus (no. 472): an enamelled plaque with the name of Rameses III (no. 473); the remains of a frieze with fantastic birds (no. 474); a negro prisoner (no. 475)."

38. Freer to Hecker, 3 February 1907.

39. Wallis, *Egyptian Ceramic Art* (1898), 30, fig. 55, a green faience tile from a foundation deposit inscribed with the cartouches and titulary of Ramesses II (ca. 1279–1213 B.C.E.), is closely paralleled by an example Freer purchased in 1909 (F1909.147). In 1908 Freer acquired a fragment of a blue glazed relief vessel (F1908.102), which belongs to a type illustrated by a complete specimen in MacGregor's collection: Wallis, *Egyptian Ceramic Art,* pl. XXIII.

40. Freer to Charles J. Morse, 7 September 1906.

41. *Les donateurs du Louvre*, 273; Lawton and Merrill, *Freer: A Legacy of Art*, 115–20; Vernoit, "Islamic Art and Architecture: An Overview of Scholarship and Collecting," 20–21; Henri Rivière, *La céramique dans l'art Musulman*, with a preface by Gaston Migeon, 2 vols. (Paris: E. Lévy, 1913), esp. vol. 1: 3.

42. Gaston Migeon, *Le Caire, le Nil et Memphis* (Paris: H. Laurens, 1906).

43. Freer to Gaston Migeon, 17 October 1906 and 8 November 1906.

44. Weitzenhoffer, *The Havemeyers: Impressionism Comes to America*, 169–70, on their enthusiastic account of the visit.

CHAPTER 3

1. Freer to Rosalind Birnie Philip, 24 September 1906, Whistler Correspondence, Glasgow University Library, Scotland.

2. *Dau's Blue Book for Detroit and Suburban Towns* (New York: Dau's Blue Books, 1906), 120.

3. Albert Nelson Marquis, *The Book of Detroiters* (Detroit: A. N. Marquis & Co., 1908), 5, those "men who have attained places of distinctive creditability in the city of Detroit."

4. Freer to Hecker, 6 September 1900; 30 September 1900. Several years later, Freer wrote Hecker, "Dr. Mann and his wife are here [London] and we are to dine together tonight" (19 June 1909). Curiously, Mann's will left one thousand dollars jointly to eleven men, among them Freer and Thomas Spencer Jerome; these instructions were to be carried out on the death of his wife, of whom the will made no other mention. Mrs. Mann had apparently predeceased him, as had Freer and Jerome. This unusual provision merited a short article in the *Detroit Free Press*, 20 April 1927. My thanks to John Gibson, archivist at the Burton Historical Collection, Detroit Public Library, for drawing this article to my attention.

5. Freer to Hecker, 19 December 1906.

6. Freer to Hecker, 12 December 1906.

7. Ibid.

8. On his three trips to Egypt, Freer sailed from Naples on ships run by both lines. The SS *Oceana* (1906) and *Oriental* (1908) were P & O liners; the *Schleswig*, on which he sailed in 1909, was a North German Lloyd ship.

9. Thomas S. Harrison, *The Homely Diary of a Diplomat in the East, 1897–1899* (Boston: Houghton, Mifflin and Company, 1917), xxiii.

10. Harrison, *The Homely Diary of a Diplomat*, 122.

11. A letter written on Shepheard's Hotel stationery ends with the postscript "Mrs. Gurtean [?] and Miss Julia Parker are at our hotel" (Freer to Hecker, 22 December 1906). *Dau's Blue Book*, 137, furnishes Miss Julia Parker's address. Mr. and Mrs. Charles M. Swift, who hosted Freer and Mann on their first night in

Cairo, were also friends from Detroit.

12. Freer to Hecker, 3 January 1907. The lawyer he met was probably either George Whitney Moore or George William Moore, law partners in Detroit both of whom achieved entries in Marquis, *The Book of Detroiters*, 332–33. Another Detroit attorney, Clarence M. Burton, stopped briefly in Egypt in March 1907 as part of a wider Mediterranean tour: "Journal of a Tour 1906 and 1907," Vol. 1 (Nov. 29, 1906–April 19, 1907), Burton Papers, Burton Historical Collection, Detroit Public Library.

13. Charles Dana Gibson, *Sketches in Egypt* (New York: Doubleday & McClure Co., 1899), 28; Nelson, *Shepheard's Hotel*, 64, describes the renovations of the 1890s.

14. Gaston Migeon, *Le Caire, le Nil et Memphis* (Paris: H. Laurens, 1906).

15. André Raymond, *Cairo*, trans. Willard Wood (Cambridge, Mass.: Harvard University Press, 2000), provides a substantial historical survey and many further references.

16. Incomplete entries in Freer's diary for at least two of these days make it impossible to reconstruct his activities in every detail. One day he spent with "Professor. . . ," leaving a blank space to write in the name of this gentleman; on the following day, he recorded a visit to the Egyptian Museum "with. . . ," another blank that was never filled.

17. Freer also mentions a Red Mosque, but this seems to be a confusion on his part; no guidebook mentions a mosque by this name.

18. Drower, *Flinders Petrie: A Life in Archaeology*, 301, cites his Journal I, xvii (Abydos 1902–03), entry for 17 November 1902.

19. Frederick N. Finney, *Letters from across the Sea, 1907–1908* (Philadelphia: J. B. Lippincott, 1909), 127.

20. E. A. Wallis Budge, *The Nile. Notes for Travellers in Egypt*, 10th ed. (London: Thomas Cook & Son, 1907), 451–52.

21. Freer to Hecker, 3 February 1907.

22. Mohamed Saleh and Hourig Sourouzian, *Official Catalogue of the Egyptian Museum Cairo* (Munich: Prestel and Philipp von Zabern, 1987), nos. 40 and 65.

23. Max Herz, *Catalogue sommaire des monuments exposés dans le Musée National de l'Art Arabe* (Cairo: G. Lekegian & Co., 1895); *Catalogue raisonné des monuments exposés dans le Musée National de l'Art Arabe*, 2d ed. (Cairo: Institut Français d'Archéologie Orientale, 1906).

24. Stephen Vernoit, "Islamic Art and Architecture: An Overview of Scholarship and Collecting, c. 1850–c. 1950," in *Discovering Islamic Art: Scholars, Collectors and Collections, 1850–1950*, ed. Stephen Vernoit (London: I. B. Tauris, 2000), 28, on the museum and library.

25. Freer to Hecker, 22 December 1906.

26. Pier, "Pottery of the Hither Orient in the Metropolitan Museum, I," 120, notes that the "walls of one of the chambers in the famous Step Pyramid at Sakkarah are faced with such tiles. . . ." Friedman, *Gifts of the Nile*, nos. 17–20, catalogues examples of the faience tiles and provides a recent discussion of their manufacture and use, with further references.

27. Marquis, *The Book of Detroiters*, 439. The Charles Lang Freer Papers preserve only one letter from Swift to Freer, dating from 1915.

28. Nancy Mowll Mathews, *Mary Cassatt: A Life* (New York: Villard Books, 1994), 32, 45, 98–99, 103–4.

29. Bacon's account of his Paris years was published as *Parisian Art and Artists* (Boston: James R. Osgood, 1883). See also Lois Marie Fink, *American Art at the Nineteenth-Century Paris Salons* (Washington, D.C., and Cambridge: National Museum of American Art, Smithsonian Institution, and Cambridge University Press, 1990), 71–72, 161–63, 217–18, 222–23; 316–17, for a comprehensive list of his exhibited paintings.

30. Lee Bacon, *Our Houseboat on the Nile* (Boston: Houghton, Mifflin and Company, 1901). Harrison, *The Homely Diary of a Diplomat*, mentions the Bacons in several diary entries for 1898–99: 19 January 1898, Mr. and Mrs. Bacon were among the small group of guests invited to the first formal dinner in the Agency residence (147); 4 February 1898, Henry Bacon and other Americans presented to the khedive (170); 9 March 1898, a dinner at which Mr. and Mrs. Bacon were also present (222); 19 March 1898, invited by Mrs. Bacon for tea at Shepheard's Hotel (234); 5 April 1898, bid farewell to Bacons (250); 8 December 1898, Mr. and Mrs. Bacon ("Henry the artist") among those invited to breakfast at the Agency residence (287).

31. Susan E. Strickler, *American Traditions in Watercolor: The Worcester Art Museum Collection* (Worcester, Mass. and New York: Worcester Art Museum and Abbeville Press, 1987), 118–25, 195–98. The Henry Bacon Papers, Archives of American Art, Smithsonian Institution, Washington, D.C., preserve sketches and several photographs from Bacon's years in Egypt.

32. Harrison, *The Homely Diary of a Diplomat*, 170.

33. Sattin, *Lifting the Veil*, 215–25.

34. T.G.H. James, *Howard Carter: The Path to Tutankhamun* (London: Kegan Paul International, 1992), 80–81, 87.

35. Freer to Hecker, 3 January 1907.

36. Freer to Hecker, 11 January 1907.

37. James, *Howard Carter*, 87–92, for Carter's collaboration with Davis in the Valley of the Kings.

38. *A Journal on the Bedawin 1889–1912*, Departmental Records, Department of Egyptian Art, Metropolitan Museum of Art, New York.

39. Corinna Putnam Smith, *Interesting People: Eighty Years with the Great and Near-Great* (Norman: University of Oklahoma Press, 1962), 141–45, on the Smiths' meeting with Freer in Detroit. In 1912, Freer acquired two oil paintings by Smith: *Priestess from Angkor Wat* (F1912.16), and *Seated Buddha from the Monument of Borobudur* (F1912.17). The Smiths and Freer shared another friend, the painter Abbott Handerson Thayer (1849–1921), who in 1891 moved to a house near Dublin, New Hampshire, birthplace of Joseph Lindon Smith. Smith and his wife were also residents of the Cornish colony near Dublin and visited Thayer when they were there. On Smith, see also Dawson and Uphill, *Who Was Who in Egyptology*, 396.

40. Dieter Arnold, *Temples of the Last Pharaohs* (New York: Oxford University Press, 1999), a detailed study of temple architecture from the end of the New Kingdom through the Roman period, covers the Nubian sites mentioned here.

41. James, *Howard Carter*, 80, with further references.

42. Budge, *The Nile*, 730–31.

43. Freer to Hecker, 8 January 1907.

44. Linda S. Ferber and William H. Gerdts, *The New Path: Ruskin and the American Pre-*

Raphaelites (Brooklyn: Brooklyn Museum of Art and Schocken Books, 1985); Leith, *A Quiet Devotion*, 7–14.

45. The Newmans took considerable pride in their Japanese acquisitions and criticized Denman Ross's Asian collection for its fakes and inferior works; this was evidently the final straw in Joseph Lindon Smith's falling out with Newman: Leith, *A Quiet Devotion*, 51 n. 204; Leith, 35–37, describes the animosity between Smith and Newman.

46. Joseph Lindon Smith, *Tombs, Temples and Ancient Art* (Norman: University of Oklahoma Press, 1956), 16–17.

47. Smith, *Tombs, Temples and Ancient Art*, 17.

48. Leith, *A Quiet Devotion*, 114.

49. Ibid., 52 n. 208.

50. Frances Waldo Ross to Joseph Lindon Smith, 29 April 1893, Joseph Lindon Smith Papers (quoted by Leith, *A Quiet Devotion*, 49 n. 194).

51. Leith, *A Quiet Devotion*, 47–48, with further references. Freer was also acquainted with Smith's mentor Denman Ross. Two months before Freer departed for Egypt, he had dined in Boston with Ross, Gaston Migeon, and Ernest F. Fenollosa.

52. Ibid., 47, quoting from Andrews's diary.

53. Ibid., 53.

54. Eustace A. Reynolds-Ball, *The City of the Caliphs* (Boston: Estes and Lauriat, 1897), 298.

55. Carson, *From Cairo to the Cataract*, 210.

56. Sattin, *Lifting the Veil*, 256–57, describes the widespread admiration for this engineering feat. Finney, an engineer from Milwaukee, was impressed by its massive scale: *Letters from across the Sea*, 144–45.

57. Sattin, *Lifting the Veil*, 255.

58. Freer to Hecker, 8 January 1907.

59. B. J. Kemp, "Abydos," in *Excavating in Egypt: The Egypt Exploration Society 1882–1982*, ed. T.G.H. James (Chicago: University of Chicago Press, 1982), esp. 71–82.

60. *Les donateurs du Louvre*, 213: Gaston Migeon, "La collection Paul Garnier," *Les Arts*, no. 51 (1906): 2–11; no. 52 (1906): 13–24.

CHAPTER 4

1. Panayotis Kyticas to Budge, 30 November 1906, E. A. Wallis Budge Correspondence, Department of the Ancient Near East, British Museum, London. For Kyticas (died 1924): Dawson and Uphill, *Who Was Who in Egyptology*, 233, with further references; his name was also spelled Cyticas (as Drower, *Flinders Petrie: A Life in Archaeology*, 330).

2. Thomas, "American Institutional Fieldwork in Egypt, 1899–1960," *American Discovery of Egypt*, 49–67.

3. Smith to Isabella Stewart Gardner, 25 December 1906, Joseph Lindon Smith Papers, Archives of American Art, Smithsonian Institution, Washington, D.C.; Smith's typed record of his letter to Gardner reads "1905," but it follows an entry dated 27 October 1906, and in any case Lythgoe did not join the Metropolitan Museum of Art before 1906. Morgan seems to have created a similar effect wherever he entered the art market: "Mr. Morgan is here [Paris] and buying enormously for his collection—prices are shockingly high— and the dealers wear diamonds and ride in autos—the whole wealth of the world is likely to eventually become theirs" (Freer to Hecker, 4 June 1909).

4. Dawson and Uphill, *Who Was Who in Egyptology*, 305.

5. Drower, *Flinders Petrie: A Life in Archaeology*, 220; *Les donateurs du Louvre*, 275; Kozloff, "Introduction," *Catalogue of Egyptian Art: The Cleveland Museum of Art*, 7.

6. For a broader study, see Alexander Kitroeff, *The Greeks in Egypt, 1919–1937: Ethnicity and Class* (London: Ithaca Press for The Middle East Centre, St. Anthony's College Oxford, 1989). Greeks in Alexandria also formed an important group of collectors and dealers in the arts of the Islamic world, who would have been well known to both Kelekian and Migeon: John Carswell, "The Greeks in the East: Alexandria and Islam," in *Discovering Islamic Art: Scholars, Collectors, and Collections, 1850–1950*, ed. Stephen Vernoit (London: I. B. Tauris, 2000), 138–46, with further references.

7. Dawson and Uphill, *Who Was Who in Egyptology*, 410 (Nicholas Tano). See also *Les donateurs du Louvre*, 240 (Hagob and Garbis Kalebdjian, antiquarians in Cairo and Paris); 329 (Tano family). Finney, *Letters from across the Sea*, 126: "Joseph Cohen has a well-known place here [Muski], largely patronized by Amerians and English, as he has the reputation for asking one price and sticking to it." Freer's diaries for Egypt travels in 1906–07, 1908, and 1909 list dealers by name. The Charles Lang Freer Papers preserve correspondence between Freer and Arabi, Girgis, Hatoun, Kelekian, and Nahman, as well as records of nearly all acquisitions.

8. Maltbie Davenport Babcock, *Letters from Egypt and Palestine* (New York: Charles Scribner's Sons, 1902), 29.

9. Drower, *Flinders Petrie: A Life in Archaeology*, esp. 47, 77–78, and 330–31; Margaret S. Drower, "The Early Years," in *Excavating in Egypt: The Egypt Exploration Society 1882–1982*, ed. T.G.H. James (Chicago: University of Chicago Press, 1982), 9–36; Flinders Petrie Journals, 1895–1908, Petrie Museum Archives, University College London.

10. T.G.H. James, "Howard Carter and the Cleveland Museum of Art," in *Object Lessons: Cleveland Creates an Art Museum*, ed. Evan H. Turner (Cleveland: Cleveland Museum of Art, 1991), 66–77; James, *Howard Carter*, 152–56, with further references; Nicholas Reeves, "Howard Carter's Collection of Egyptian and Classical Antiquities," in *Chief of Seers: Egyptian Studies in Memory of Cyril Aldred*, ed. Elizabeth Goring, Nicholas Reeves and John Ruffle (London: Kegan Paul International, in association with National Museum of Scotland, 1997), 242–50.

11. Dawson and Uphill, *Who Was Who in Egyptology*, 119. See also Gerry D. Scott III, "Go Down into Egypt: The Dawn of American Egyptology," *American Discovery of Ancient Egypt*, 46; Thomas, "American Institutional Fieldwork in Egypt, 1899–1960," *American Discovery of Ancient Egypt*, 182; both with further references.

12. Ambrose Lansing, "The Pierpont Morgan Gift," *Bulletin of the Metropolitan Museum of Art* 13, no. 1 (1918): 2–5.

13. Dawson and Uphill, *Who Was Who in Egyptology*, 22, with further references. Harrison, *The Homely Diary of a Diplomat*, 157–58, describes a visit by Ayers, portraying a pompous, garrulous individual. See also Thomas, *American Discovery of Ancient Egypt*, 86–87, cat. no. 7.

14. See below for Freer's 1911 letter to Giovanni Dattari mentioning the Field

Museum. Freer was well acquainted with the museum through his friendship with curator Berthold Laufer: Lawton and Merrill, *Freer: A Legacy of Art*, 212, 227–28.

15. Fazzini et al., *Ancient Egyptian Art in the Brooklyn Museum*, vii–x; Thomas, "American Institutional Fieldwork in Egypt, 1899–1960," *American Discovery of Ancient Egypt*, 49–70; Kozloff, "Introduction," *Catalogue of Egyptian Art: The Cleveland Museum of Art*, 1–29. Gerry D. Scott III, *Temple, Tomb and Dwelling: Egyptian Antiquities from the Harer Family Trust Collection* (San Bernardino: California State University, San Bernardino, 1992), a collection that includes many objects originally acquired by Anthony J. Drexel Jr., given to the Drexel Institute in 1895, and sold to the Minneapolis Institute of Arts in 1916.

16. Freer to Hecker, 19 December 1906.

17. Fouquet, "Contribution à l'étude de la céramique orientale," esp. 45–118; Vernoit, "Islamic Art and Architecture: An Overview of Scholarship and Collecting," 30.

18. Kyticas to Budge, 14 February 1906, E. A. Wallis Budge Correspondence, Department of the Ancient Near East, British Museum, London.

19. In 1908 Freer bought Persian ceramics from Dimitri Andalft in Cairo (including F1908.76–F1908.78), and a fragment of Persian luster ware (F1908.208) and a "Raqqa ware" vessel from Nahman (F1908.69); Freer's diary mentions Professor Arvantakis and his purchase from Arabi (3 August 1909). In 1905, Joseph Lindon Smith purchased a Mughal helmet in Cairo for Isabella Stewart Gardner: Yasuko Horioka, Marilyn M. Rhie, and Walter B. Denny, *Oriental and Islamic Art in the Isabella Stewart Gardner Museum* (Boston: Trustees of the Isabella Stewart Gardner Museum, 1975), 133–34, no. 64.

20. Daniel Marie Fouquet, "Notes sur les momies des Pharaohs Ramses II et Ramses III," in Gaston Maspero, *Les momies royals de Deir el-Bahari*, Mémoires de la Mission Archéologique Française 1 (Paris: Ernest Leroux, 1889), 773–82; "Notes sur les crânes de Dahchour," in J. de Morgan, *Fouilles à Dahchour, mars–juin 1894* (Vienna: Adolphe Holzhausen, 1895), 147–51.

21. This handwritten manuscript, which bears no date, belonged to the library Freer bequeathed to the museum.

22. Dawson and Uphill, *Who Was Who in Egyptology*, 155; *Les donateurs du Louvre*, 209, mentions his gifts to the Louvre of Sasanian ceramic figurines and Greco-Roman glass. Kelekian, *Kelekian Collection of Persian and Analogous Potteries*, Preface, acknowledges "Dr. Fouquet, of Cairo, whose own research work is well known. . . . " Pier, *Pottery of the Near East*, 37, 45, and 63, refers to "the learned Dr. Fouquet" and his collection of Egyptian and "Syro-Egyptian" pottery.

23. Émile Chassinat, *Les antiquités égyptiennes de la collection Fouquet* (Paris: privately printed, 1922).

24. *Collection du Docteur Fouquet du Caire*, 2 vols. (Paris: Georges Petit, 1922); Sales 10 and 11 June 1922.

25. Collection sold at Sotheby's on 18 June, 29 July (lots 299–313), and 31 July 1923. Theophilus G. Pinches, *The Babylonian Tablets of the Berens Collections*, Asiatic Society Monographs 16 (London: Royal Asiatic Society, 1915), nearly one hundred tablets composed chiefly of Neo-Sumerian economic texts probably dug up at the site of Tello in southern Mesopotamia.

26. A. G. McDowell, *Hieratic Ostraca in the Hunterian Museum Glasgow (the Colin Campbell Ostraca)* (Oxford: Griffith Institute, Ashmolean Museum, 1993), a collection of twenty-seven limestone and hieratic ostraca deriving chiefly from the New Kingdom community of Deir al-Medina.

27. Dawson and Uphill, *Who Was Who in Egyptology*, 82.

28. Freer to J. M. Kennedy, 18 January 1907. Years later, Freer and Campbell corresponded about the Gospel manuscripts Freer had purchased in 1906 (Campbell to Freer, 22 September 1914). "I often recall mostly pleasantly the delightful chats we enjoyed together at Luxor, and if my strength returns sufficiently to enable me to revisit Egypt for another winter I shall be most happy, and when I make the journey I hope that you will also be in that fascinating part of the world." (Freer to Campbell, 29 October 1914.)

29. Freer to Hecker, 3 February 1907.

30. Freer to Kennedy, 19 January 1907.

31. Freer to Kennedy, 22 January 1907.

32. Henry A. Sanders, "Age and Ancient Home of Biblical Manuscripts in the Freer Collection," *American Journal of Archaeology* 13 (1909): 130–41.

33. 23 January 1908, Diary, Francis W. Kelsey Papers, Bentley Historical Library, University of Michigan, Ann Arbor.

34. Freer to Hecker, 26 May 1908.

35. Stephen Quirke, *Ancient Egyptian Religion* (London: British Museum Press, 1992), 114–15.

36. Carol Andrews, *Amulets of Ancient Egypt* (London: Published for the Trustees of the British Museum by British Museum Press, 1994), offers an informative survey, with additional bibliography.

37. Freer to Kelsey, 23 May 1908, Francis W. Kelsey Records, Kelsey Museum Archives, Bentley Historical Library, University of Michigan, Ann Arbor.

38. Freer to Kelsey, 14 April 1908, Francis W. Kelsey Records, Kelsey Museum Archives, Bentley Historical Library, University of Michigan, Ann Arbor. Freer later reiterated to Kelsey his wish to keep the contents of his collection and his collecting aims under wraps: "Your suggestion of publishing an authorized statement of the contents of the collections in my care as a preface or introduction at the beginning of the volume of 'Studies in Byzantine Art' does not appeal to me at the present moment. Information of this kind is being sought for from different sources but I am not yet ready to announce authoritatively the contents of the collection. You will, I am sure, appreciate how anxious dealers in art objects are to know many things concerning the collection which it is far better for me that they should not know. Further, there are still objects required to round out certain of the different departments of the group and I don't wish my competitors to have such facts as your proposed statement would embrace." (Freer to Kelsey, 19 September 1913, Francis W. Kelsey Records, Kelsey Museum Archives, Bentley Historical Library, University of Michigan, Ann Arbor.)

39. Freer to Hecker, 16 May 1908.

40. Leslie S. B. MacCoull, "Greek and Coptic Papyri in the Freer Gallery of Art" (Ph.D. diss., Catholic University of America, Washington, D.C., 1973).

41. Richard Gottheil and William H. Worrell,

Fragments from the Cairo Genizah in the Freer Collection, University of Michigan Studies, Humanistic Series 13 (New York: Macmillan, 1927). On the corpus of documents from the Cairo Geniza, see also Jonathan P. Berkey, "Culture and Society during the Late Middle Ages," in *The Cambridge History of Egypt, 1: Islamic Egypt, 640–1517*, ed. Carl F. Petry (Cambridge: Cambridge University Press, 1998), 375–411; and Norman A. Stillman, "The Non-Muslim Communities: The Jewish Community," *Cambridge History of Egypt, 1: Islamic Egypt, 640–1517*, 198–210.

42. Dawson and Uphill, *Who Was Who in Egyptology*, 414–15. My thanks to John Ray, Herbert Thompson Reader in Egyptology, University of Cambridge, for information on the dates of Thompson's visit to Egypt (letter dated 10 September 2001).

43. Freer to Hecker, 28 July 1909.

44. Charles Rufus Morey, *Studies in East Christian and Roman Art, Part I: East Christian Paintings in the Freer Collection*, University of Michigan Studies, Humanistic Series 12 (New York: Macmillan, 1914); Gary Vikan, "Byzantine Art as a Mirror of Its Public," *Apollo* 118, no. 258 (August 1983): 164–67.

45. Freer to Hecker, 28 July 1909. Freer purchased the two Persian pots from Tabbagh Frères, Paris, in June and July 1909: Atil, *Ceramics from the World of Islam*, 99, no. 43 (F1909.112); 153, no. 69 (F1909.111). The inscribed block statue made of faience (see fig. 4.13) was published by John D. Cooney, "Glass Sculpture in Ancient Egypt," *Journal of Glass Studies* 2 (1960): 35–36, figs. 27 and 28.

46. Percy Newberry, *Proceedings of the Society of Biblical Archaeology* (1900): 220. On Dattari, see also Dawson and Uphill, *Who Was Who in Egyptology*, 116.

47. Dattari to Newberry, 16 June 1909, Percy Newberry Correspondence 11/18, Griffith Institute, Oxford University.

48. Auth, "Ancient Egyptian Glass from the Dattari Collection"; Paul T. Nicholson and Julian Henderson, "Glass," in *Ancient Egyptian Materials and Technology*, ed. Paul T. Nicholson and Ian Shaw (Cambridge: Cambridge University Press, 2000), 195–224, with bibliography.

49. W. B. Honey, *Glass: A Handbook for the Study of Glass Vessels of All Periods and Countries and a Guide to the Museum Collection. Victoria and Albert Museum* (London: Ministry of Education, 1946), 17–18, pl. IB–C; Nolte, *Die Glasgefässe im alten Ägypten*, esp. 86–147.

50. Kozloff and Bryan, *Egypt's Dazzling Sun*, 373–92; Arielle P. Kozloff, "The Malqata/El-Amarna Blues: Favourite Colours of Kings and Gods," in *Chief of Seers: Egyptian Studies in Memory of Cyril Aldred*, ed. Elizabeth Goring, Nicholas Reeves, and John Ruffle (London: Kegan Paul International, in association with National Museum of Scotland, 1997), 178–92; Andrew J. Shortland, *Vitreous Materials at Amarna: The Production of Glass and Faience in 18th Dynasty Egypt*, British Archaeological Reports International Series 827 (Oxford: Archaeopress, 2000), analyzes archaeological and technical evidence for these industries.

51. Dattari to Freer, 15 July 1911.

52. Freer to Dattari, 3 August 1911.

53. Dattari to Freer, 26 August 1911.

54. Kelekian to Percy Newberry, 24 June 1912, Percy Newberry Correspondence 27/41, Griffith Institute, Oxford University.

55. Jean Strouse, *Morgan: American Financier*, 1st ed. (New York: Random House, 1999), 499, has Freer in Washington in January 1905 attending a dinner with Morgan to celebrate the founding of the American Academy in Rome, but the "architect" she mentions was surely Charles Adams Platt (1861–1933), not Charles Lang Freer. Platt later designed the Freer Gallery of Art, which is presumably the source of the confusion. Strouse, *Morgan: American Financier*, 509–20, provides substantial information on Greene.

56. Henry A. Sanders and Carl Schmidt, *The Minor Prophets in the Freer Collection and the Berlin Fragment of Genesis*, University of Michigan Studies, Humanistic Series 21 (New York: Macmillan, 1927), 1–2, for the history of the manuscript. In the same year, Sanders published a facsimile in an edition of 400 copies: *Facsimile of the Washington Manuscript of the Minor Prophets in the Freer Collection and the Berlin Fragment of Genesis* (Ann Arbor: University of Michigan, 1927). For those in the Morgan Library: Leo Depuydt and David A. Loggie, *Catalogue of Coptic Manuscripts in the Pierpont Morgan Library*, 2 vols., Corpus of Illuminated Manuscripts, 4, 5; Oriental Series 1, 2 (Leuven: Peeters, 1993).

57. James, *Howard Carter*, 153; Carson, *From Cairo to the Cataract*, 196.

58. T. G. Wakeling, *Forged Egyptian Antiquities* (London: Adam & Charles Black, 1912), 6–7.

59. Freer to Hecker, 3 February 1907.

60. Freer to Hecker, 16 May 1908.

61. Freer to Kelsey, 17 July 1917, Francis W. Kelsey Records, Kelsey Museum Archives, Bentley Historical Library, University of Michigan, Ann Arbor.

62. Lawton and Merrill, *Freer: A Legacy of Art*, 73–74, describe an episode in Japan that particularly enraged Freer.

63. Freer to Kennedy, undated; probably 19 January 1907.

64. Freer to Kennedy, 22 January 1907.

65. Wakeling, *Forged Egyptian Antiquities*, 125.

66. Ibid., 26.

67. Ibid., 6.

68. Other probable forgeries include a wooden statuette depicting a female figure purported to be an image of Isis, a gift from Ali Arabi (F1908.233); and an amulet depicting Hathor, possibly made of faience, purchased from Kelekian (see fig. 5.6, center, F1907.153).

69. Angela Milward, who examined the Freer's collection of New Kingdom faience bowls in 1977, questioned on stylistic grounds the authenticity of this piece and that of two other bowls of this type (comments in museum object files for F1907.15, F1907.637). In 1995, at Betsy M. Bryan's suggestion, a sample was removed from the object for TL testing, conducted by D. Stoneham at the Research Laboratory for Archaeology and the History of Art, Oxford, report dated 25 August 1995.

70. Freer to Tanios Girgis, 23 July 1907. According to a note in Freer's diary for 1907, Girgis informed the collector that the sculpture represented the daughter of Ramesses III.

71. 1908 diary, 27 and 29 May. Kitroeff, *The Greeks in Egypt*, 40; Charles E. Wilbour, *Travels in Egypt (December 1880 to May 1891): Letters of Charles Edwin Wilbour*, ed. Jean Capart (Brooklyn: Brooklyn Museum, 1936), 173–4, mentions two men by the name of Sinadino among the passengers aboard the *Péluse* from Alexandria to Calabria in April 1882, possibly members of the family of Constantin Sinadino. My thanks to James F.

Romano for this reference. Freer occasionally misspells the name as "Sinadano" or "Sinadanio."

72. Freer to Hecker, 30 May 1908.

73. Freer to Hecker, 12 June 1909, written from Grosvenor Square, London.

74. Freer to Hecker, 24 July 1909, on board the *Schleswig*.

75. Freer to Hecker, 28 July 1909.

76. *Catalogue des riches collections de bijoux anciens et objects de fouilles appartenant à la succession Despina Constantin Sinadino exposées aux Galeries Fouad, 14–15 Mars 1936* (Alexandria: privately printed, 1936). Émile Chassinat, "Tombe inviolée de la XVIII Dynastie," *Bulletin de l'Institut Français d'Archéologie Orientale* 1 (1901): 227–34, lists and illustrates several objects from a Dynasty 18 tomb near al-Gurob, which had made their way to Constantin Sinadino's collection.

CHAPTER 5

1. Freer to Kelsey, 18 June 1912.

2. Freer to Worrell, 17 July 1912.

3. Freer to Kelsey, 1 August 1909, Francis W. Kelsey Records, Kelsey Museum Archives, Bentley Historical Library, University of Michigan, Ann Arbor.

4. Worrell, *The Coptic Psalter in the Freer Collection*, frag. #9.

5. Lawton, "The Gold Treasure," 180–82, with further references.

6. Kelsey to Freer, 22 October 1913, Francis W. Kelsey Records, Kelsey Museum Archives, Bentley Historical Library, University of Michigan, Ann Arbor.

7. *List of a Selection of Art Objects Owned by the National Gallery of Art (Freer Collection) Exhibited November 14th, 1912* (Detroit: privately printed), 6; see also Linda Merrill, *The Peacock Room: A Cultural Biography* (Washington, D.C., and New Haven: Freer Gallery of Art and Yale University Press, 1998), esp. 341–46, on the display of the room in Detroit.

8. Lawton and Merrill, *Freer: A Legacy of Art*, 209–12.

9. Berthold Laufer, *Catalogue of a Selection of Art Objects from the Freer Collection Exhibited in the New Building of the National Museum* (Washington, D.C.: Smithsonian Institution, 1912), 15.

10. Kelsey to Freer, 10 May 1912, Francis W. Kelsey Records, Kelsey Museum Archives, Bentley Historical Library, University of Michigan, Ann Arbor. On the 1912 exhibition: Lawton and Merrill, *Freer: A Legacy of Art*, 212–16, with further references.

11. Lawton and Merrill, *Freer: A Legacy of Art*, esp. 236–52.

12. Freer to Langley, 27 December 1904.

13. Lawton and Merrill, *Freer: A Legacy of Art*, esp. 239–46; Charles Adams Platt to Freer, 14 July 1915.

14. Lawton and Merrill, *Freer: A Legacy of Art*, 186, quoting a letter from Freer to Langley, 18 January 1905.

15. Freer to Gustav Mayer, 26 January 1904.

16. Bernard Berenson to Isabella Stewart Gardner, 1 April 1909, in *Letters of Bernard Berenson and Isabella Stewart Gardner*, 440, with reference notes identifying the objects. "Schoolmaster" refers to the standing figure of Ka-aper (better known as the "Sheikh el-Beled"), which so impressed Freer: Saleh and Sourouzian, *Official Catalogue of the Egyptian Museum Cairo*, no. 40.

17. Klaus Berger, *Japonisme in Western Painting from Whistler to Matisse*, trans. David Britt (Cambridge: Cambridge University Press, 1992 [1980]), 12.

18. Ernest F. Fenollosa, "The Place in History of Mr. Whistler's Art," *Lotus* 1 (December 1903): 16.

19. Ernest F. Fenollosa, "The Collection of Mr. Charles L. Freer," *Pacific Era* 1, no. 2 (November 1907): 62.

20. "The Freer Collection of Art," *Century* 73, no. 3 (January 1907): 359.

21. Morris Bierbrier, "The Discovery of the Mummy Portraits," in Susan Walker et al., *Ancient Faces: Mummy Portraits from Roman Egypt* (London: Trustees of the British Museum, 1997), 23–24; this catalogue surveys the subject, incorporating current research.

22. Freer to Maurice Nahman, 27 October 1908. Albert M. Lythgoe to Kelsey, 5 June 1917: "We have here in the Museum a series of seven panels which I bought of Nahman, the Cairo dealer, in 1909 for a total price of £600 sterling. You will probably remember that these are excellent examples and in practically perfect condition." (Francis W. Kelsey Records, Kelsey Museum Archives, Bentley Historical Library, University of Michigan, Ann Arbor; marked copy, "original of this letter sent to Harry G. Stevens.") Freer was not invariably attracted to the "Fayum" portraits, however. In 1917, when Kelsey notified Freer that a Cairo dealer was offering "three Roman portraits similar to those found by Petrie at Hawara," Freer replied that they were "undoubtedly of real interest, but the three portraits are not in harmony with the Egyptian objects already in my collection, nor do they appeal to my esthetic sense" (Kelsey to Freer, 26 April 1917; Freer to Kelsey, 28 April 1917; both in Francis W. Kelsey Records, Kelsey Museum Archives, Bentley Historical Library, University of Michigan, Ann Arbor).

23. Albert M. Lythgoe, "Graeco-Egyptian Portraits," *Bulletin of the Metropolitan Museum of Art* 5, no. 3 (1910): 70, left; Klaus Parlasca, *Ritratti di Mummie*, ed. Achille Adriani, *Repertorio d'arte dell'Egitto greco-romano. Series B, Pittura*, 2 (Rome: L'Erma di Bretschneider, 1961), 45, no. 312; pl. 74, 1. Nahman apparently acquired this group of portraits shortly after their discovery: Klaus Parlasca, *Mumienporträts und verwandte Denkmäler* (Wiesbaden: Franz Steiner in association with the Deutsches Archäologisches Institut, 1966), 41–42, with further references.

24. Thomas Lawton, *Chinese Figure Painting*, Freer Gallery of Art Fiftieth Anniversary Exhibition, II (Washington, D.C.: Freer Gallery of Art, Smithsonian Institution, 1973), 165–70, nos. 41–42; Lawton also cites the catalogue sent to Freer and notes that two of the three other album leaves are in the Yale University Art Gallery; the third is in the Metropolitan Museum of Art. My thanks to Thomas Lawton for information on these paintings.

25. Lawton and Merrill, *Freer: A Legacy of Art*, 51 with n. 40 (Freer to William K. Bixby, 7 November 1900).

26. Freer to Hecker, 3 February 1907.

27. James Henry Breasted, *A History of Egypt* (New York: Charles Scribner's Sons, 1905), 347.

28. Freer to Willard R. Metcalf, 22 November 1918.

29. This was a fragment of a painted limestone wall relief of the Ptolemaic period (305–30 B.C.E.): Freer Gallery of Art, Smithsonian Institution, Washington, D.C., gift

of Charles Lang Freer (F1916.234).

30. Among the photographs given by Freer to the museum is one of an Egyptian stone head, "received from Mr. [Marcel] Bing, Paris, Aug. 1910. Object formerly owned by Mr. Datari [sic], Cairo." Freer Papers, Photograph File no. 14, no. 177.

31. Johnston, *William and Henry Walters, The Reticent Collectors*, 211–12, for objects acquired—through Kelekian—from the MacGregor sale.

32. Georg Steindorff, *A Royal Head from Ancient Egypt*, Freer Gallery of Art Occasional Papers 1:5 (Washington, D.C.: Freer Gallery of Art, Smithsonian Institution, 1951); James F.

Romano, "Sixth Dynasty Royal Sculpture," in *Les critères de datation stylistiques à l'Ancien Empire*, ed. Nicholas Grimal, Bibliothèque d'Étude 120 (Cairo: Institut Français d'Archéologie Orientale, 1998), 275–76, with further references; note his important caveat concerning the authenticity of the head. A limestone relief sculpture allegedly of Ptolemaic date was given to the museum in 1970: Freer Gallery of Art, Smithsonian Institution, Washington, D.C., gift of Eugene and Agnes E. Meyer (F1970.50).

33. *Les donateurs du Louvre*, 263; Kozloff, "Introduction," *Catalogue of Egyptian Art: The Cleveland Museum of Art*, 21–26, provides additional information on Mallon's career,

sales of Egyptian antiquities, and the correct date of his death. Freer and Mallon corresponded in 1914 concerning a Han dynasty (206 B.C.E.– 220 C.E) bronze vessel, which the dealer offered to Freer.

SELECTED BIBLIOGRAPHY

PRIMARY SOURCES

Archives and manuscripts

Charles Lang Freer Papers, Freer Gallery of Art Archives, Smithsonian Institution, Washington, D.C.

Henry Bacon Papers, Archives of American Art, Smithsonian Institution, Washington, D.C.

Joseph Lindon Smith Papers, Archives of American Art, Smithsonian Institution, Washington, D.C.

Francis W. Kelsey Records, Kelsey Museum Archives, Bentley Historical Library, University of Michigan, Ann Arbor.

Francis W. Kelsey Papers, Bentley Historical Library, University of Michigan, Ann Arbor.

F. Llewellyn Griffith Papers, Griffith Institute, Oxford University.

Percy Newberry Correspondence, Griffith Institute, Oxford University.

E. A. Wallis Budge Correspondence, Department of the Ancient Near East, British Museum, London.

SECONDARY SOURCES

Charles Lang Freer and his collection

Lawton, Thomas, and Linda Merrill. *Freer: A Legacy of Art.* Washington, D.C., and New York: Freer Gallery of Art, Smithsonian Institution and Harry N. Abrams, 1993.

Guidebooks and travelers' accounts, 1895–1910

Budge, E. A. Wallis. *The Nile. Notes for Travellers in Egypt.* 10th ed. London: Thomas Cook & Son, 1907.

Carson, Blanche Mabury. *From Cairo to the Cataract.* Boston: L. C. Page & Co., 1909.

Finney, Frederick Norton. *Letters from across the Sea, 1907–1908.* Philadelphia: J. B. Lippincott, 1909.

Guerville, Amédée Baillot de. *New Egypt.* London: W. Heinemann, 1906.

Kalfatovic, Martin R. *Nile Notes of a Howadji: A Bibliography of Travelers' Tales from Egypt, from the Earliest Time to 1918.* Metuchen, N. J.: Scarecrow Press, 1992.

Maspero, Gaston. *Guide to the Cairo Museum.* Translated by J. E. Quibell and A. A. Quibell. 3d ed. Cairo: French Institute of Oriental Archaeology, 1906.

Migeon, Gaston. *Le Caire, Le Nil et Memphis.* Paris: H. Laurens, 1906.

Medieval and modern Cairo

Raymond, André. *Cairo.* Translated by Willard Wood. Cambridge, Mass.: Harvard University Press, 2000.

History of Egyptian archaeology

Dawson, Warren R., and Eric P. Uphill. *Who Was Who in Egyptology.* 3d ed. London: Egypt Exploration Society, 1995.

Drower, Margaret S. *Flinders Petrie: A Life in Archaeology.* Wisconsin Studies in Classics. Madison: University of Wisconsin Press, 1995.

James, T.G.H., ed. *Excavating in Egypt: The Egypt Exploration Society, 1882–1982.* Chicago: University of Chicago Press, 1982.

———. *Howard Carter: The Path to Tutankhamun.* London: Kegan Paul International, 1992.

Thomas, Nancy, Gerry D. Scott III, and Bruce G. Trigger. *The American Discovery of Ancient Egypt.* Los Angeles and New York: Los Angeles County Museum of Art and Harry N. Abrams, 1995.

Thomas, Nancy, ed. *The American Discovery of Ancient Egypt.* Los Angeles: Los Angeles County Museum of Art and American Research Center in Egypt, 1996.

General reference works on ancient Egypt

Baines, John, and Jaromir Malek. *Cultural Atlas of Ancient Egypt.* New York: Checkmark Books, 2000.

Redford, Donald B., ed. *The Oxford Encyclopedia of Ancient Egypt.* 3 vols. New York: Oxford University Press, 2001.

Ancient Egyptian sites and monuments

Arnold, Dieter. *Temples of the Last Pharaohs.* New York: Oxford University Press, 1999.

Strudwick, Nigel and Helen. *Thebes in Egypt: A Guide to the Tombs and Temples of Ancient Luxor.* Ithaca: Cornell University Press, 1999.

"The 1905–1907 Breasted Expeditions to Egypt and the Sudan: A Photographic Study." http://www.oi.uchicago.edu/OI/MUS/PA/EGYPT/BEES/BEES_Intro.html

"Photographic Archive, Middle East Department, University of Chicago Library." http://www.lib.uchicago.edu/e/su/mideast

Ancient Egyptian art, materials, and technology

Andrews, Carol. *Amulets of Ancient Egypt.* London: Published for the Trustees of the British Museum by British Museum Press, 1994.

Friedman, Florence Dunn, ed. *Gifts of the Nile: Ancient Egyptian Faience.* New York: Thames and Hudson, 1998.

Nicholson, Paul T., and Ian Shaw, eds. *Ancient Egyptian Materials and Technology.* Cambridge: Cambridge University Press, 2000.

Robins, Gay. *The Art of Ancient Egypt.* Cambridge, Mass.: Harvard University Press, 1997.

Saleh, Mohamed, and Hourig Sourouzian. *Official Catalogue of the Egyptian Museum Cairo.* Munich and Mainz: Prestel and Philipp von Zabern, 1987.

INDEX

LIBRARY OF CONGRESS CATALOGING-IN-PUBLICATION DATA

Gunter, Ann Clyburn, 1951-
 A collector's journey : Charles Lang Freer and Egypt / Ann C. Gunter.
 p. cm.
Includes bibliographical references and index.
 1. Freer, Charles Lang, 1856-1919—Journeys—Egypt. 2. Art patrons—United States--Biography. 3. Art, Egyptian. 4. Freer Gallery of Art. I. Title: Charles Lang Freer and Egypt. II. Freer, Charles Lang, 1856-1919. III. Freer Gallery of Art. IV. Arthur M. Sackler Gallery (Smithsonian Institution) V. Title.
N857.5 .G86 2002
709'.32'075--DC21

2002006660